SCOTLAND

PICTORIAL BRITAIN

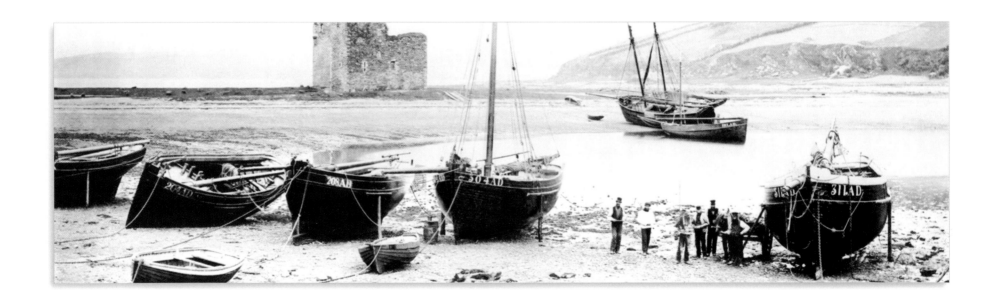

THE FRANCIS
FRITH
COLLECTION®

First published in the United Kingdom in 2005 by The Francis Frith Collection®

Hardback edition published in 2005 ISBN 1-84589-185-6

Text and Design copyright The Francis Frith Collection®
Photographs copyright The Francis Frith Collection® except where indicated.

British Library Cataloguing in Publication Data

Scotland
Pictorial Britain
Compiled and edited by Terence Sackett

The Francis Frith Collection
Frith's Barn, Teffont,
Salisbury, Wiltshire SP3 5QP
Tel: +44 (0) 1722 716 376
Email: info@francisfrith.co.uk
www.francisfrith.co.uk

Aerial photographs reproduced under licence from Simmons Aerofilms Limited
Historical Ordnance Survey maps reproduced under licence from Homecheck.co.uk

Printed and bound in Malta

Front Cover & Frontispiece: ARRAN, THE CASTLE AND LOCH RANZA c1890 A93001P
The colour-tinting in this image is for illustrative purposes only, and is not intended to be historically accurate

Every attempt has been made to contact copyright holders of illustrative material. We will be happy to give full acknowledgement in future
editions for any items not credited. Any information should be directed to The Francis Frith Collection.

AS WITH ANY HISTORICAL DATABASE, THE FRANCIS FRITH ARCHIVE IS CONSTANTLY BEING CORRECTED AND IMPROVED,
AND THE PUBLISHERS WOULD WELCOME INFORMATION ON OMISSIONS OR INACCURACIES

SCOTLAND

PICTORIAL BRITAIN

CONTENTS

THE MAKING OF AN ARCHIVE

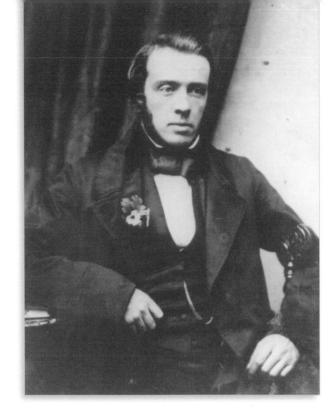

Francis Frith, Victorian founder of the world-famous photographic archive, was a devout Quaker and a highly successful Victorian businessman. By 1860 he was already a multi-millionaire, having established and sold a wholesale grocery business in Liverpool. He had also made a series of pioneering photographic journeys to the Nile region. The images he returned with were the talk of London. An eminent modern historian has likened their impact on the population of the time to that on our own generation of the first photographs taken on the surface of the moon.

Frith had a passion for landscape, and was as equally inspired by the countryside of Britain as he was by the desert regions of the Nile. He resolved to set out on a new career and to use his skills with a camera. He established a business in Reigate as a specialist publisher of topographical photographs.

Frith lived in an era of immense and sometimes violent change. For the poor in the early part of Victoria's reign work was a drudge and the hours long, and ordinary people had precious little free time. Most had not travelled far beyond the boundaries of their own town or village. Mass tourism was in its infancy during the 1860s, but during the next decade the railway network and the establishment of Bank Holidays and half-Saturdays gradually made it possible for the working man and his family to enjoy holidays and to see a little more of the world. With characteristic business acumen, Francis Frith foresaw that these new tourists would enjoy having souvenirs to commemorate their days out. He began selling photo-souvenirs of seaside resorts and beauty spots, which the Victorian public pasted into treasured family albums.

Frith's aim was to photograph every town and village in Britain. For the next thirty years he travelled the country by train and by pony and trap, producing fine photographs of seaside resorts and beauty spots that were keenly bought by millions of Victorians.

Each photograph was taken with tourism in mind, the small team of Frith photographers concentrating on busy shopping streets, beaches, seafronts, picturesque lanes and villages. They also photographed buildings: the Victorian and Edwardian eras were times of huge building activity, and town halls, libraries, post offices, schools and technical colleges were springing up all over the country. They were invariably celebrated by a proud Victorian public, and photo souvenirs – visual records – published by F Frith & Co were sold in their hundreds of thousands. In addition, many new commercial buildings such as hotels, inns and pubs were photographed, often because their owners specifically commissioned Frith postcards or prints of them for re-sale or for publicity purposes.

In order to gain some understanding of the scale of Frith's business one only has to look at the catalogue issued by Frith & Co in 1886: it runs to some 670 pages. By 1890 Frith had created the greatest specialist photographic publishing company in the world, with over 2,000 stockists! The picture on page 7 shows the Frith & Co display board on

the wall of the stockist at Ingleton in the Yorkshire Dales (left of window). Beautifully constructed with a mahogany frame and gilt inserts, it displayed a dozen scenes.

The ever-popular holiday postcard we know today took many years to appear, and F Frith & Co was in the vanguard of its development. Postcards became a hugely popular means of communication and sold in their millions. Frith's company took full advantage of this boom and soon became the major publisher of photographic view postcards.

Francis Frith died in 1898 at his villa in Cannes, his great project still growing. His sons Eustace and Cyril continued their father's monumental task, expanding the number of views offered to the public and recording more and more places in Britain, as the coasts and countryside were opened up to mass travel. The archive Frith created continued in business for another seventy years. By 1970 it contained over a third of a million pictures of 7,000 cities, towns and villages. The massive photographic record Frith has left to us stands as a living monument to a special and very remarkable man.

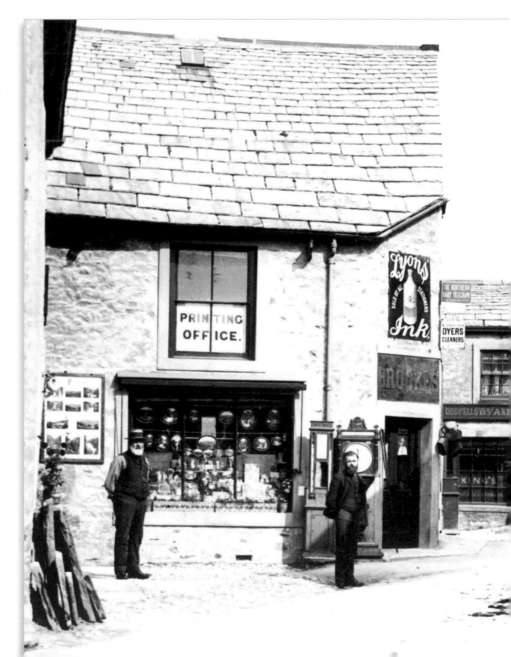

SCOTLAND

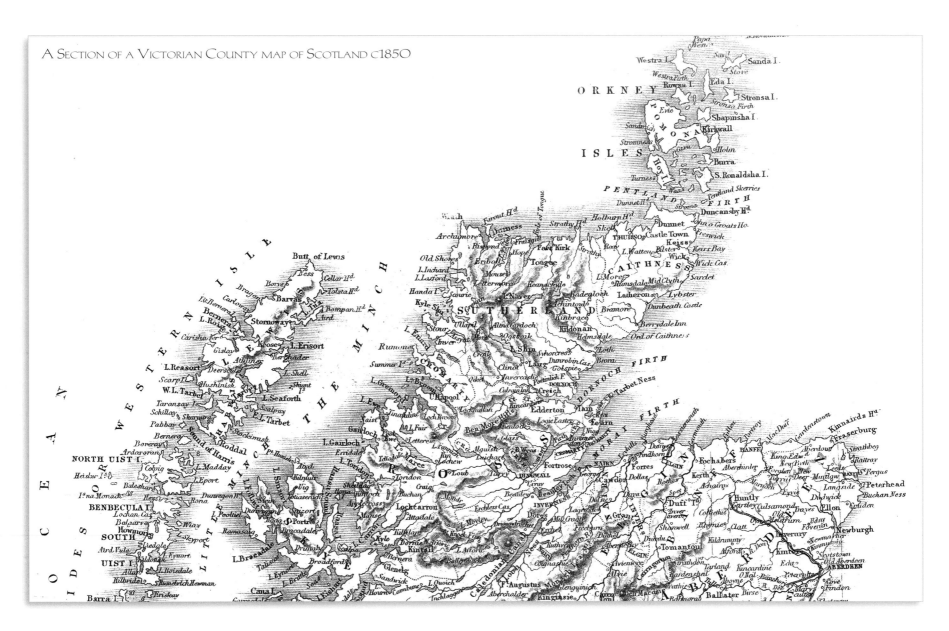

A Section of a Victorian County map of Scotland c1850

8

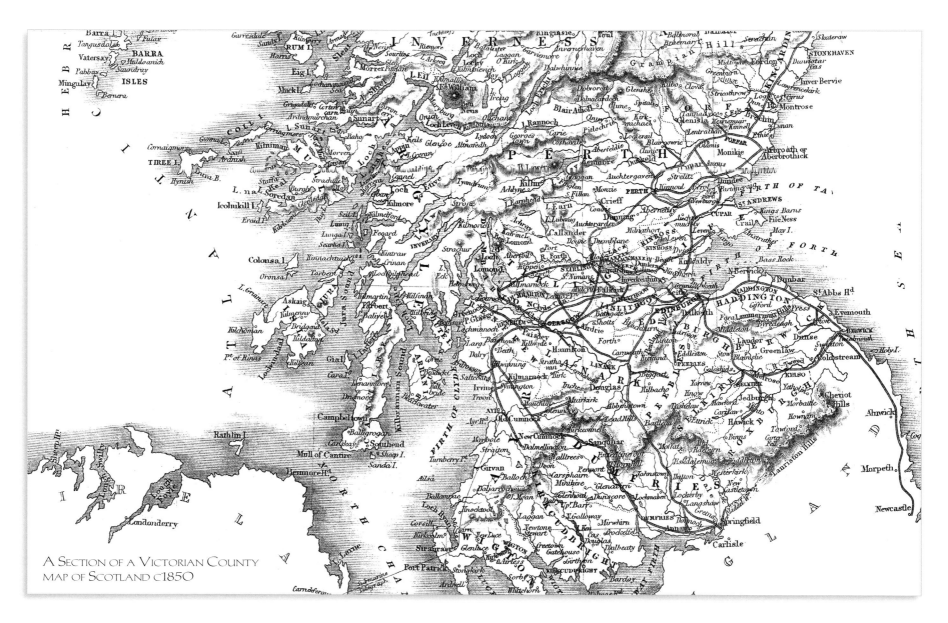

A Section of a Victorian County
map of Scotland c1850

INTRODUCTION SCOTLAND

This book shows Scotland as it was photographed for the world-famous Francis Frith archive from late-Victorian times, and depicts the considerable changes the country has undergone over the course of a century or more. Frith historical photographs are renowned for their clarity and fine detail. Atmospheric and beautifully printed, they reveal the true character and essence of Scotland, and offer an enthralling journey into Britain's past and into our shared history and heritage.

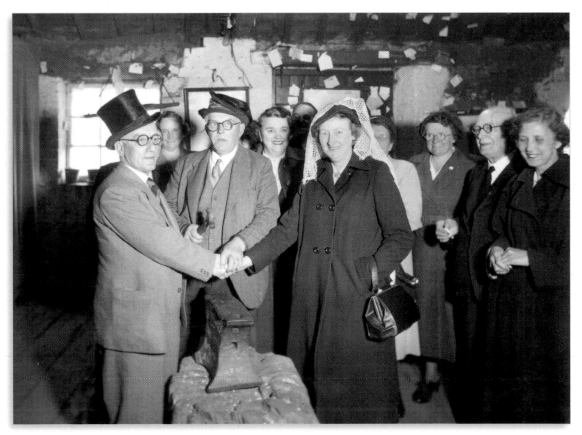

GRETNA GREEN, AN ANVIL WEDDING c1940
G163002

Gretna stands on the Scottish/English border, and as a result became popular for runaway marriages of English couples - Lord Hardwicke's act of 1754 abolished irregular marriages in England, but not in Scotland. Once across the bridge, runaways could marry very quickly in accordance with 18th-century Scots law, which required neither banns nor licence.

ECCLEFECHAN,
THE BIRTHPLACE OF
THOMAS CARLYLE
c1960
E120006

The writer and social
historian Thomas Carlyle
was born in this house
in 1795. It had been
built by Carlyle's father
and uncle just four
years before—they were
both stonemasons in
the village. Carlyle left
Ecclefechan when he
was just 13, and walked
almost 90 miles to
Edinburgh to attend the
university. He became one
of the most respected of
Victorian commentators
on social philosophy,
his views and opinions
always conditioned by the
childhood years he spent
in this plain house and
isolated rural community.

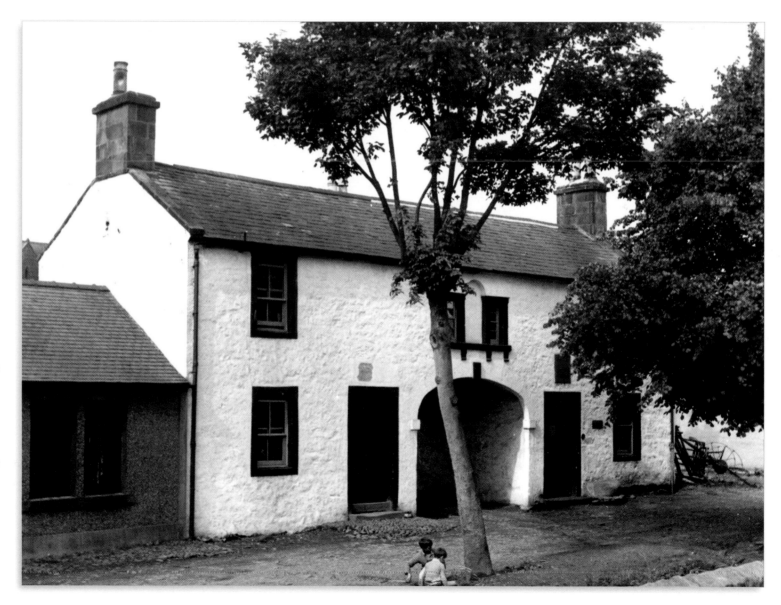

DUMFRIES & GALLOWAY

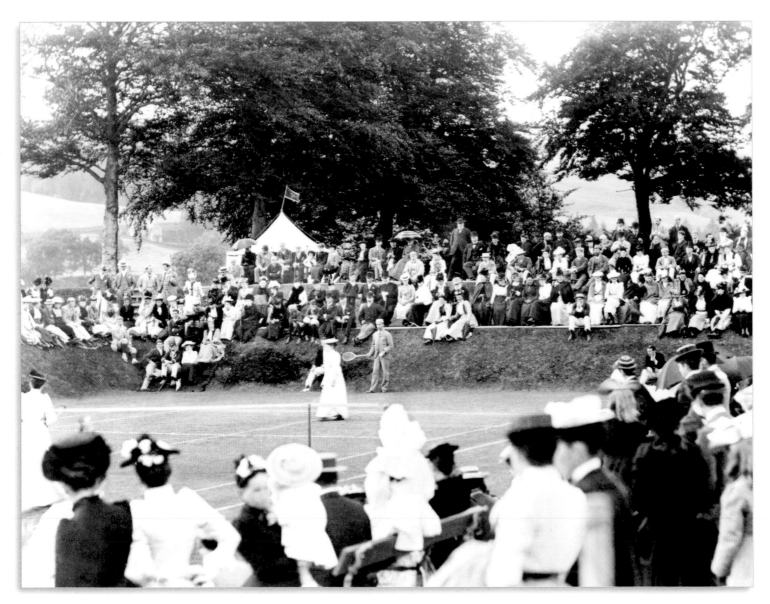

MOFFAT,
TENNIS TOURNAMENT
1892
M113003

At the beginning of the
20th century, Moffat
attracted tourists wishing
to sample the delights of
the nearby sulphureous-
saline wells. It was around
this time that tennis became
something of an event, with
most spa towns organising
annual tournaments.

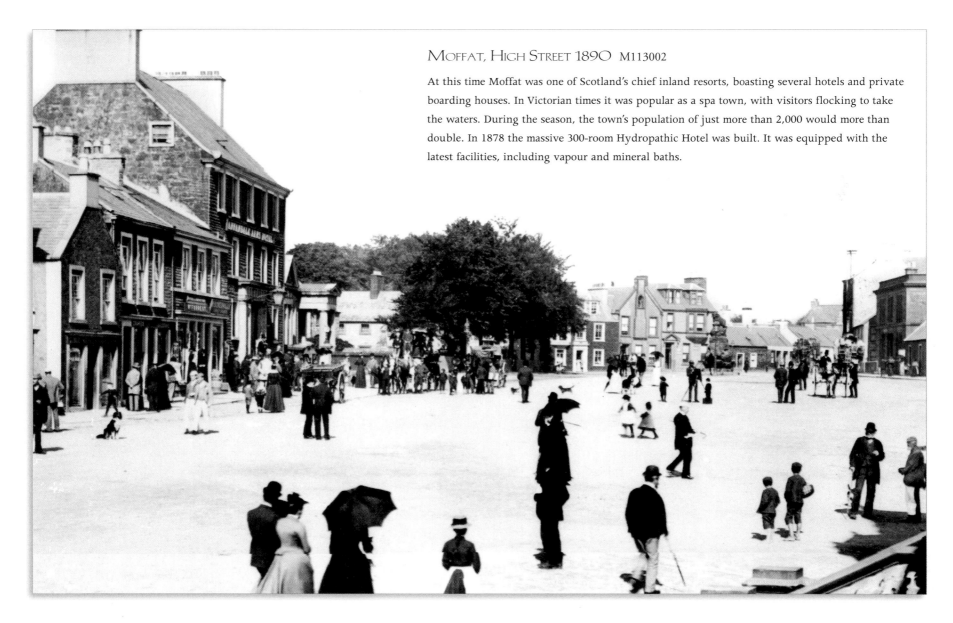

Moffat, High Street 1890 M113002

At this time Moffat was one of Scotland's chief inland resorts, boasting several hotels and private boarding houses. In Victorian times it was popular as a spa town, with visitors flocking to take the waters. During the season, the town's population of just more than 2,000 would more than double. In 1878 the massive 300-room Hydropathic Hotel was built. It was equipped with the latest facilities, including vapour and mineral baths.

DUMFRIES & GALLOWAY

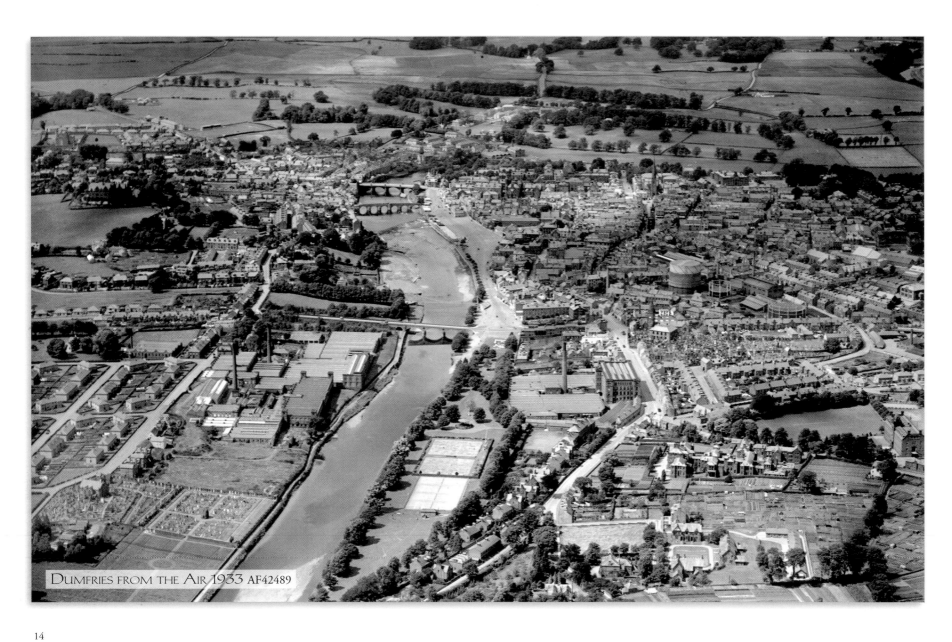

DUMFRIES FROM THE AIR 1933 AF42489

Dumfries, The Bridges c1890 D78002

The River Nith divides Dumfries from Maxwelltown. Dumfries itself became a royal burgh in the 12th century, but the two towns were not officially amalgamated until 1929. Robert Burns came to the town in 1791 and lived with his wife and family in a house in Millhole Brae. Burns died in 1796 at the age of 36 and is buried in St Michael's Church.

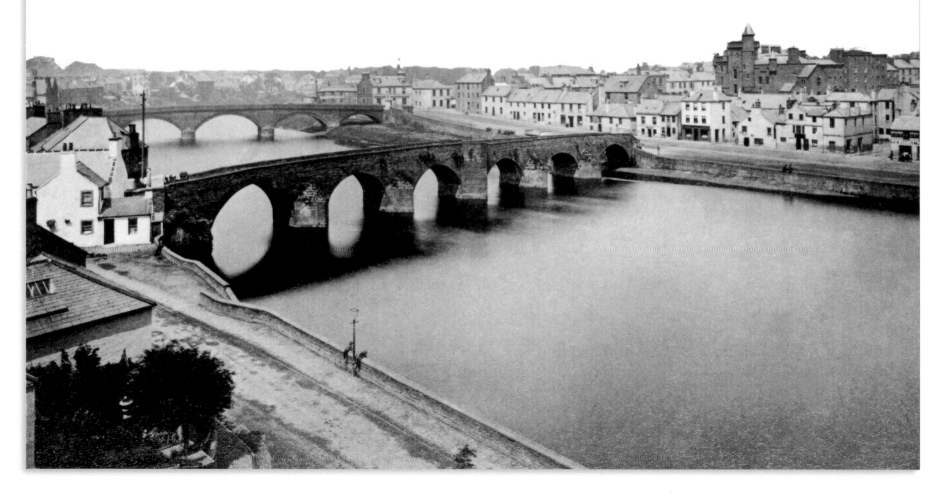

CROSSMICHAEL, THE VILLAGE c1960 C362001

This small village sits astride the road from Ayr to Castle Douglas. Its roots have always been in its farming community, and here we see cut corn being dried in the sun, stacked in stooks in the traditional manner. Houses and cottages, many single-storey and built of local stone with slate roofs, line the long, winding main street. The church is believed to have been built in 1547, and the attractive round bell tower was added in 1611.

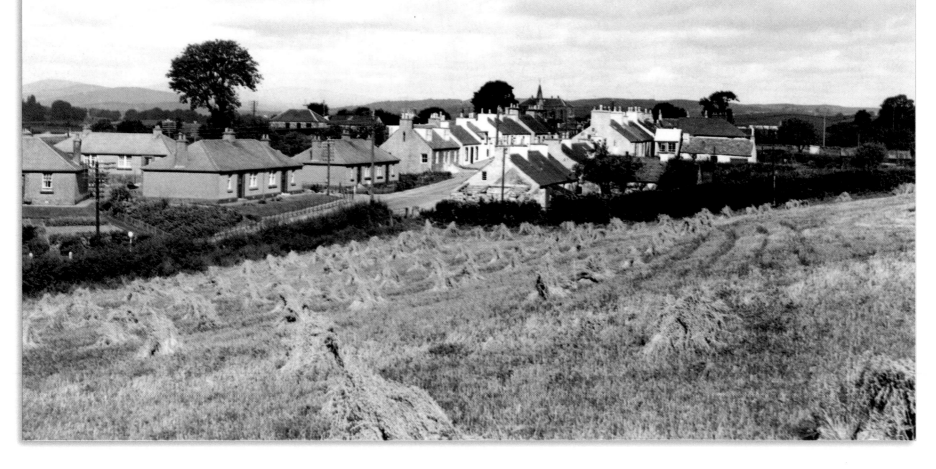

CASTLE DOUGLAS, LOCHSIDE PARK C1955 C361002

Castle Douglas lies close by the main road from Dumfries to Stranraer at the north end of Carlingwark Loch. Until the end of the 1700s it was known as Carlingwark. It was renamed Castle Douglas in 1792 after Sir William Douglas laid out a new village on the site of the old. It was once a centre for the hand spinning of cotton, but was unable to compete with the industrialized mills of New Lanark. However, its strategic position made it into an important coaching stop, and hotels sprung up to cater for the visitors. When the railway arrived in 1859, the town's status as a regional centre for rural Galloway was assured.

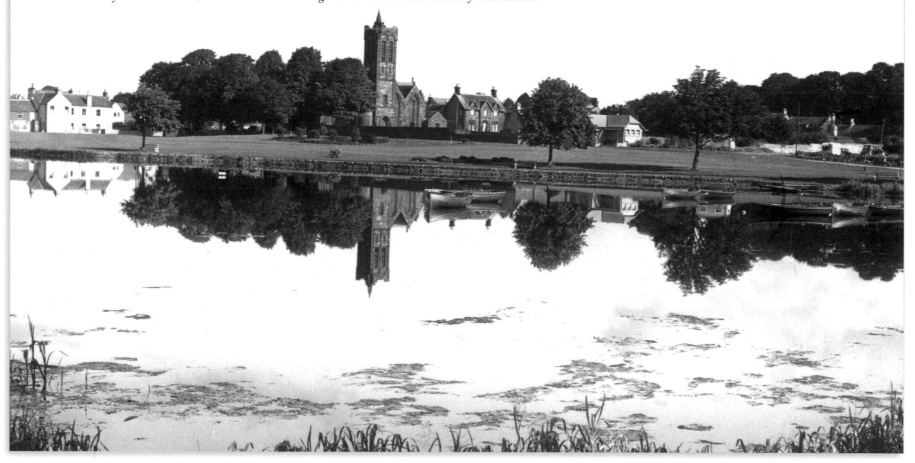

DUMFRIES & GALLOWAY

PALNACKIE, THE HARBOUR C1960 P190002

The village of Palnackie is set in a region of wooded hills and streams. It was for centuries an important port, and sailing ships plied up the meandering course of the Urr to unload their cargoes, many having to be towed by teams of horses. Silting up has made it difficult for large vessels to continue to use Palnackie port, and visits have been restricted in recent years to smaller pleasure craft, and more modest fishing and cockling boats.

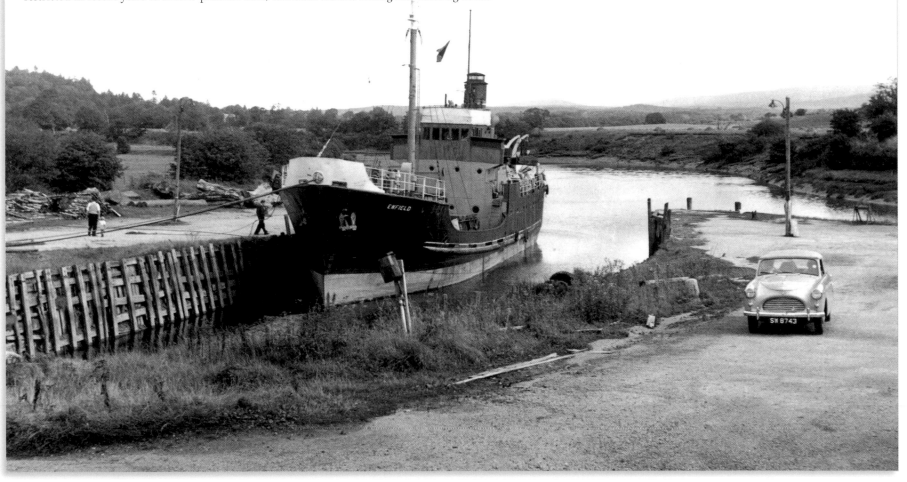

KIPPFORD, THE HARBOUR c1955 K101012

The picturesque village of Kippford is set close to the mouth of the River Urr downstream from Dalbeattie, on the eastern shore of the estuary. It was once a significant coastal packet port, and sloops and other vessels were built on the narrow shore. In early days they had to be launched sideways on, a difficult and often perilous procedure. By the 1920s shipbuilding had declined, and in the years since Kippford has become a popular yachting centre, its harbour and channel busy with visiting boats in the summer months.

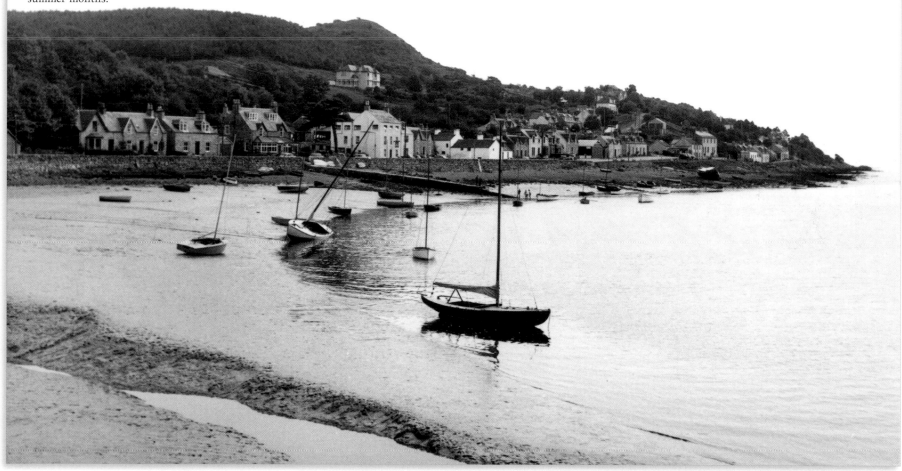

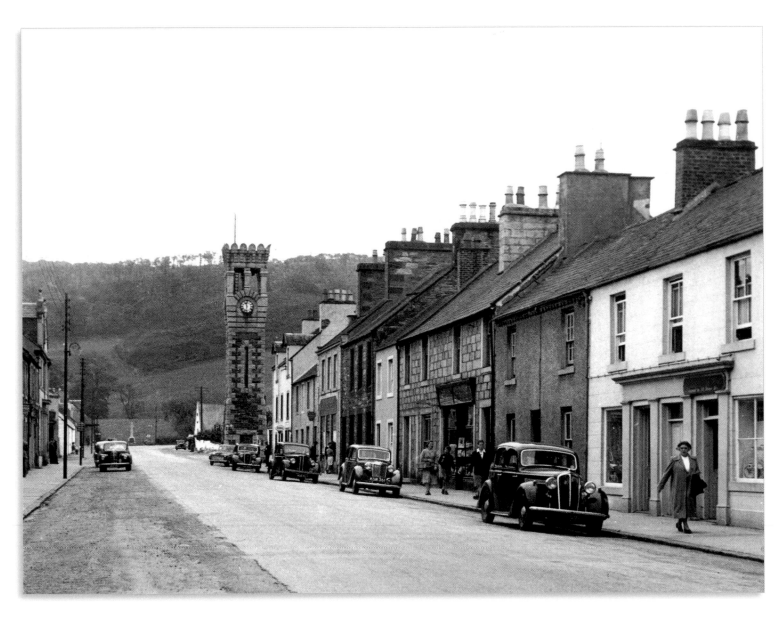

GATEHOUSE OF FLEET, HIGH STREET c1955
G162011P

Gatehouse of Fleet is situated near the mouth of the Water of Fleet, a few miles north-west of Kirkcudbright. James Murray of Broughton established it in the 1760s as the estate village for Cally, his country house. It grew into a centre for brewing, cotton manufacturing, boat building and tanning, and was once known as 'the Glasgow of the South'. Its name derives from the 'Gait-House', which was built by the Murrays in the 17th century, the 'gait' being the road from Dumfries to Creetown.

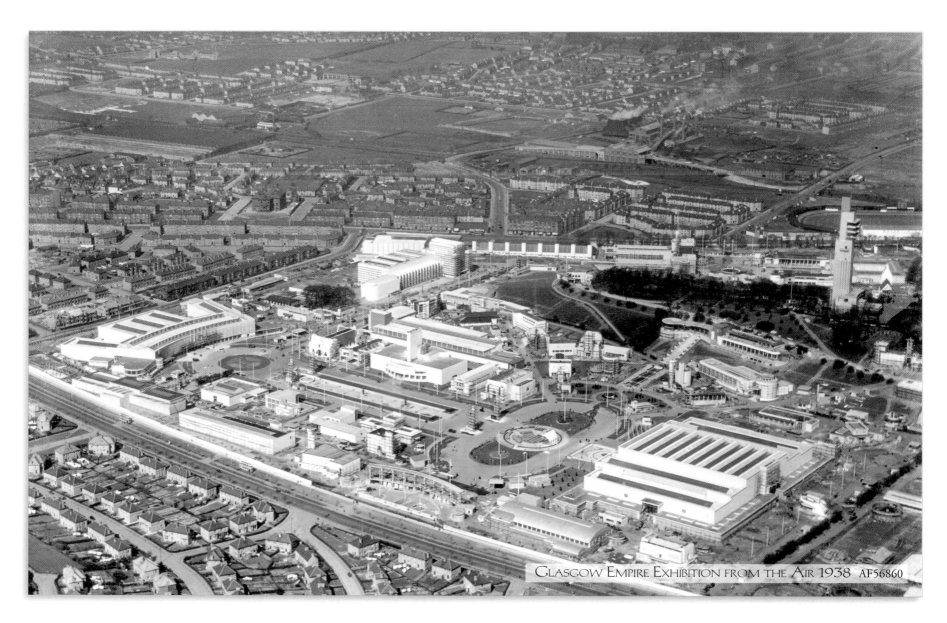

GLASGOW EMPIRE EXHIBITION FROM THE AIR 1938 AF56860

GLASGOW

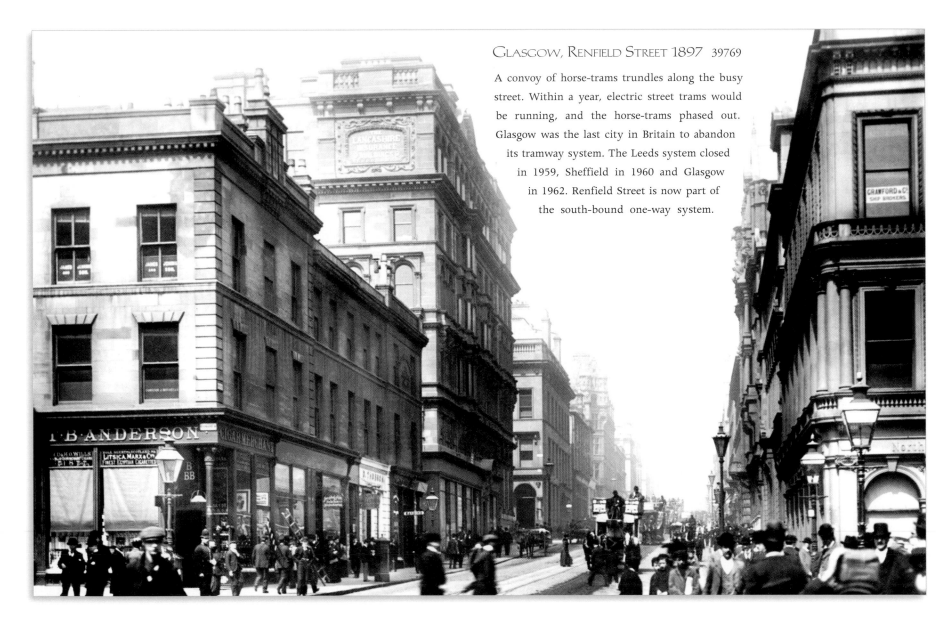

GLASGOW, RENFIELD STREET 1897 39769

A convoy of horse-trams trundles along the busy street. Within a year, electric street trams would be running, and the horse-trams phased out. Glasgow was the last city in Britain to abandon its tramway system. The Leeds system closed in 1959, Sheffield in 1960 and Glasgow in 1962. Renfield Street is now part of the south-bound one-way system.

GLASGOW,
ST VINCENT'S PLACE
1897 39764t

Here, within the heartland
of the city's commercial and
financial life, the imposing
Victorian buildings we see
are still standing today.
We are looking towards
George Square, and in the
hazy background of the
photograph can be one of the
domes of the City Chambers.
Nearby are the National
Bank, the Royal Exchange,
the Stock Exchange, and
the Athenaeum Club.

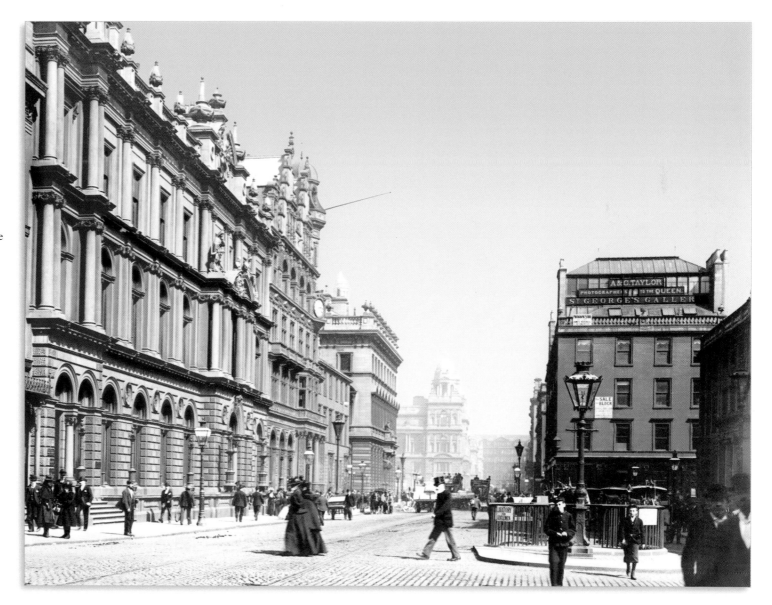

GLASGOW, SAUCHIEHALL STREET 1897 39763

Sauchiehall Street joined the east and west quarters of the city, and it was here that you could buy quality confectionery from Assafrey, dine out at the Hippodrome, attend an exhibition at the Institute of Fine Arts, or stay at a temperance hotel. We are looking west. This section is now pedestrianised. Most of the buildings have gone, and on the site of the clock tower there is now a large indoor shopping complex and car parking facilities.

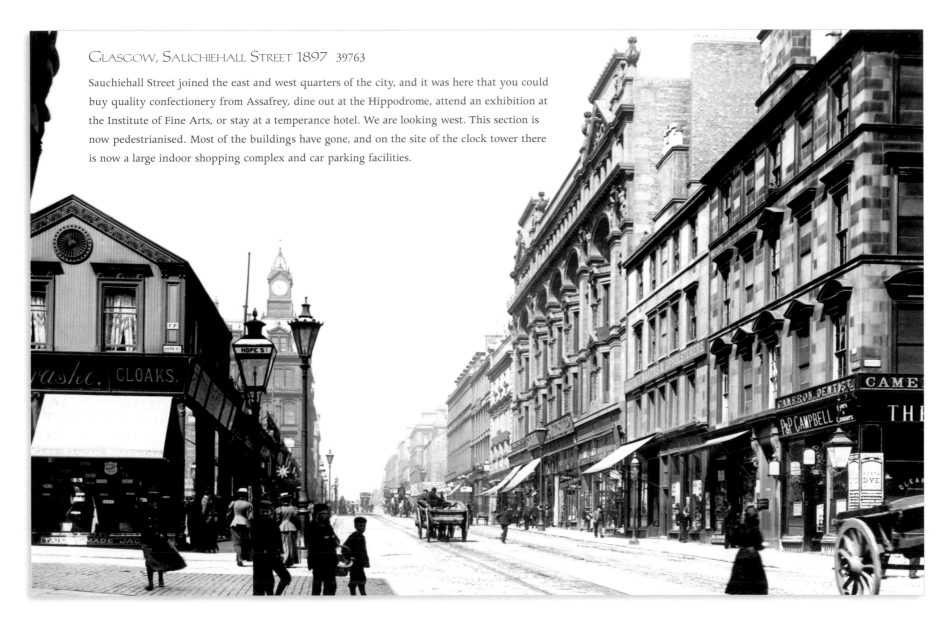

GLASGOW, GEORGE SQUARE 1897 39759

It used to be said that George Square reminded visiting Londoners of Trafalgar Square, but the central column was a monument to Sir Walter Scott rather than Lord Nelson. The square served to emphasise Glasgow's self-proclaimed status as 'the second city of the Empire'. It contained the magnificent municipal buildings completed in 1888 at a cost of £540,000—the Post Office, the Bank of Scotland, the Merchant's House and several hotels.

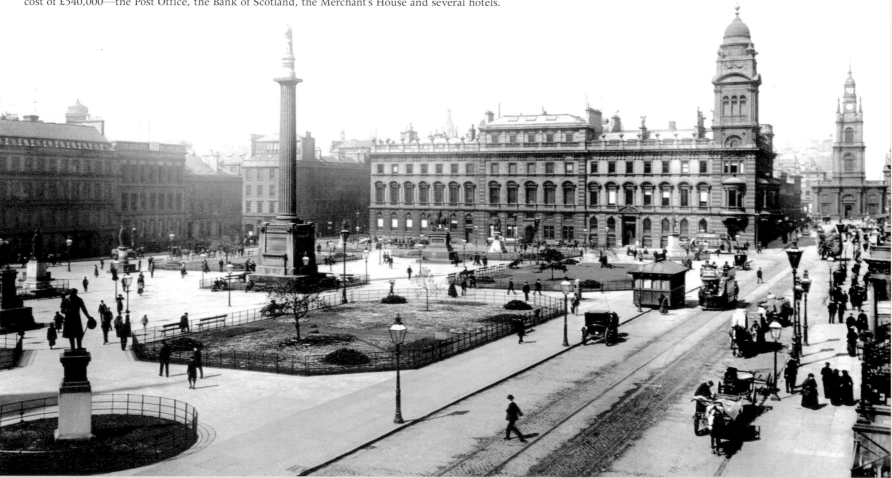

GLASGOW

GLASGOW, BROOMIELAW 1897 39801

This overhead view of the Broomielaw area of the city shows the George V bridge in the foreground. Ships are tied up at the quay waiting to load up with cargo and passengers for the Clyde and Scottish coastal resorts.

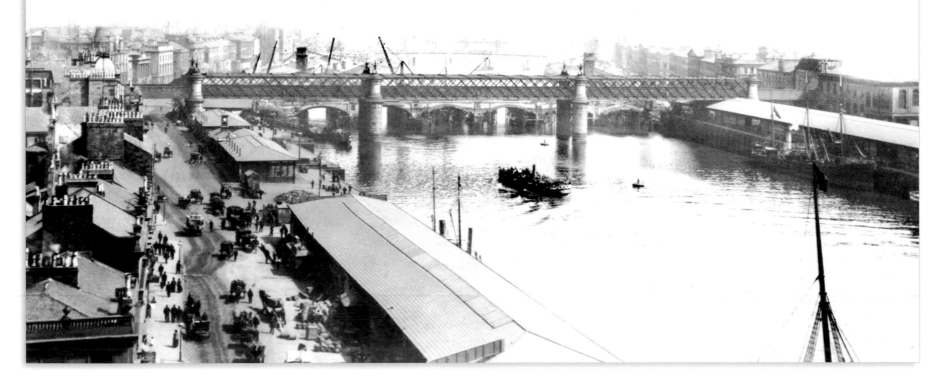

GLASGOW,
KELVINGROVE PARK
1897
39757

Sir Joseph Paxton, designer of the Crystal Palace, laid out this park on the banks of the River Kelvin. It was opened in 1853. The Art Galleries and Museum are in the grounds, and contain many Italian, Flemish, Dutch and French paintings, as well as British ones. The museum halls include many varied exhibits, including armoury, engineering and natural history.

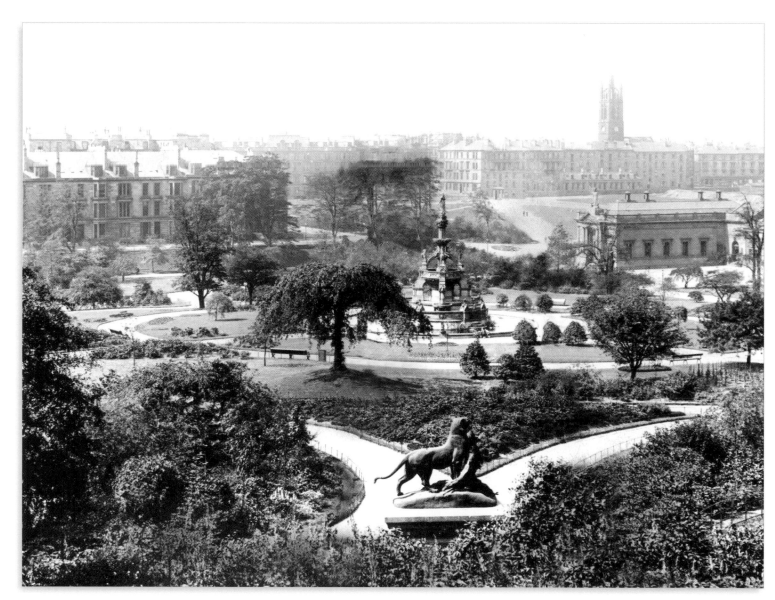

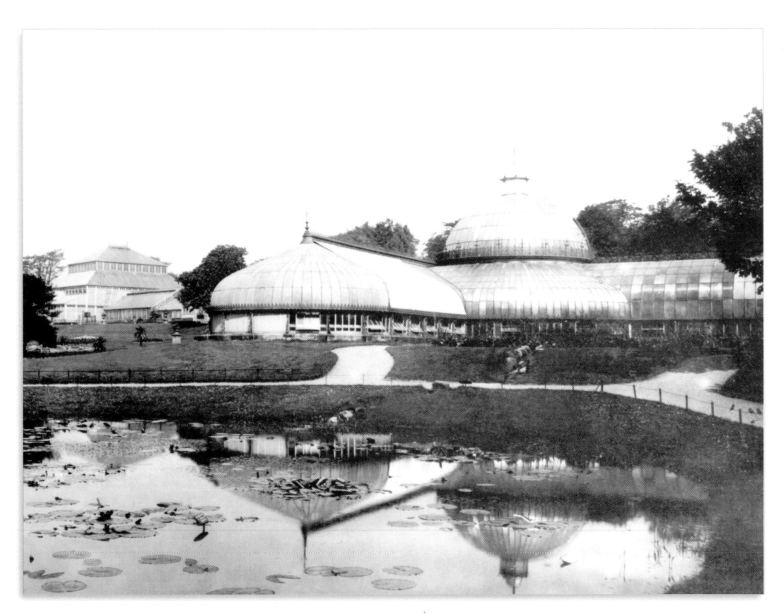

GLASGOW,
THE BOTANIC
GARDENS 1897
39796

The Botanic Gardens
occupy 43 acres off Great
Western Road, and many
orchids, tropical plants
and trees are grown in
its conservatories. The
Kibble Palace, the largest
glasshouse in Britain, is
now a Winter Garden,
but was formerly used
for public meetings
and concerts. Disraeli
(Earl Beaconsfield) and
Gladstone delivered their
Rectorial addresses to
the Glasgow University
students under its
immense dome.

GLASGOW,
CROOKSTON CASTLE,
1897
39808

Crookston was the first
property to be acquired
by the National Trust for
Scotland. The estate was
held in the 12th century
by Sir Robert Croc of
Neilston, and it is from him
that the castle derives its
name. In the 14th century
the estate passed into the
hands of Alan Stewart of
Darnley; the tower was
probably built in the early
15th century by Sir John
Stewart, Constable of the
Scots in the French service.

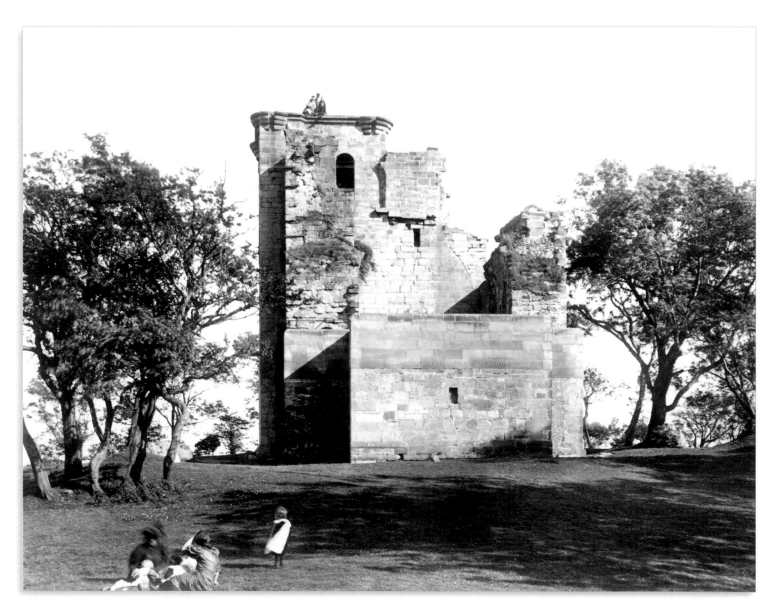

GLASGOW

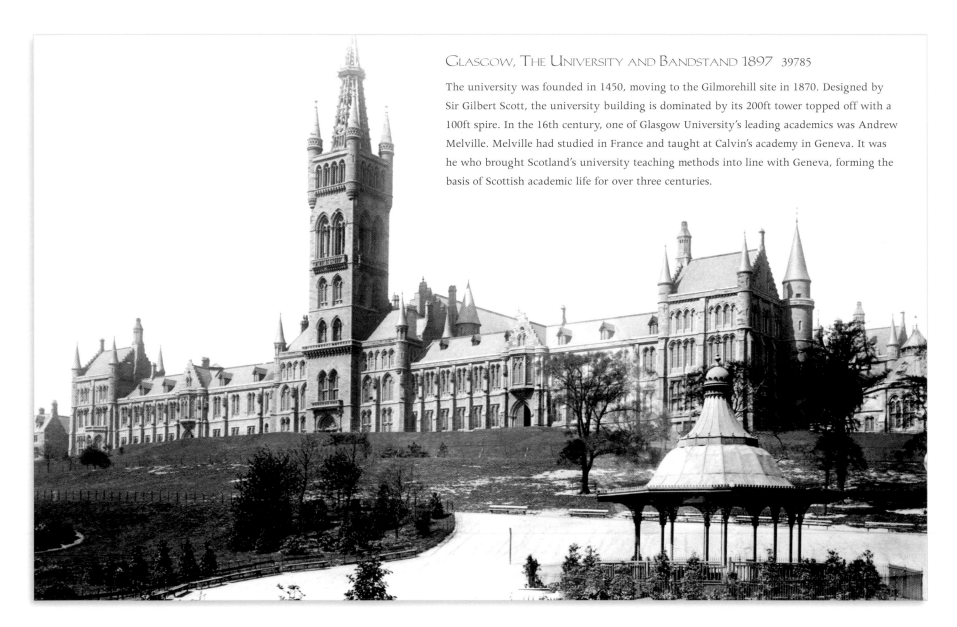

GLASGOW, THE UNIVERSITY AND BANDSTAND 1897 39785

The university was founded in 1450, moving to the Gilmorehill site in 1870. Designed by Sir Gilbert Scott, the university building is dominated by its 200ft tower topped off with a 100ft spire. In the 16th century, one of Glasgow University's leading academics was Andrew Melville. Melville had studied in France and taught at Calvin's academy in Geneva. It was he who brought Scotland's university teaching methods into line with Geneva, forming the basis of Scottish academic life for over three centuries.

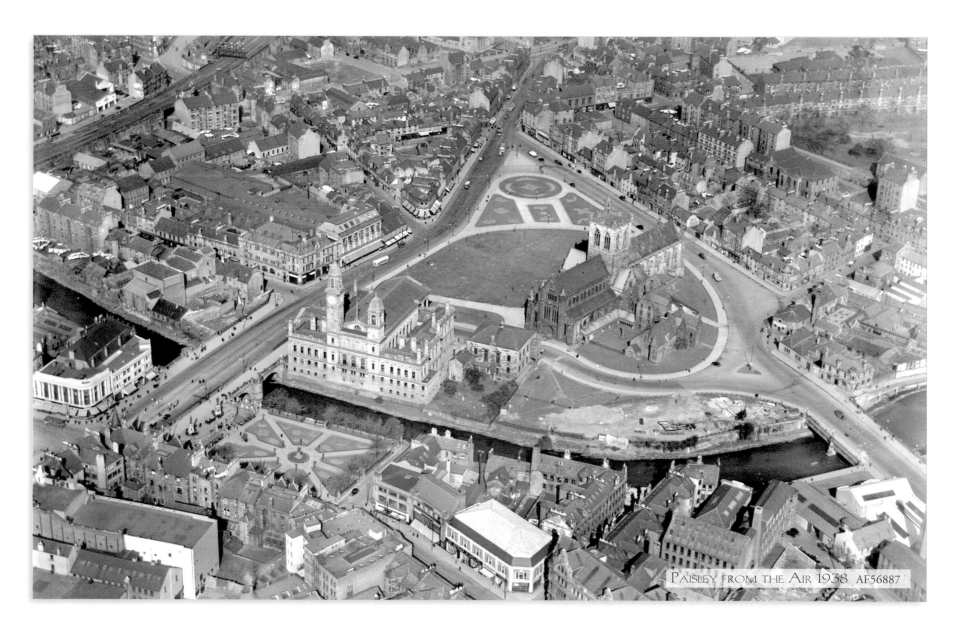

PAISLEY FROM THE AIR 1938 AF56887

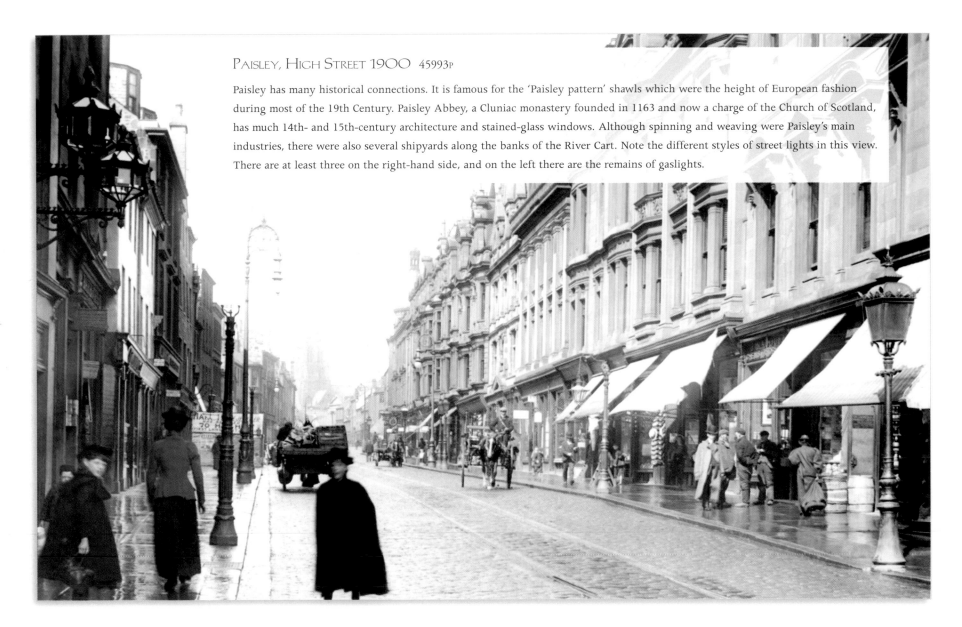

PAISLEY, HIGH STREET 1900 45993P

Paisley has many historical connections. It is famous for the 'Paisley pattern' shawls which were the height of European fashion during most of the 19th Century. Paisley Abbey, a Cluniac monastery founded in 1163 and now a charge of the Church of Scotland, has much 14th- and 15th-century architecture and stained-glass windows. Although spinning and weaving were Paisley's main industries, there were also several shipyards along the banks of the River Cart. Note the different styles of street lights in this view. There are at least three on the right-hand side, and on the left there are the remains of gaslights.

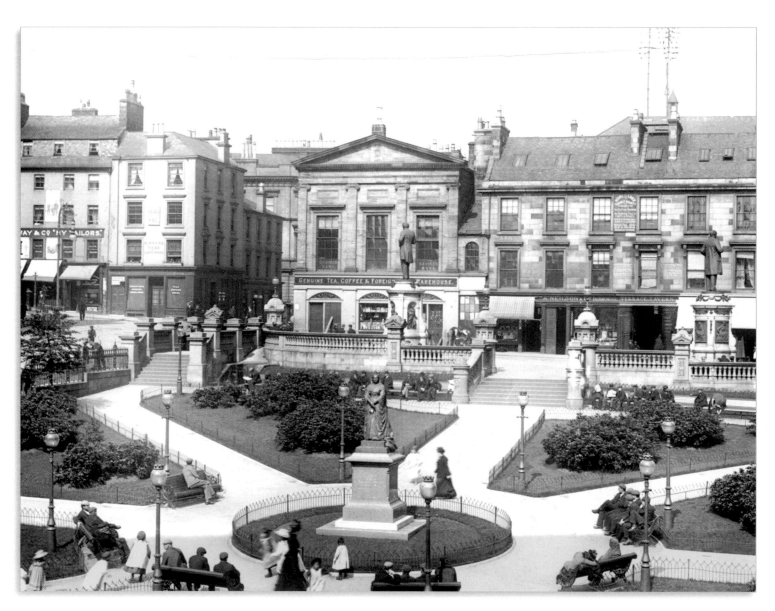

PAISLEY,
DUNN SQUARE 1901
47397

Dunn Square is a haven of tranquil peace amidst the bustle of a busy town centre. The statues, including those of Queen Victoria, and of Robert Tannahill, the weaver and poet who was born in Paisley, still adorn this square, although the layout has been altered since this photograph was taken.

STRATHCLYDE

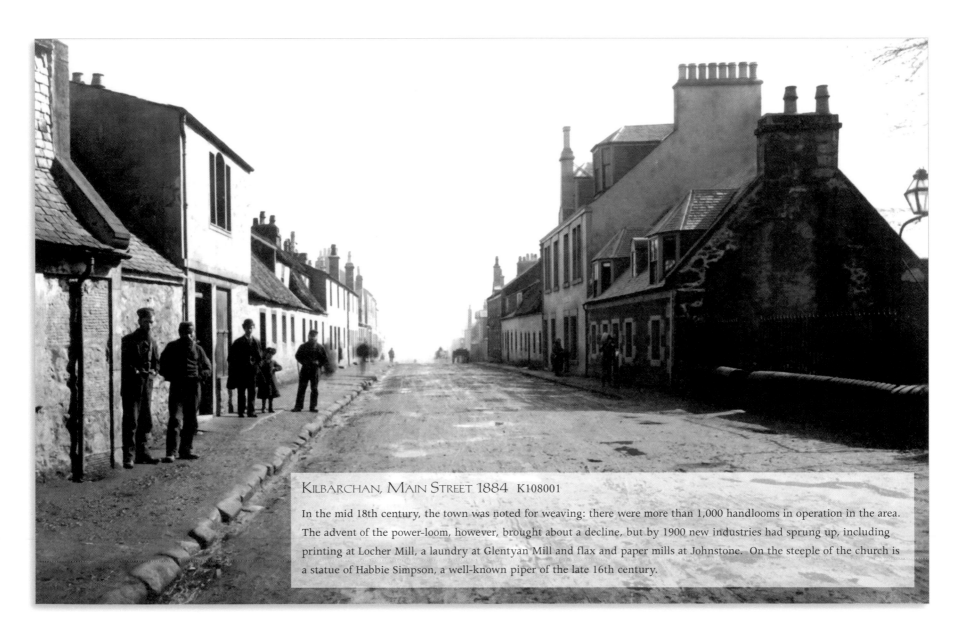

KILBARCHAN, MAIN STREET 1884 K108001

In the mid 18th century, the town was noted for weaving: there were more than 1,000 handlooms in operation in the area. The advent of the power-loom, however, brought about a decline, but by 1900 new industries had sprung up, including printing at Locher Mill, a laundry at Glentyan Mill and flax and paper mills at Johnstone. On the steeple of the church is a statue of Habbie Simpson, a well-known piper of the late 16th century.

GREENOCK, THE VIEW FROM WHINHILL 1899 43400

It was in the 17th century that Greenock developed as a port, providing a packet service to and from Ireland. During the early years of the 18th century, facilities were improved with the construction of a harbour and quays. By 1760, the first shipyards at Greenock were open, and in 1786 a graving dock was completed. A new graving dock was built in the early 1870s and work on the James Watt Dock began in 1881. In this view, we see the smoking chimneypots of Greenock and the entrance to Gare Loch.

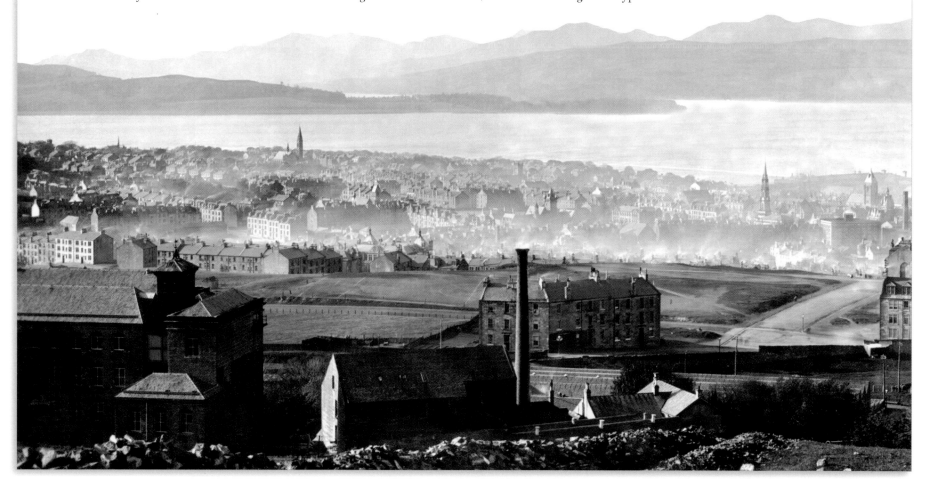

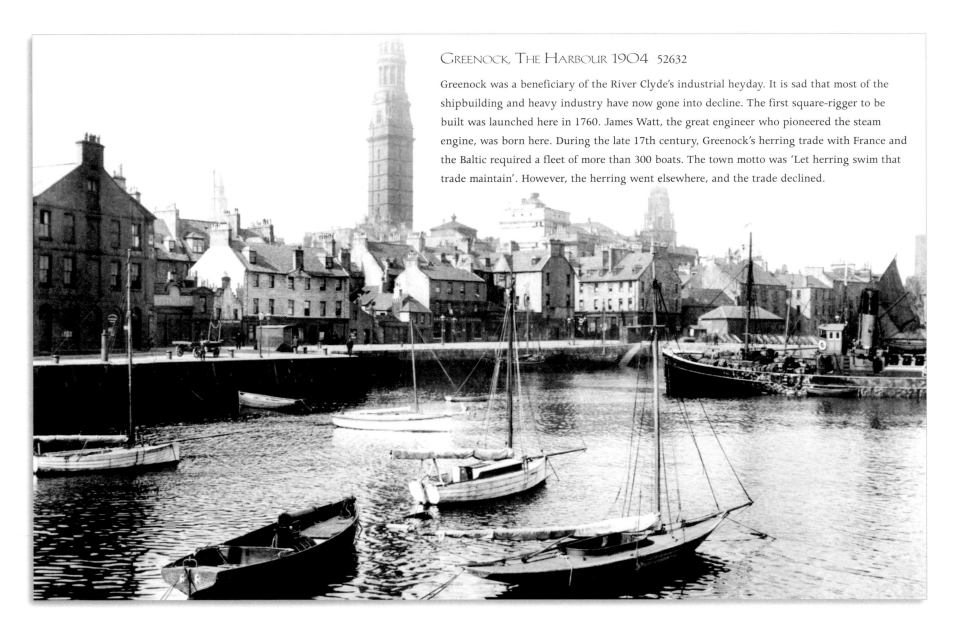

GREENOCK, THE HARBOUR 1904 52632

Greenock was a beneficiary of the River Clyde's industrial heyday. It is sad that most of the shipbuilding and heavy industry have now gone into decline. The first square-rigger to be built was launched here in 1760. James Watt, the great engineer who pioneered the steam engine, was born here. During the late 17th century, Greenock's herring trade with France and the Baltic required a fleet of more than 300 boats. The town motto was 'Let herring swim that trade maintain'. However, the herring went elsewhere, and the trade declined.

GREENOCK, PRINCES PIER 1904 52634

An excursion steamer manoeuvres alongside Princes Pier. Owned by the Glasgow & South Western Railway, the pier was rebuilt
and extended between 1892 and 1894, and more than £20,000 was spent by the company on alterations to the pier railway station.
The new buildings featured four Italianate towers constructed of red Ruabon brick.

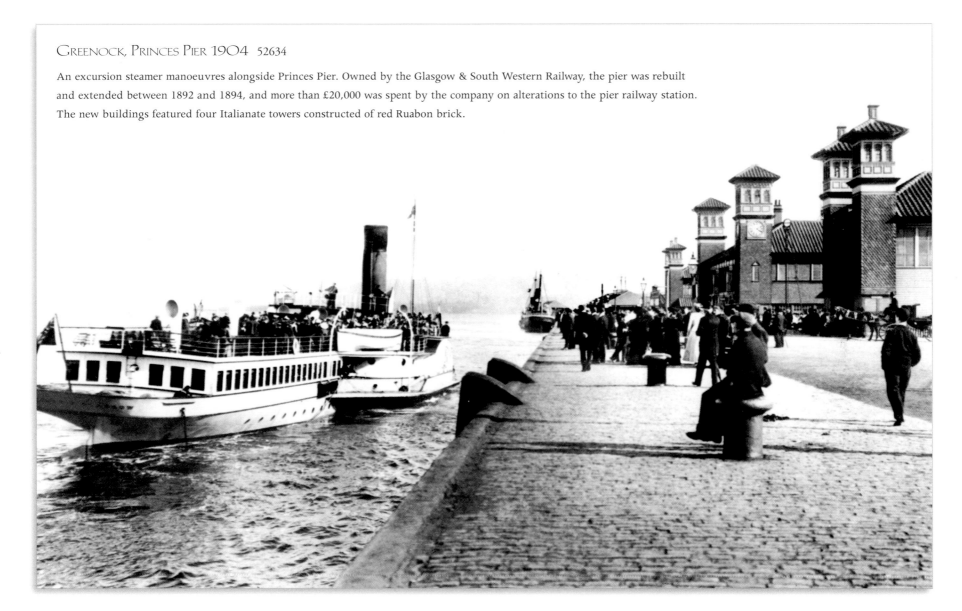

GOUROCK, THE ESPLANADE 1900 45969

Positioned on the Firth of Clyde, this seaside resort looks across the Firth towards Kilcreggan, Loch Long and Dunoon. It is a popular centre for yachting and for boating trips in the Firth and to the Kyles of Bute. Here we see the esplanade with the pebble beach in evidence. As well as being a resort, Gourock was noted for its herring curing, the first recorded curing of red herrings having taken place here in 1688.

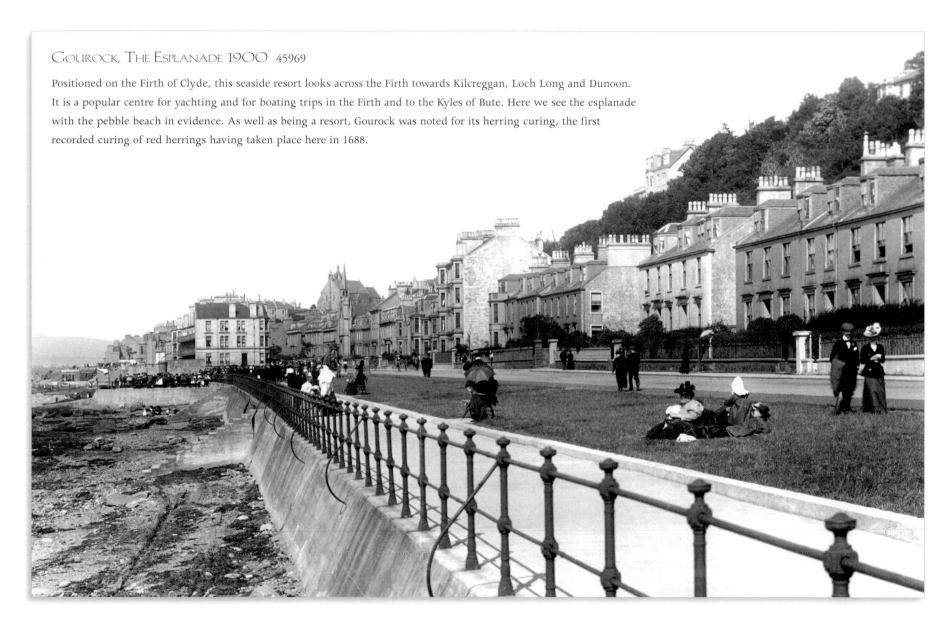

Gourock, From the Pier 1900 45975p

This view shows the backs of buildings along Kempock Street. Kempock Place is just in view on the extreme left of the picture. Over to the right is Seaton's Temperance Hotel, one of several in the town. At this time temperance hotels abounded throughout the UK, but there was in fact little difference between them and private hotels, as neither had liquor licences.

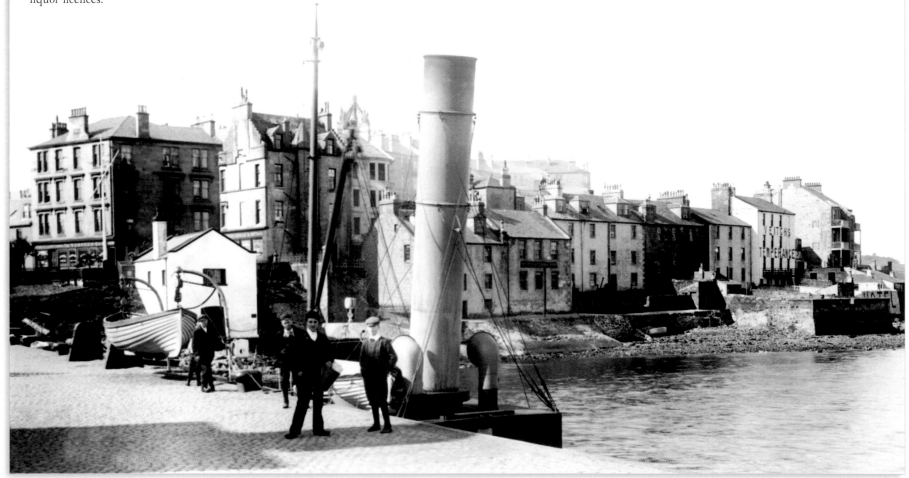

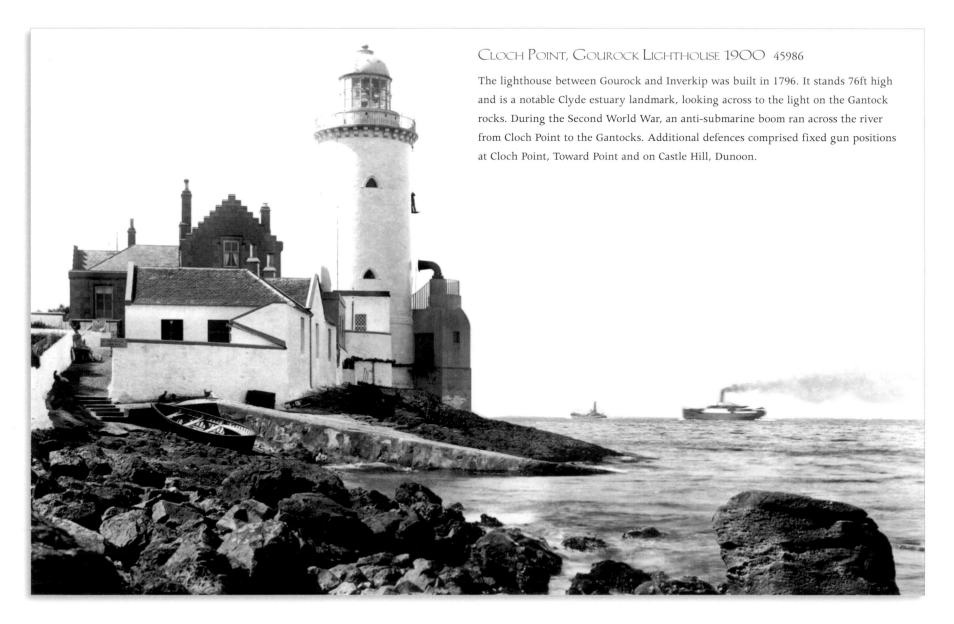

CLOCH POINT, GOUROCK LIGHTHOUSE 1900 45986

The lighthouse between Gourock and Inverkip was built in 1796. It stands 76ft high and is a notable Clyde estuary landmark, looking across to the light on the Gantock rocks. During the Second World War, an anti-submarine boom ran across the river from Cloch Point to the Gantocks. Additional defences comprised fixed gun positions at Cloch Point, Toward Point and on Castle Hill, Dunoon.

INVERKIP VALLEY 1899 43411

The village used to be called Auldkirk, because the people of Greenock worshipped here until they built their own church at the end of the 16th century. In 1640 witch mania was rife throughout Scotland. The General Assembly instructed ministers to 'take notice of witches, charmers and all such abusers of the people'. Inverkip joined in the burnings, becoming a notorious centre for following the Bible's demand that, 'Thou shalt not suffer a witch to live'.

STRATHCLYDE

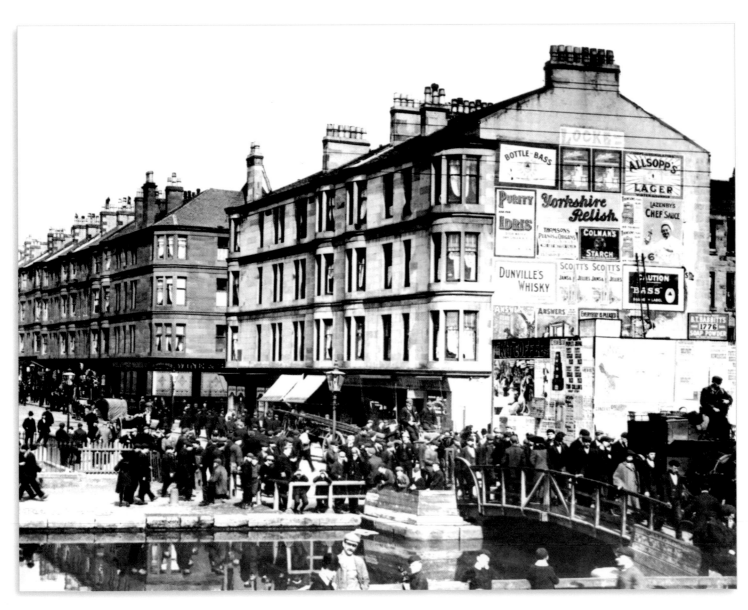

CLYDEBANK, KILBOWIE ROAD 1900
C208002

Situated on the Clyde, opposite the mouth of the River Cart, Clydebank was little more than farmland until 1871–72, when J & G Thomson began the construction of a shipyard. Clydebank went into production in 1872, with three steamers being built for Thomas Skinner of Glasgow. A town eventually grew up on land behind the shipyard. The swelling population certainly seems to be causing congestion on this narrow bridge.

CLYDEBANK,
TOWN HALL UNDER
CONSTRUCTION
1900
C208003

The streets are packed
with onlookers, and
anxious officials wait by
the entrance to the site of
the new town hall.
In 1881 the population
of Clydebank was 1,600,
most of whom depended
upon the shipyard.
In 1882, the American
firm of Singer opened a
sewing-machine factory,
bringing yet more jobs
and more people to the
area. Clydebank became a
burgh in 1886.

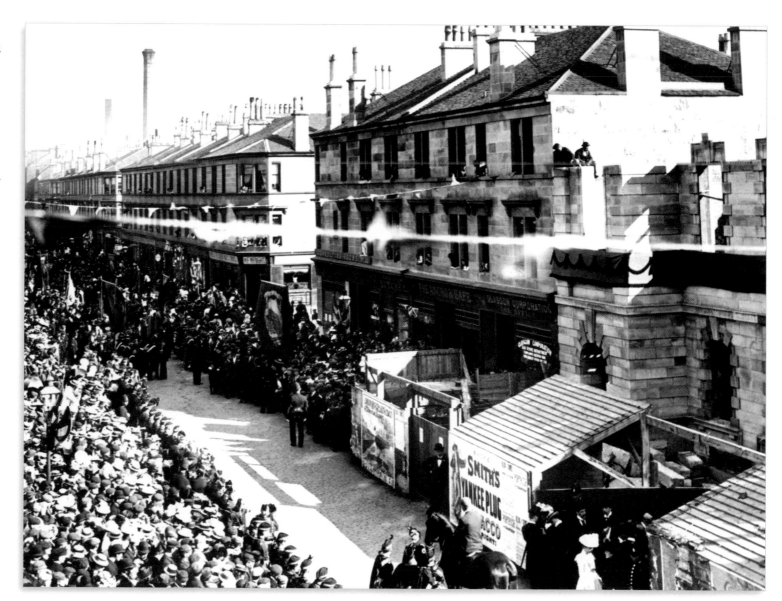

STRATHCLYDE

DUMBARTON, THE CASTLE 1897 39809

South of Dumbarton rise the massive twin peaks of the volcanic plug of Dumbarton Rock. In ancient times the Kingdom of Strathclyde, which covered a significant part of south-west Scotland, had its capital at Dumbarton, and Viking raiders continually laid siege to the castle on the Rock. The oldest part of the existing castle, the Portcullis Arch (shown here) dates from the 14th century. It was from here in 1548, that six-year-old Mary, Queen of Scots left for France to marry the Dauphin. In return, France offered Scotland military assistance against England.

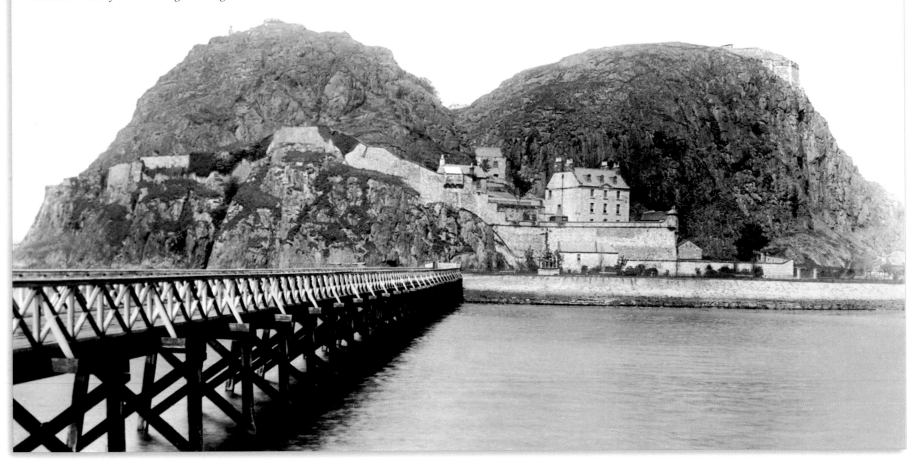

HELENSBURGH, THE ESPLANADE 1901 47484

Founded in 1776 by Sir James Colquhoun of Luss (who named the town after his wife), Helensburgh has become popular as a holiday resort and as a golfing, fishing and yachting centre. It stands on the Lower Clyde near the entrance to Gare Loch. Henry Bell, who became a Provost of the burgh, designed and built the steamboat 'Comet'; an obelisk to him stands on the Esplanade, and the flywheel from the 'Comet' is preserved in Hermitage Park.

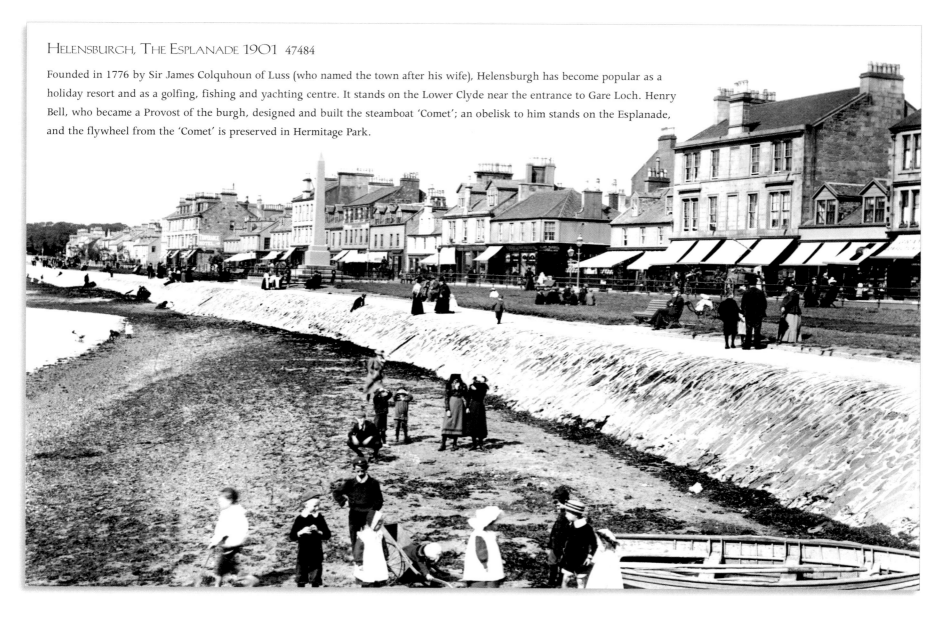

STRATHCLYDE

HELENSBURGH, THE ESPLANADE 1901 47402P

The coming of the railway put Helensburgh into the Glasgow commuter belt, whilst its steamer connections helped it develop as a holiday centre. In the distance, and slightly to the left of the clock tower, is the obelisk erected to the memory of Henry Bell. Another famous son of the town was J Logie Baird, the inventor of television.

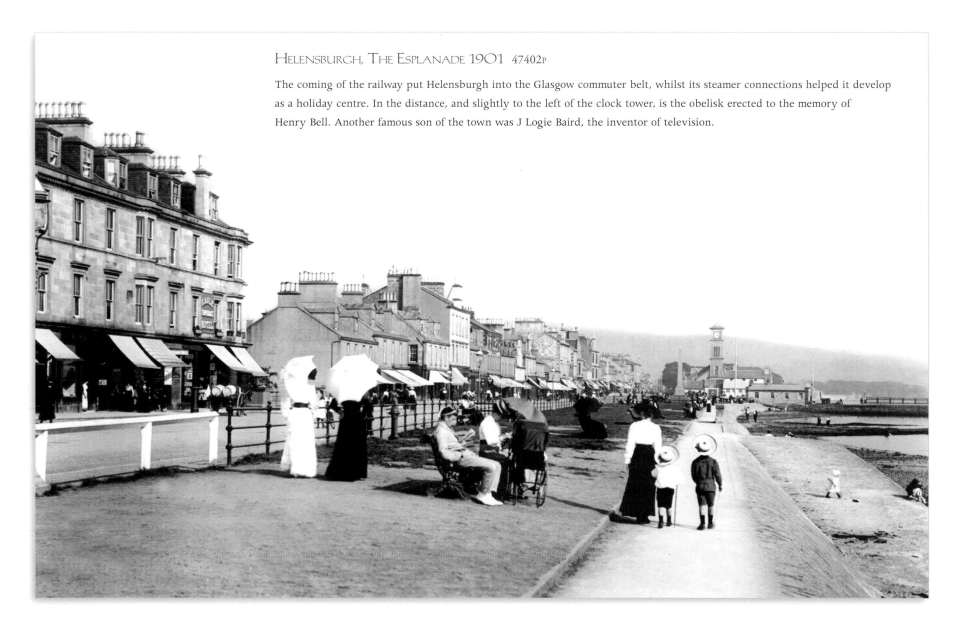

Garelochhead 1901 47491

The hills in the background overlook Loch Long and are known as Argyll's Bowling Green.
In the foreground is the North British Railway Company's line to Fort William and Mallaig.

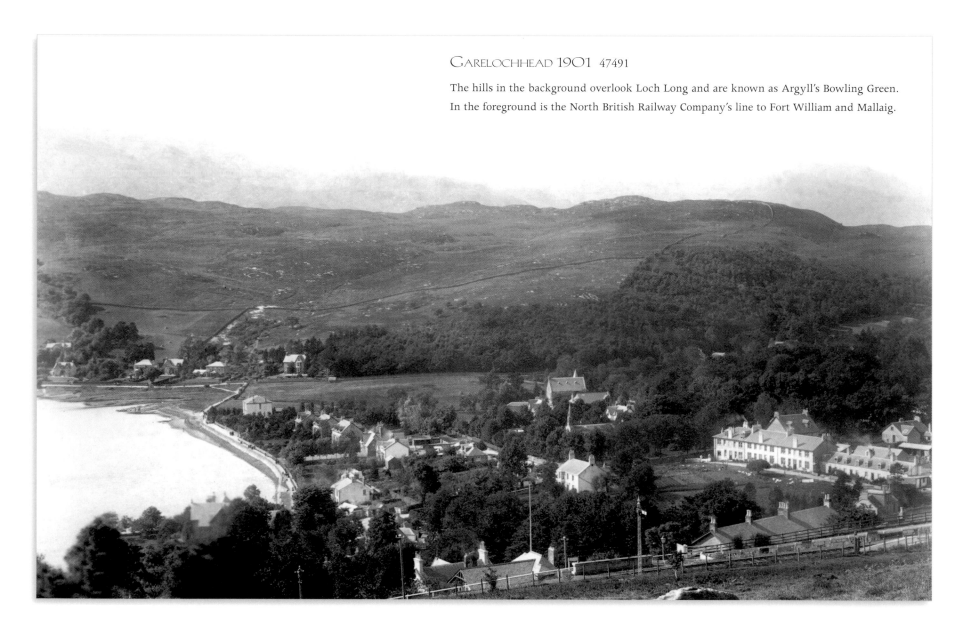

LUSS, FROM THE PIER ENTRANCE c1950 L483019

Luss, on the shores of Loch Lomond, had a thriving cotton mill and slate quarries in the 18th and 19th centuries. It was once known as Clachan Dubh, (the dark village) because its mountain setting offered two hours less sunlight during winter evenings. Luss's vernacular cottages were described by James Denholm, in 1804 : 'the houses, in general, appear exceeding uncomfortable. They are mostly built of loose stones, perhaps with a layer of turf betwixt each row are covered with rushes; the produce of the Loch'.

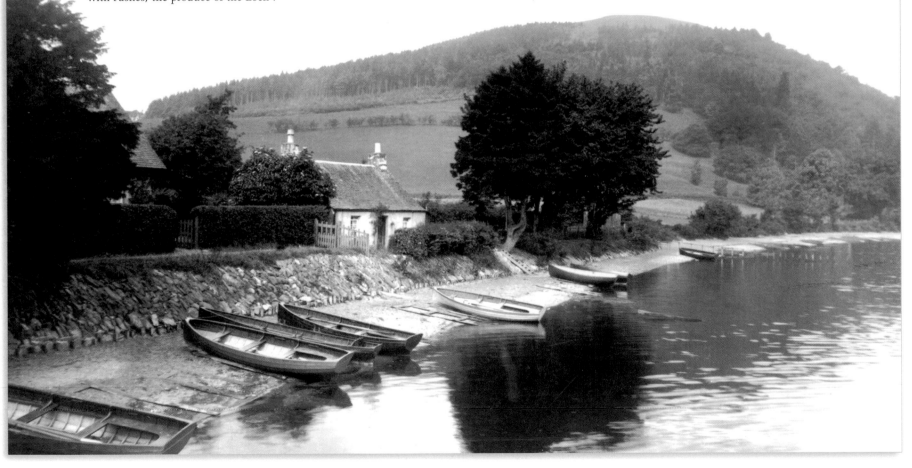

LOCH LOMOND, THE PIER AT TARBET 1899 43209

Loch Lomond became a popular destination for day trippers from around Clydeside, especially after the opening of the Dumbarton & Balloch Joint Railway. The loch itself was served by the steamers of the Loch Lomond Steam Boat Company, whose first ship, the 'Prince of Wales', was built at Port Glasgow in 1858. Tarbet lies at the eastern end of a narrow neck of land that extends from Arrochar on Loch Long.

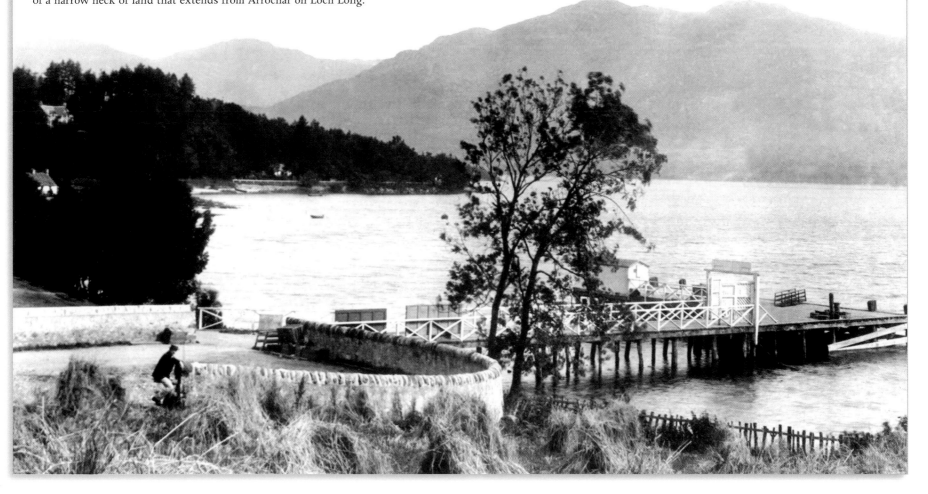

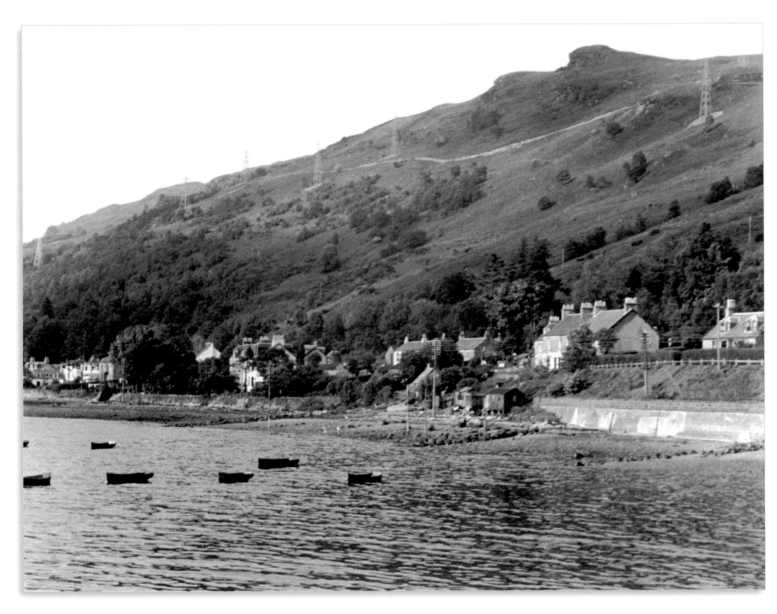

ARROCHAR,
THE SHORE FROM
LOCH LONG c1955
A60005

Arrochar is a picturesque
village in the south-west
Highlands, at the head of
Loch Long. The locality
is famous with climbers,
who tackle the formidable
Ben Arthur, which is more
commonly known as 'The
Cobbler'. This peak has
curious rock formations
at its summit, that are
said to resemble a cobbler
working at his last.

HOLY LOCH 1897 39849

Holy Loch is little more than an inlet of the Clyde estuary. In the 1960s, however, this quiet backwater became internationally famous when it was chosen as a base for the United States Navy nuclear submarine force. The picture dates from 1897, when submarines were still very much in the experimental stage.

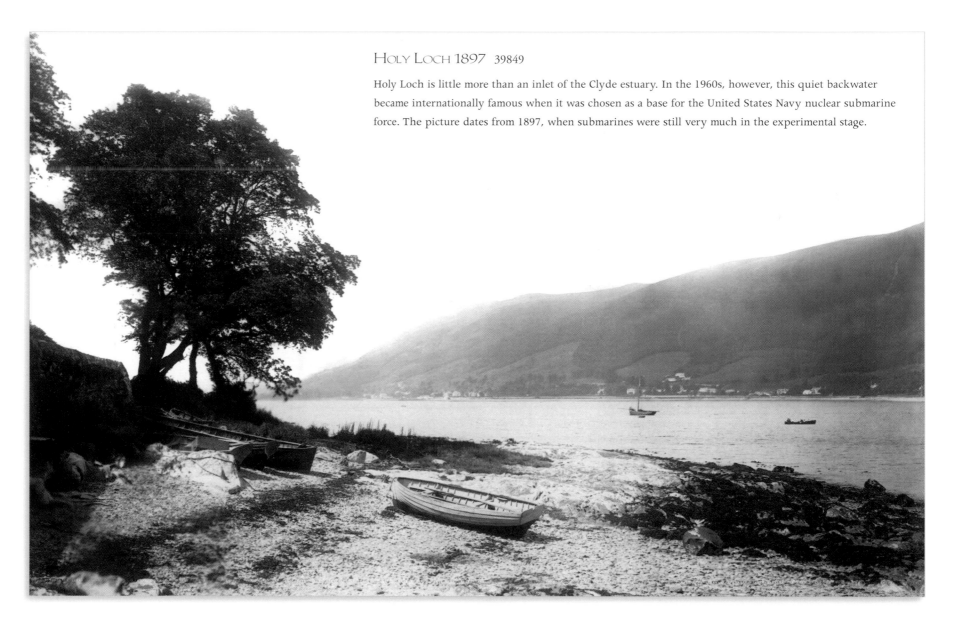

STRATHCLYDE

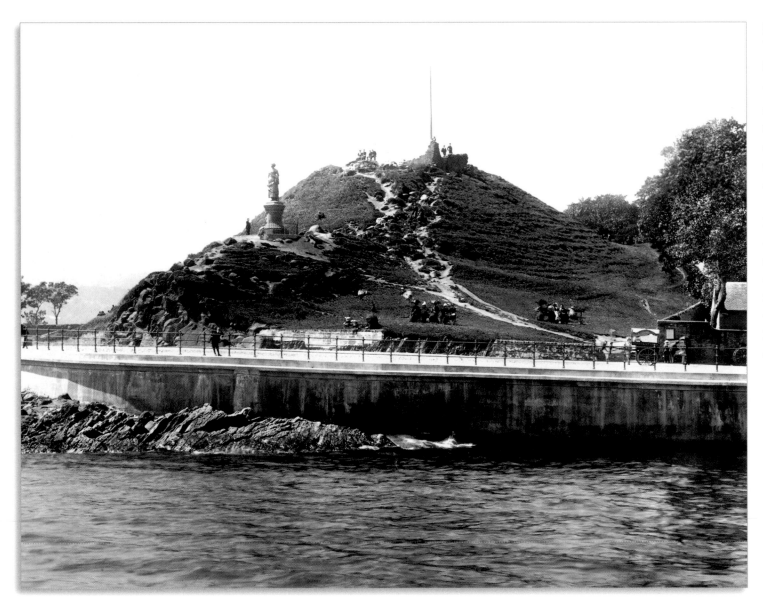

DUNOON,
THE CASTLE 1897
39831

Visitors clamber over the site of the old castle. Little of its fabric survives, and it is thought to have been one of the very earliest of Scotland's stone castles, dating from the 12th century. Its hereditary keepers were the Earls of Argyll. The modern castle is comparatively new, being completed in 1822. The statue is of Burns's Highland Mary, who was born at Auchnamore Farm nearby. The statue was erected in 1896.

DUNOON, THE PIER 1904 52620

Until the early 19th century, Dunoon was little more than a modest village clustered around its castle. The popularity of the Clyde excursion steamers changed all that: Dunoon developed into a holiday resort, the largest and best known on the Cowal. Here, one steamer has just departed and two others are alongside. The one on the right appears to belong to the North British Railway. Dunoon handled 10,000 visits by steamers every year.

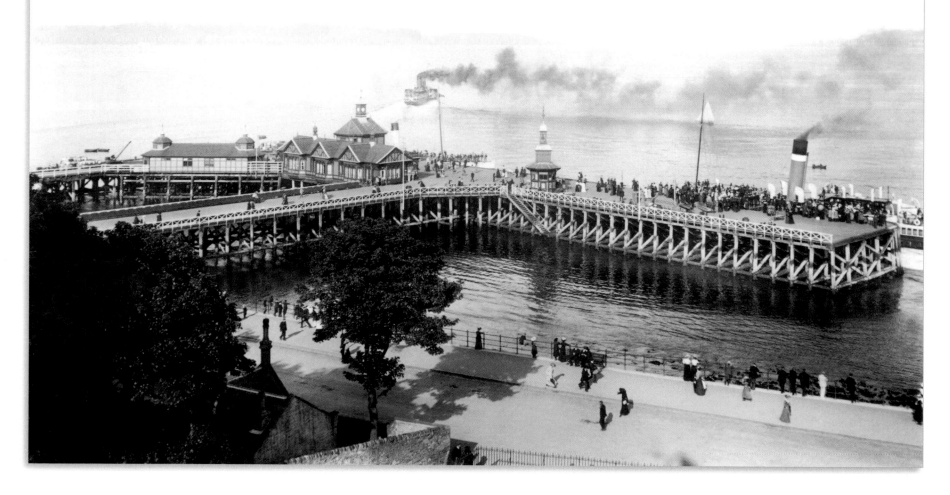

DUNOON, WEST BAY 1904 52615

Since the 1850s, Dunoon has always been a favourite resort for Glaswegians. The 'doon the watter' trips from the Broomielaw in Glasgow became an institution from then until the Second World War. The group of people on the left appear to be on a well-organised outing and are enjoying a picnic. The small huts are where vistors hired boats for by-the-hour rowing trips around the bay.

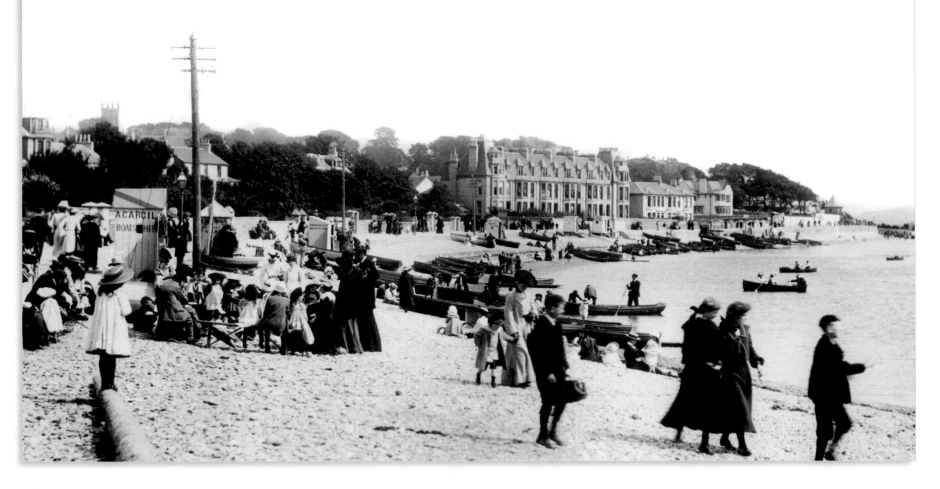

Dunoon, 'Columba' 1904 52621

The MacBrayne steamer, Columba, picks up speed as she pulls away from Dunoon. Built in 1878, and flagship of the MacBrayne fleet, Columba was renowned for the quality of her passenger comfort, with saloons the full width of her hull, a barber's shop and a post office. When first commissioned, she was placed on the up-market daily run from Glasgow to Tarbert and Ardrishaig, by way of Greenock, Dunoon, Rothesay and the Kyles of Bute.

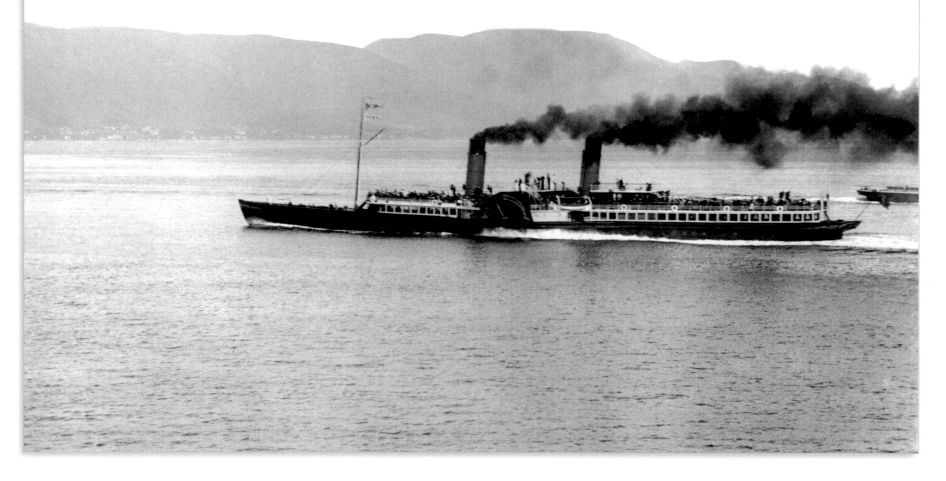

STRATHCLYDE

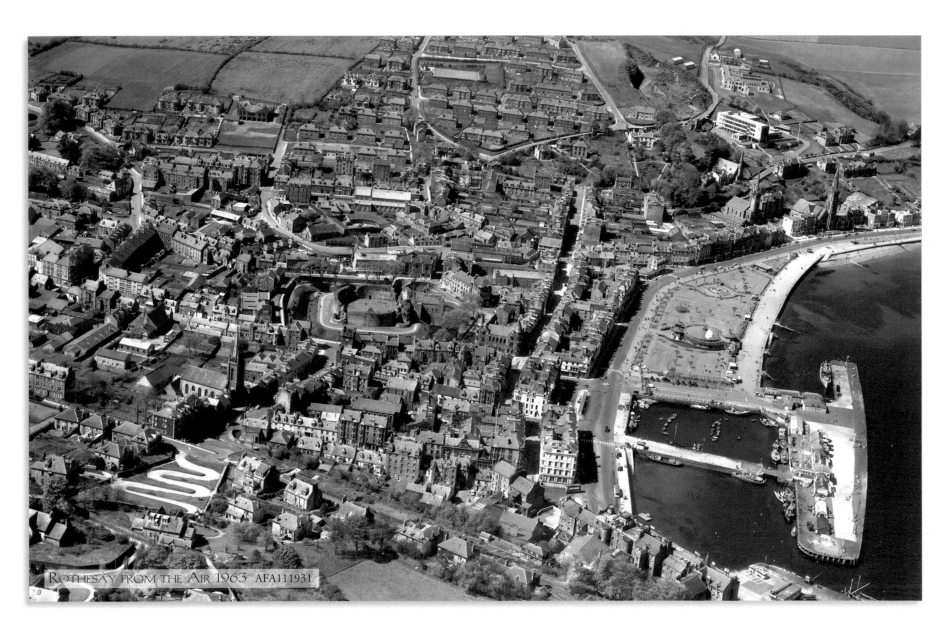

ROTHESAY FROM THE AIR 1963 AFA111931

ROTHESAY, THE ESPLANADE 1897 39837

The tram and tramlines are gone now, but the buildings and the main hotels still exist. The Victorian elegance has given way to more casual fashions, and horse-drawn vehicles have all but disappeared. The pier continues to cater for steamer excursions, and there are ample opportunities for the sea angler. The town also boasts winter gardens, a swimming pool, dancing, and golf.

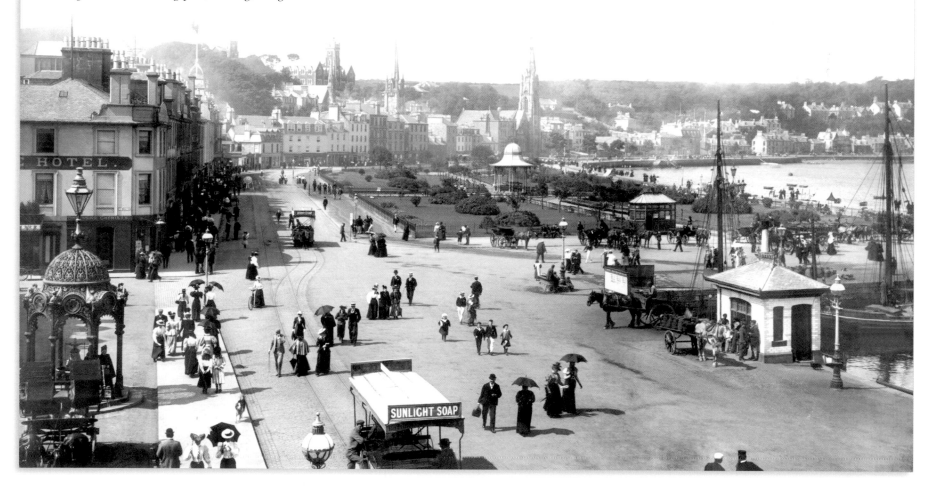

ROTHESAY, THE PIER 1897 39836

Rothesay is in an ideal location in the sheltered 'sweet Rothesay Bay', to quote the popular song. It is the county town on the eastern side of the Island of Bute. The pier has changed little from how it appears in this photograph: in the holiday period it is still as busy as it was a century ago. The main sailing destinations from Rothesay are to Wemyss Bay on the Ayrshire coast and, in the summer season, to the Island of Arran.

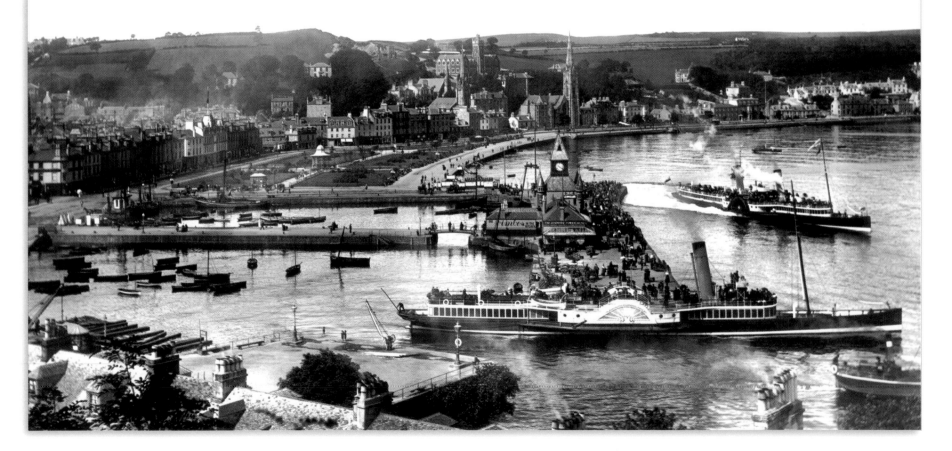

ROTHESAY CASTLE 1897 39844

Described in 1549 as 'the round castle of Buitte callit Rosay of the auld', the first stone castle at Rothesay was a circular shell keep 142ft in diameter with walls 30ft high and 9ft thick; four projecting drum towers were added in the 13th century. The design is unique. The original parapet survives, embedded in the stonework of the subsequent extended curtain. Here we see part of the circular courtyard of the 13th century castle, a favourite spot with Victorian visitors for a picnic. On the left can be seen the honeycombed internal stonework of one of the turrets.

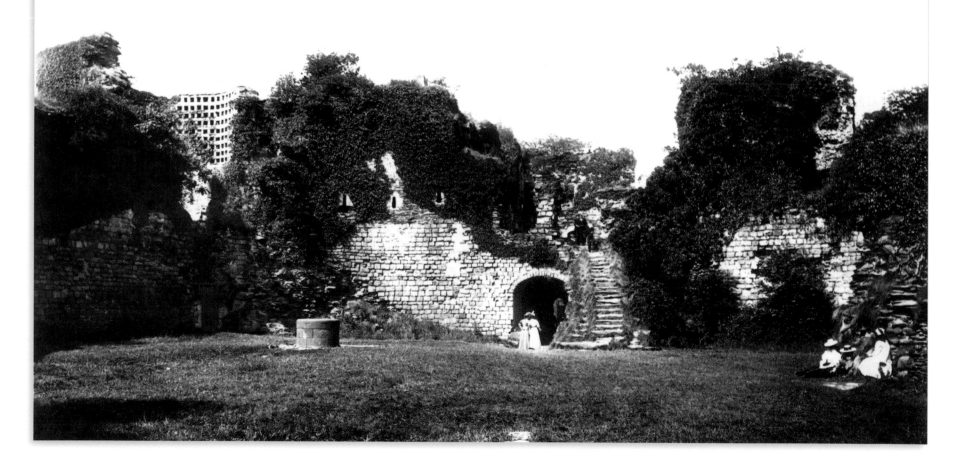

ARRAN, THE CASTLE AND LOCH RANZA c1890 A93001P

Loch Ranza is a sea-loch that forms an inlet of the Kilbrannan Sound. This view was photographed near the northern tip of the island. A ruined 14th-century double-towered castle stands guard over Loch Ranza. It was here that Robert the Bruce is said to have landed on his return from Ireland in 1306.

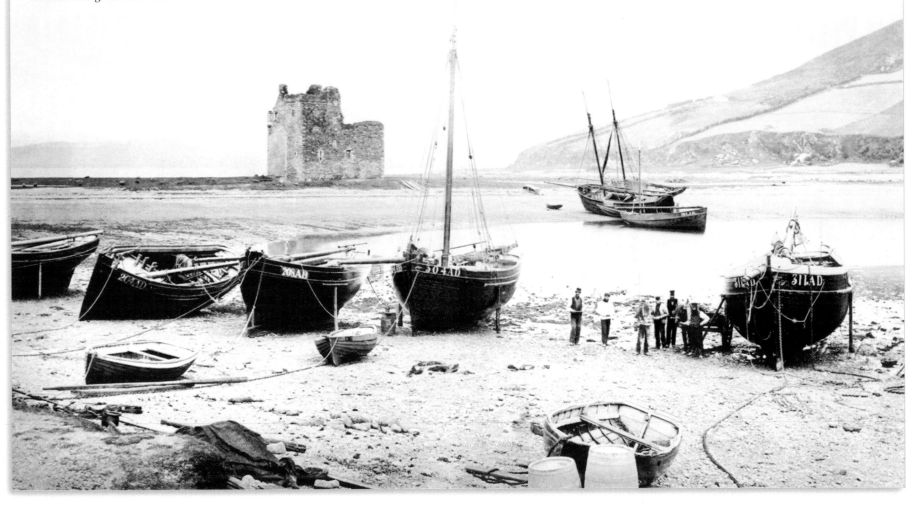

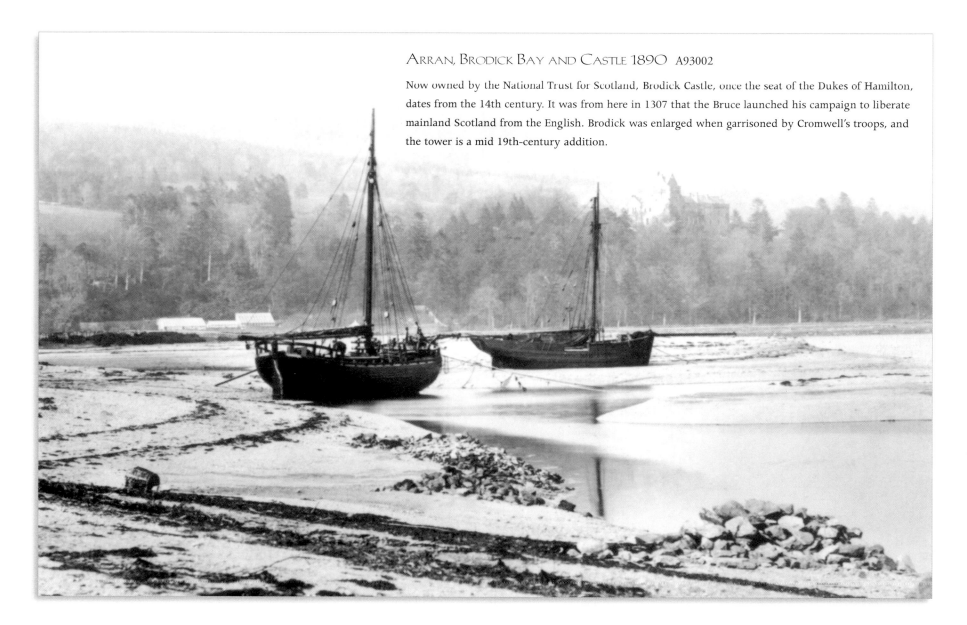

Arran, Brodick Bay and Castle 1890 A93002

Now owned by the National Trust for Scotland, Brodick Castle, once the seat of the Dukes of Hamilton, dates from the 14th century. It was from here in 1307 that the Bruce launched his campaign to liberate mainland Scotland from the English. Brodick was enlarged when garrisoned by Cromwell's troops, and the tower is a mid 19th-century addition.

STRATHCLYDE

TARBERT, AT THE HEAD OF EAST LOCH TARBERT 1890 T102001

This is an inlet of Loch Fyne. West Loch Tarbert is just a couple of miles distant; it is said that in 1093 Magnus Barefoot dragged his longship overland between the two lochs, claiming Kintyre as a Norse possession. Tarbert is a celebrated fishing port renowned for its seafood—prawns, mackerel, herring and scallops are all landed. Its ancient castle overlooks the harbour.

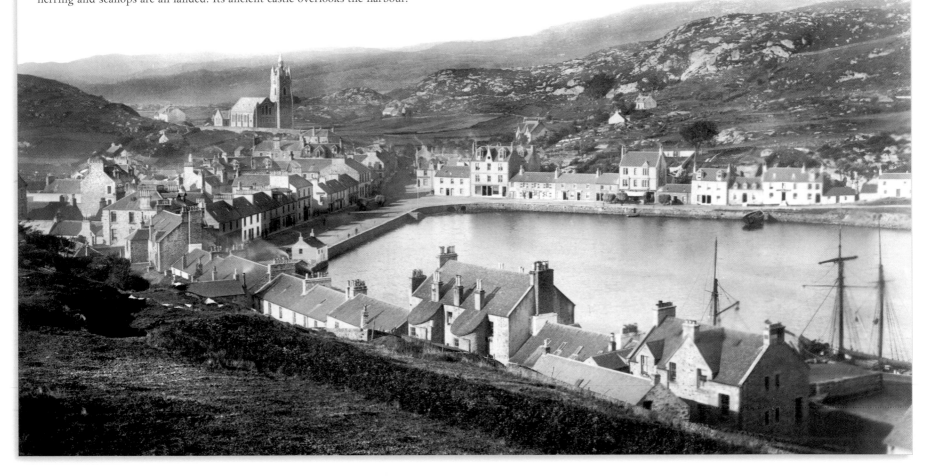

MILLPORT, THE HARBOUR 1897 39857

The Collegiate Church built in 1851 was consecrated as the Episcopal Cathedral of Argyll and the Isles in 1876. Famous for the quality of its beaches, Millport developed as a resort following the construction of the harbour and the introduction of a ferry service to and from Largs. As late as the 1940s, there was only one bus, a few motor taxis and some horse-drawn cabs on the island.

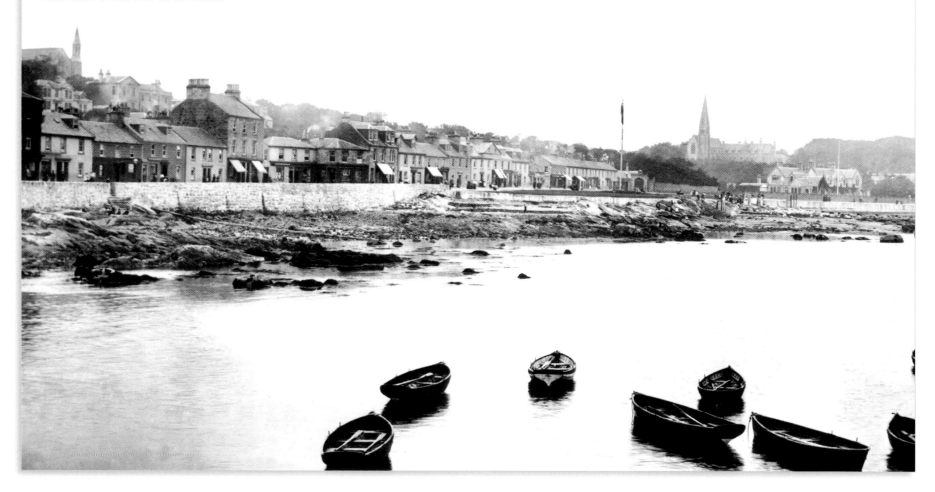

STRATHCLYDE

LARGS, THE PIER 1897 39851

The bustling holiday town of Largs has long been famous as the site of a battle in 1263 between the Norwegians and the Scots. The Battle of Largs was important because it led to the Treaty of Perth, under which Man and the Western Isles were purchased by the Scottish crown. Sheltered by the nearby island of Cumbrae, Largs is a popular place for messing about in boats. It was also a good centre for steamer excursions.

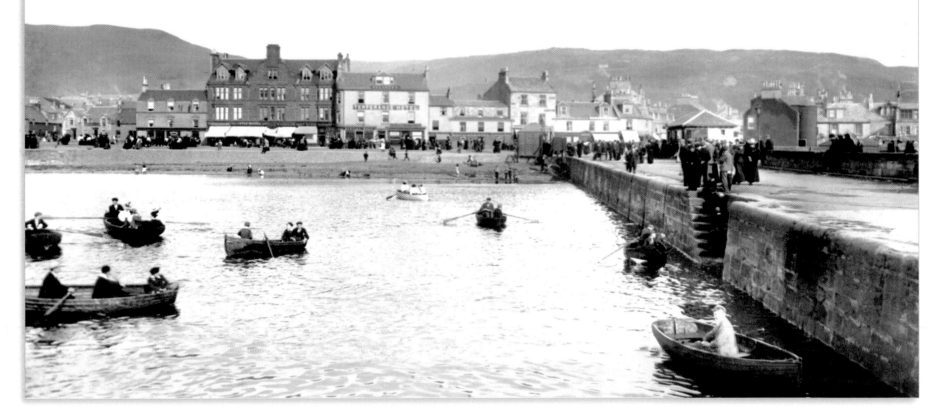

LARGS, THE CHURCH AND THE SEAFRONT 1897 39856

Largs was well-served by steamers from all parts of the Clyde, and by the Glasgow & South Western Railway to Ardrossan, via Fairlie and West Kilbride. One of Largs's own well-travelled sons was Sir Thomas Brisbane, who became governor of New South Wales and had an Australian city named after him.

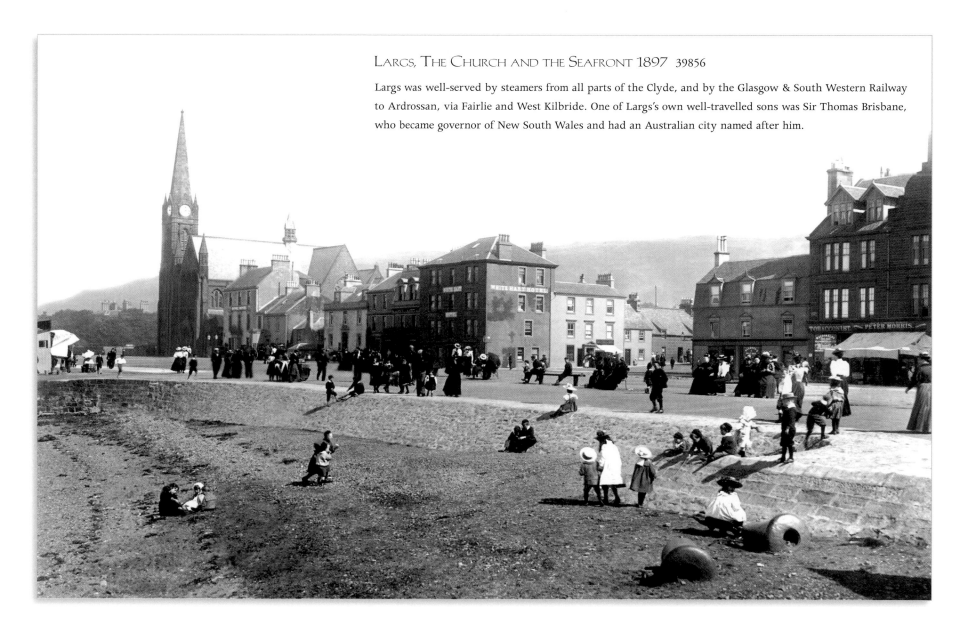

STRATHCLYDE

IRVINE, THE HARBOUR 1904 53154

A royal burgh and port, Irvine was, by the 1920s, a town of 7,000 inhabitants. Many of these were employed in ironworking, chemical manufacturing and coal-mining, or in Nobel's dynamite works at Ardeer. The novelist John Galt was born in the town in 1779, but Irvine is more famous as the place where Robert Burns eked out a living as a flax-dresser between 1781 and 1783.

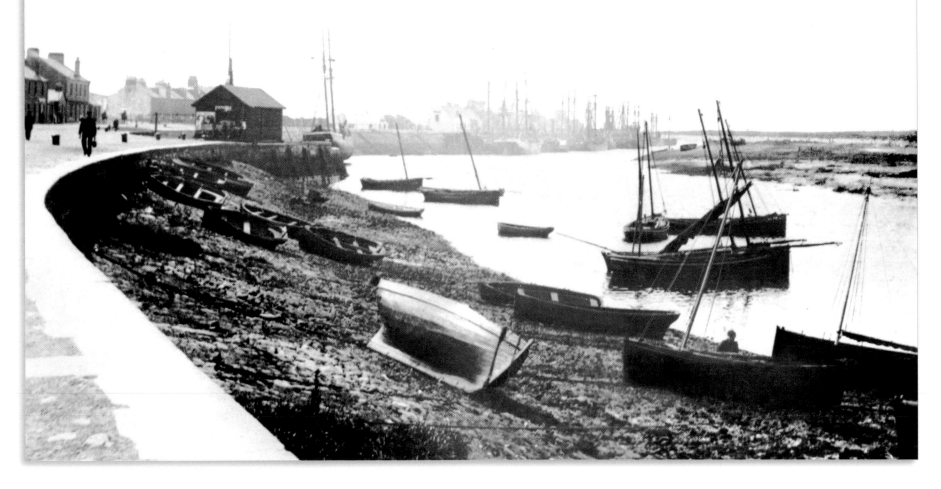

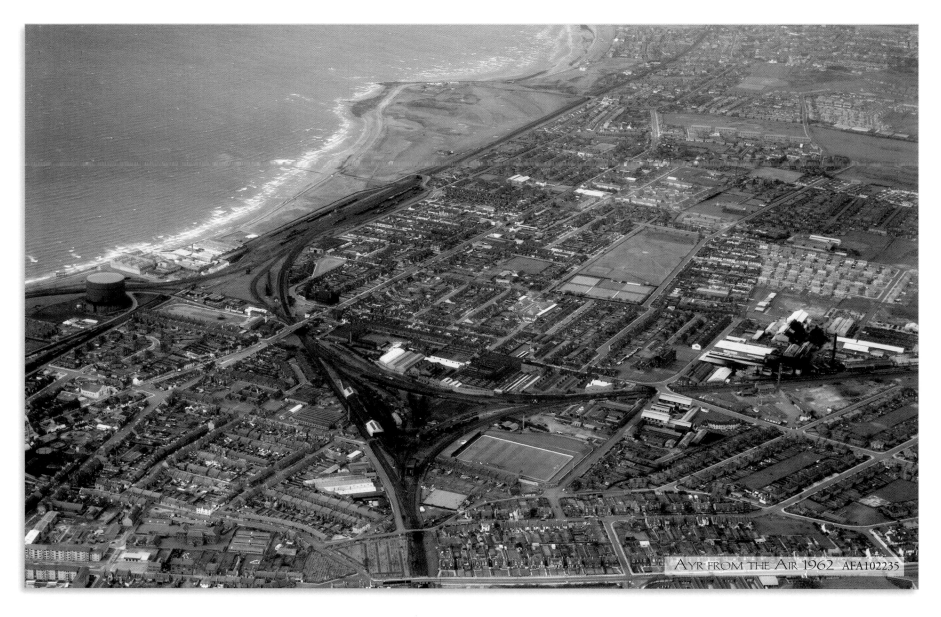

AYR FROM THE AIR 1962 AFA102235

AYR, TWA BRIGS 1900 46000

Famous as the birthplace of John Macadam in 1756 and of Robert Burns in 1759, Ayr was founded under a charter granted by William the Lion. The 'Twa Brigs of Ayr' became famous as a result of a poem by Robert Burns. The Auld Brig, which is thought to date from the 13th century, is still standing. The New Brig was rebuilt in 1879 having lasted less than 100 years.

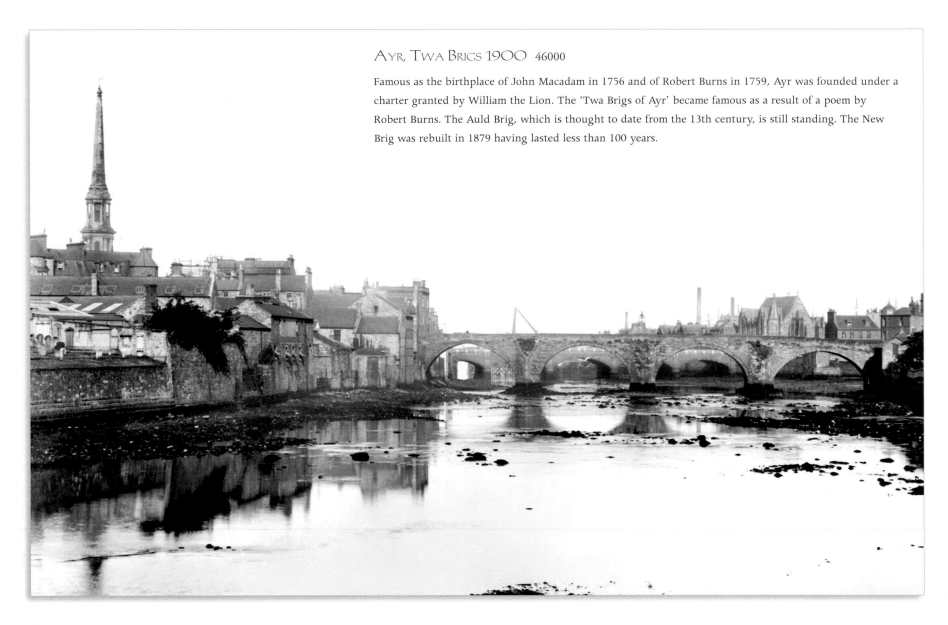

AYR, THE WALLACE TOWER AND HIGH STREET 1900 46002t

Little survives of the old town, although parts of the former Greyfriars church of St John, where Robert the Bruce held a Parliament in 1315, are thought to date back to its origins. The 130ft-high neo-Gothic Wallace Tower, in the High Street, was completed in 1832. It replaced an earlier structure in which Sir William Wallace was alleged to have been imprisoned.

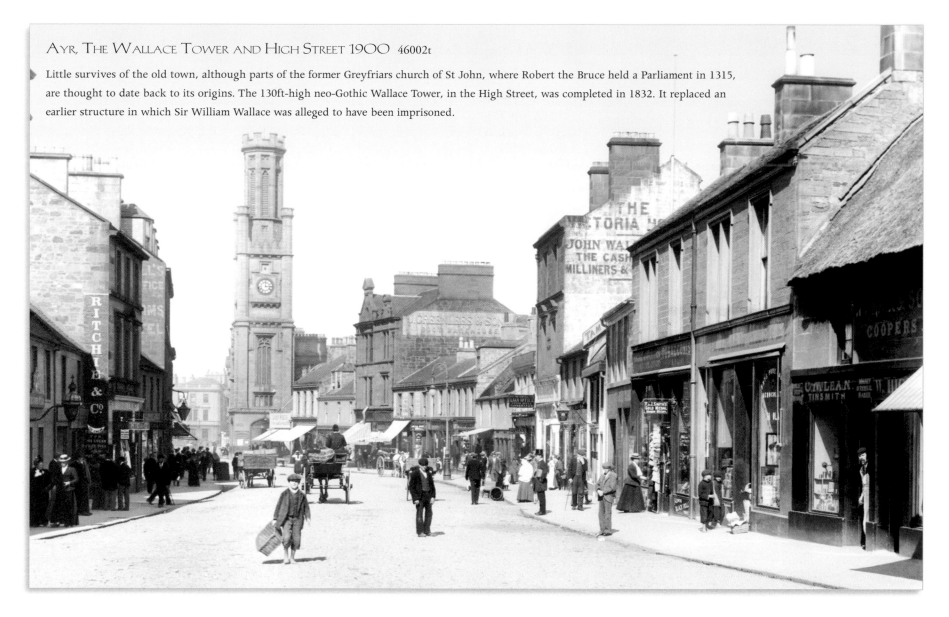

STRATHCLYDE

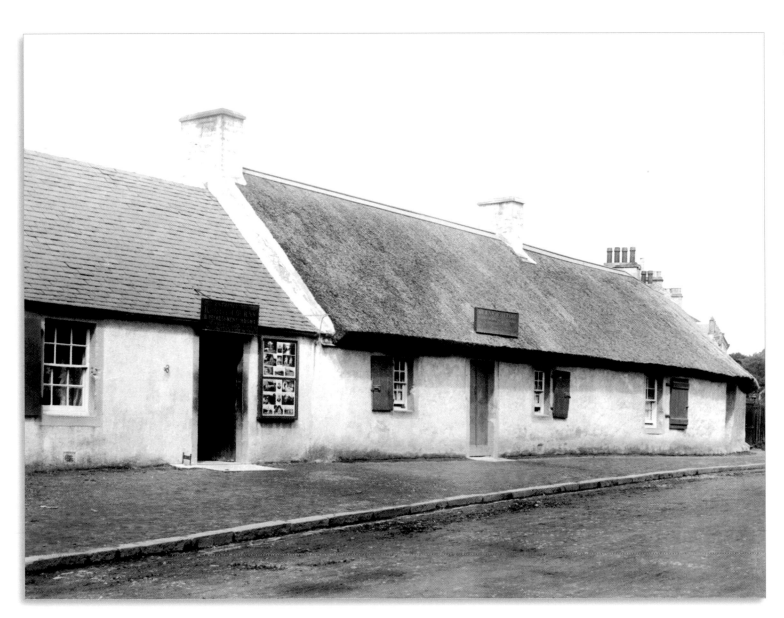

ALLOWAY,
THE BIRTHPLACE OF
ROBERT BURNS 1897
39858

Scotland's most celebrated poet Robert Burns was born in this simple cottage on 25 January 1759. The cottage, a 'but and ben' or two-room clay cottage, was built by the poet's father, a gardener from Kincardineshire. It later became an inn. Burns's verses are famous the world over. He died at the early age of thirty-seven in Dumfries. In 1881 the cottage was purchased by the trustees of the Burns Monument and opened as a museum. The pleasant village of Alloway is now the centre of pilgrimage for lovers of Burns's poetry.

ALLOWAY, THE KIRK 1897

39861

Robert Burns played in this churchyard as a boy, and the popular legends about hauntings and the ghostly atmosphere of the roofless ruin affected him deeply. He used the Kirk and the Auld Brig O'Doon near by as scenes for his celebrated ghost story 'Tam O' Shanter', which first appeared in the Edinburgh Review in 1791. Burns's father, who had repaired the kirk wall to keep the sheep at bay, is buried in the churchyard.

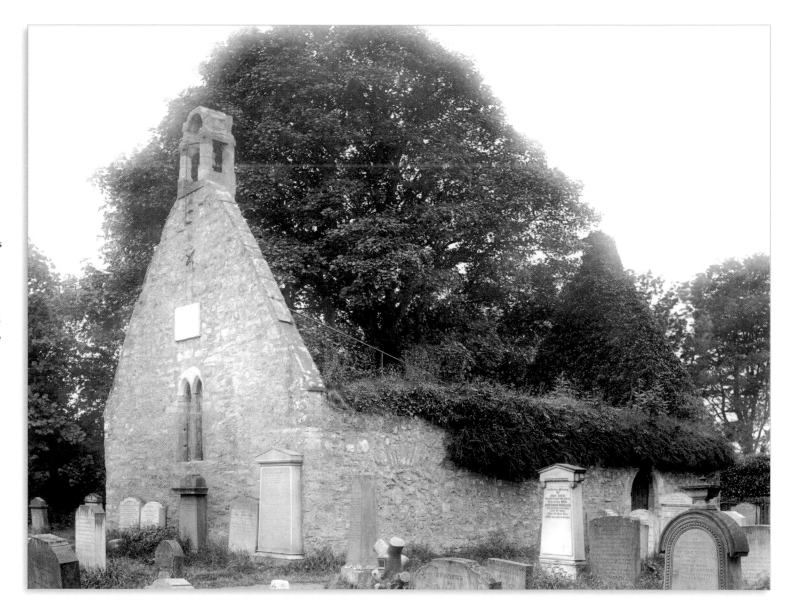

THE HIGHLANDS & ISLANDS

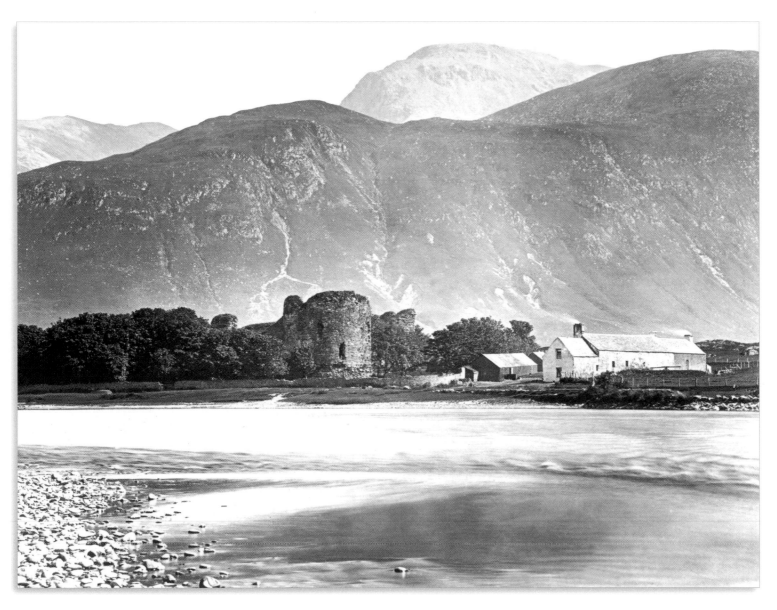

INVERLOCHY,
THE CASTLE c1890
I30001

This 13th-century castle, home of the Comyn family, is built in the form of a square, with round towers at the corners. Set on the banks of the River Lochy, it is one of Scotland's earliest stone castles, and it was here in February 1645, after a forced march across difficult terrain in appalling weather, that the Marquis of Montrose with 1,500 troops defeated a 5,000 strong force of Campbells and Lowlanders. The clan power of Argyll is said to have been destroyed for a generation.

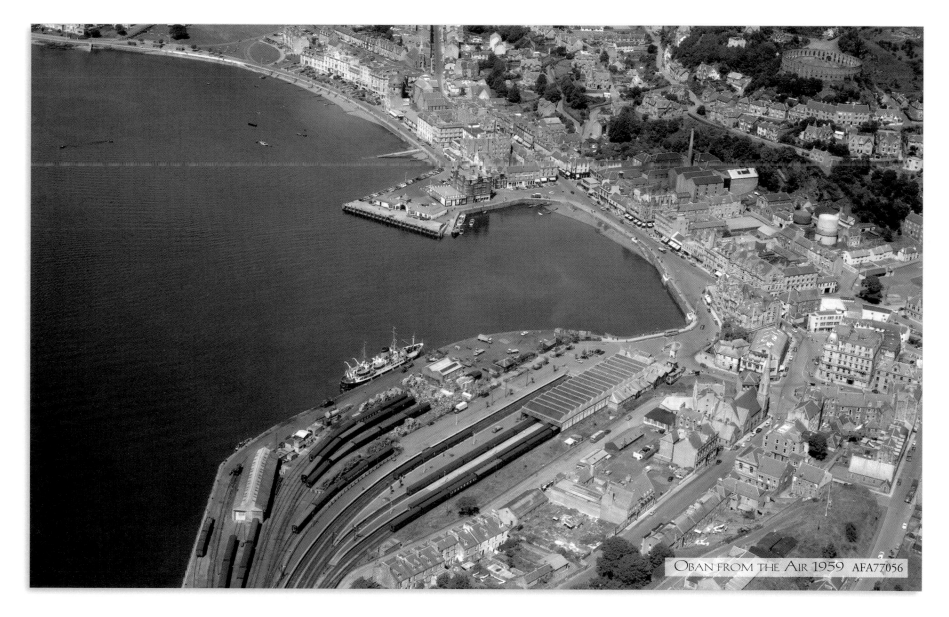

Oban from the Air 1959 AFA77056

OBAN, THE BAY c1900 O4001

The town of Oban is only a little more than 200 years old. It owes its origins to when a fishing station was established here by the government Fishery Board in 1786. The aim had been to develop commercial fishing in the Firth of Lorne. The project was eventually abandoned, but by this time Oban had begun to develop, albeit very slowly. The railway station is in the foreground, with the north pier and esplanade on the far side of the bay beyond the yachts and steamers.

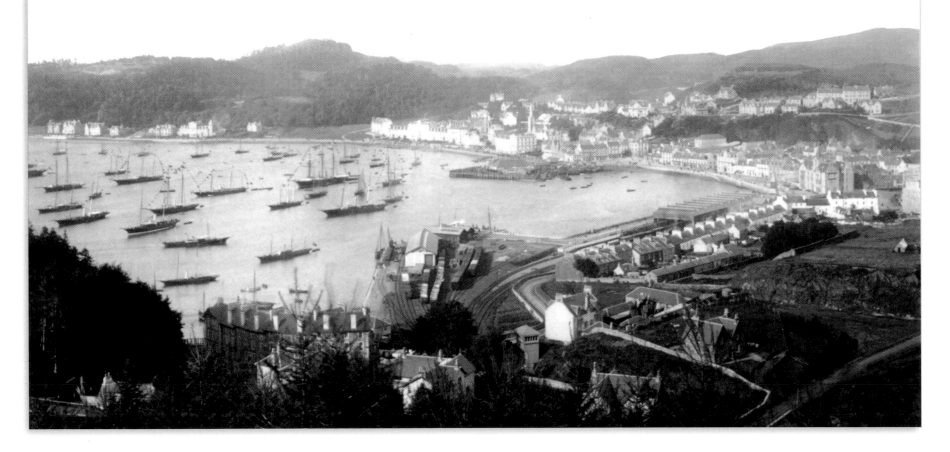

Oban, George Street 1901 47511t

Fishing and agriculture played an important part in the economy of the area, but it was the opening up of the Western Highlands to tourism that gave the town the boost it so desperately needed. On the right is the Caledonian Hotel, one of a number of hotels in the town. The Great Western and the Alexandria were the most prestigious. There were three temperance hotels, one of which can be seen next to the King's Arms.

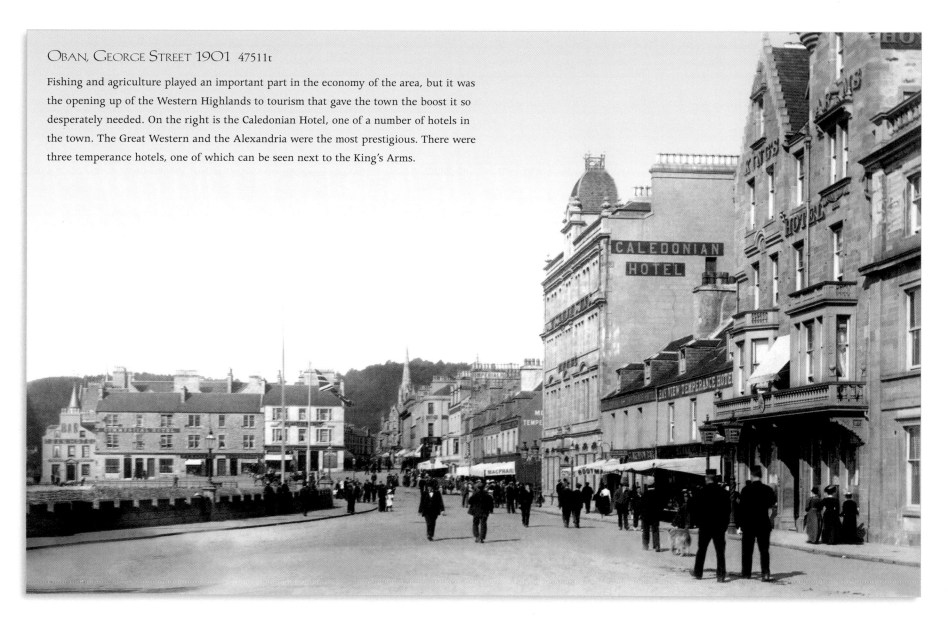

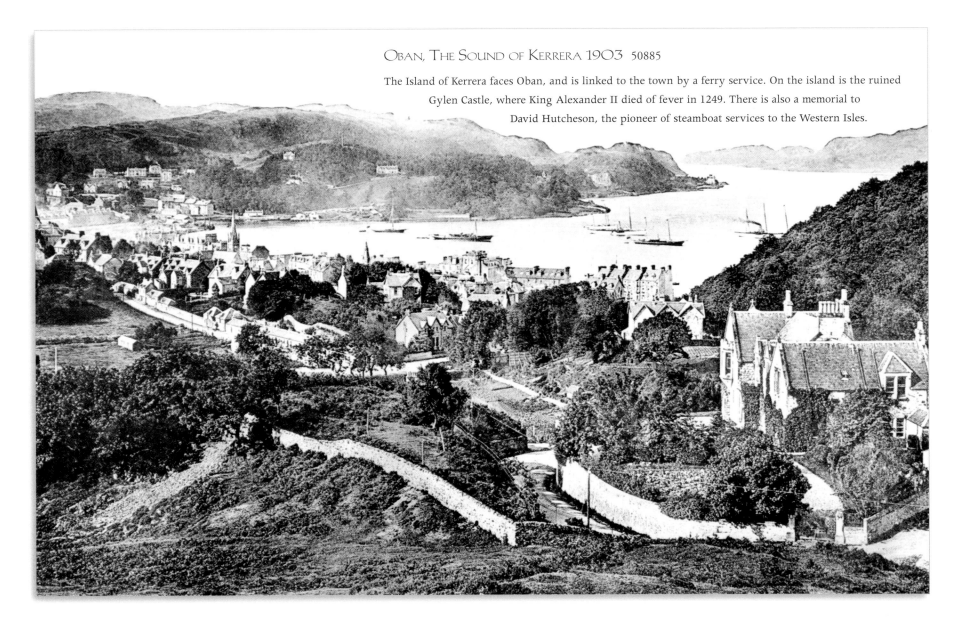

Oban, The Sound of Kerrera 1903 50885

The Island of Kerrera faces Oban, and is linked to the town by a ferry service. On the island is the ruined Gylen Castle, where King Alexander II died of fever in 1249. There is also a memorial to David Hutcheson, the pioneer of steamboat services to the Western Isles.

STAFFA,
FINGAL'S CAVE 1903
50897

Lying to the north-east
of Iona, the uninhabited
island of Staffa is
celebrated for its caves and
rock formations. Legend
has it that the cave was
formed when the giant Finn
McCoul made the island.
Finn is also said to have
built the Giant's Causeway
in Northern Ireland.

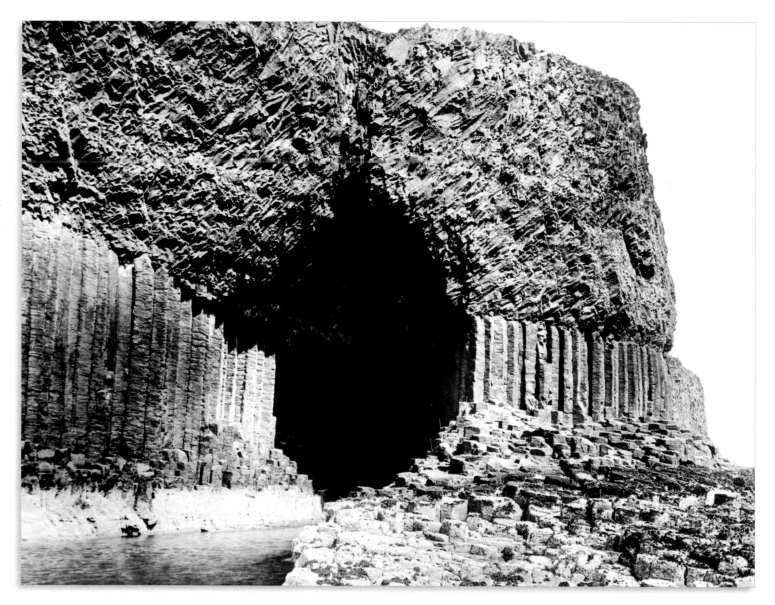

IONA, COTTAGES BY THE SHORE 1903 50887

Iona lies just off the extreme south-west shores of Mull. In 1203, the Benedictines founded a monastery on the island that lasted until the Reformation. In 1899, the 8th Duke of Argyll presented the ruins of the abbey to the Church of Scotland, in the hope that restoration work might be undertaken. The building was eventually re-roofed, and used for worship once again in 1910.

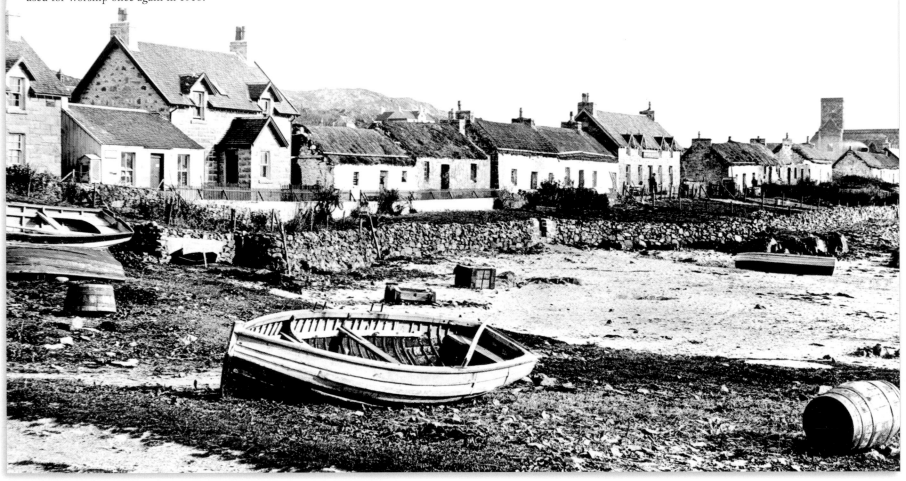

IONA,
THE CATHEDRAL 1903
50889

Iona was chosen by St Columba in AD 563 as the site for a religious house from where he could carry out his missionary work. St Columba was a member of the O'Neill clan; he left Ireland after the battle of Cuil-dremne. It is said that it was Columba himself who caused the battle: he was accused by the High King of taking a psalter without permission, so Columba appealed to his clan for help in clearing his name, and the matter was settled by sword and axe.

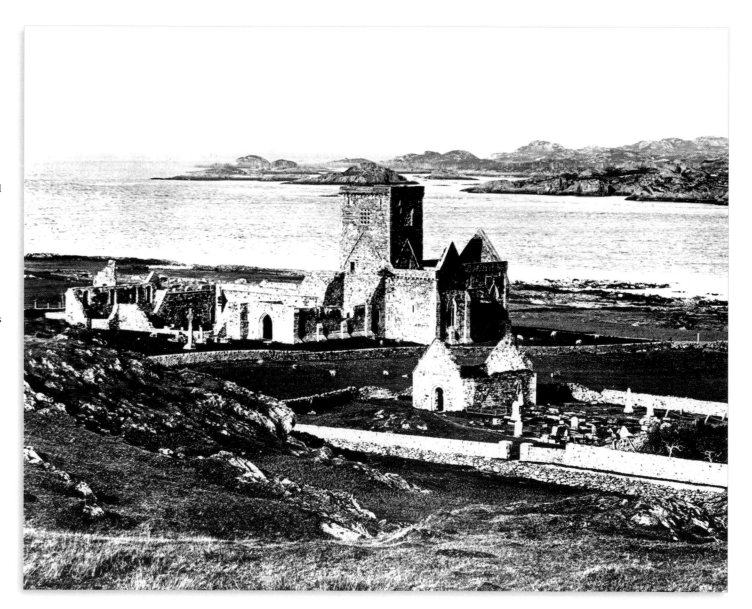

Inverary, The Bay 1899 43200

Inverary is set picturesquely on the shores of Loch Fyne, where it meets Loch Shira. Though now a substantial settlement, it was built on the site of a modest fishing village in the 1700s by the 3rd Duke of Argyll. He demolished the old village and constructed a grand castle, rehousing the local people in well-designed Georgian dwellings along the new Main Street.

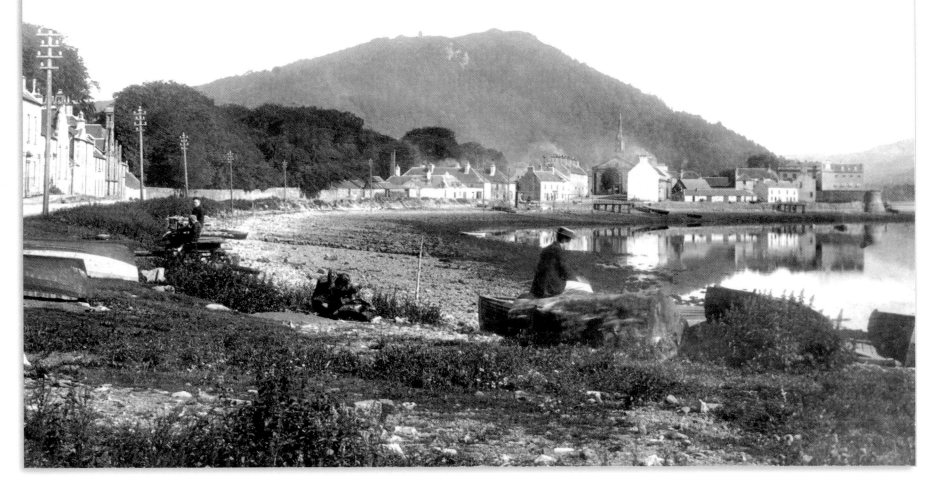

INVERARY CASTLE c1955 I15004

The original castle at Inverary was built about 1520. The 3rd Duke of Argyll decided to build a new castle: Roger Morrison was the architect and William Adam the clerk of works. The new site was 80 yards or so from the old castle. Work began in 1743 and ended in 1770. The old castle was demolished in 1773.

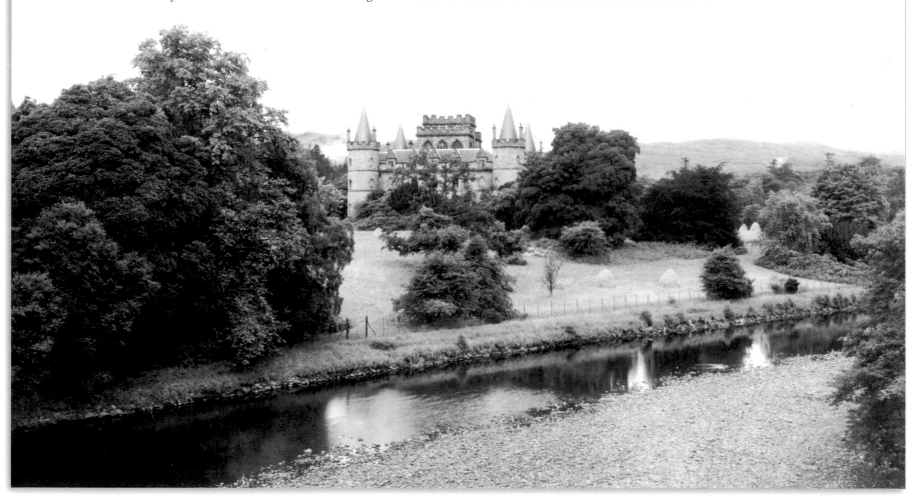

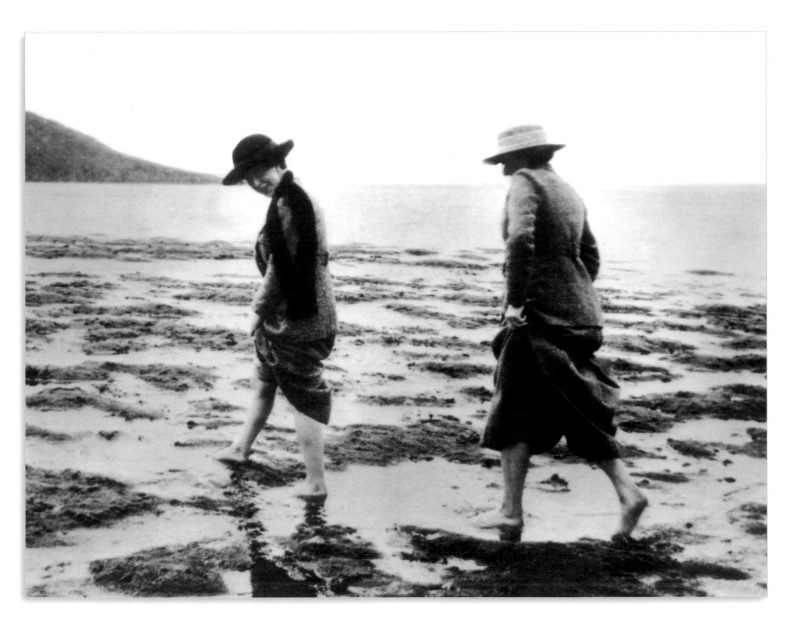

INVERARY,
BY THE LOCH c1915
I15003P

It is time for a paddle—
two well-dressed ladies
rather daringly show
their legs. In earlier days,
during his visit to the
Highlands, Dr Johnson
was entertained at
Inverary by the 5th Duke.
It was to Inverary that
MacIan of Glencoe was
sent to swear allegiance
to William III. MacIan's
unavoidable delay in
reaching Inverary led to
the massacre of Glencoe.

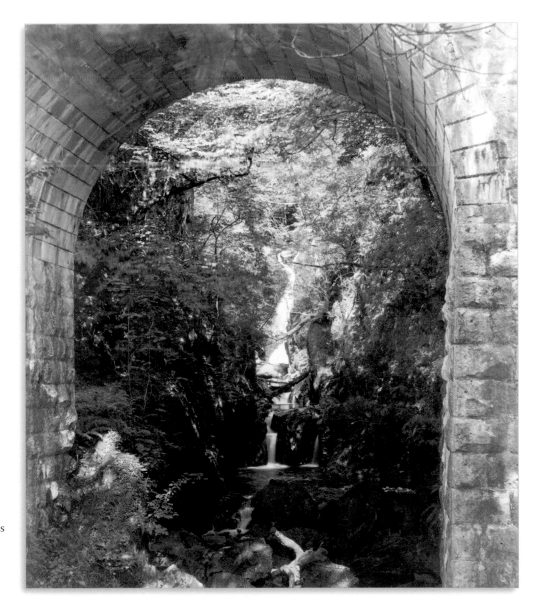

INVERARY,
THE FALLS OF CRUACHAN c1955
I15303

The hugely impressive mountain of Ben Cruachan—its summit 1126m above sea level—boasts two Munros, and it is one of the most celebrated mountains in Scotland, with its dramatic ridges and steep, soaring cliffs. The climb to the great dam of Cruachan Reservoir is popular with walkers, who ascend the steep paths through beautiful woodland, passing these tumbling falls.

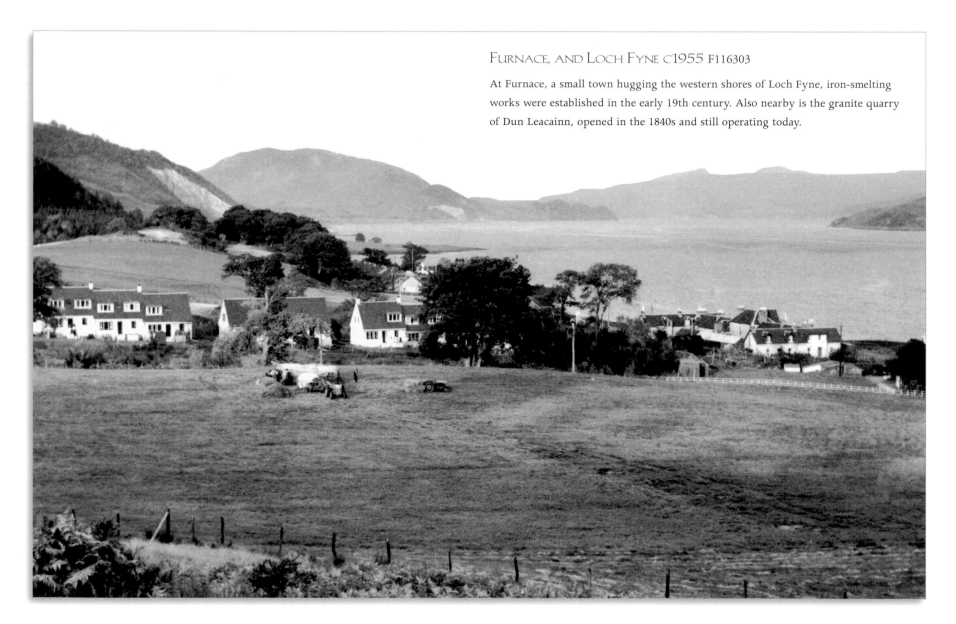

FURNACE, AND LOCH FYNE c1955 F116303

At Furnace, a small town hugging the western shores of Loch Fyne, iron-smelting works were established in the early 19th century. Also nearby is the granite quarry of Dun Leacainn, opened in the 1840s and still operating today.

GLENCOE 1899
43199

Glencoe village stands on the shores of Loch Leven. Here we see a row of classic stone-built thatched cottages, in the characteristic vernacular style. The reason for the infamous Glencoe massacre was the failure of MacIan to swear allegiance to William III before 1 January 1692. MacIan had arrived at Fort William on 31 December, but was redirected to Inverary, with the result that he did not take the oath until 6 January.

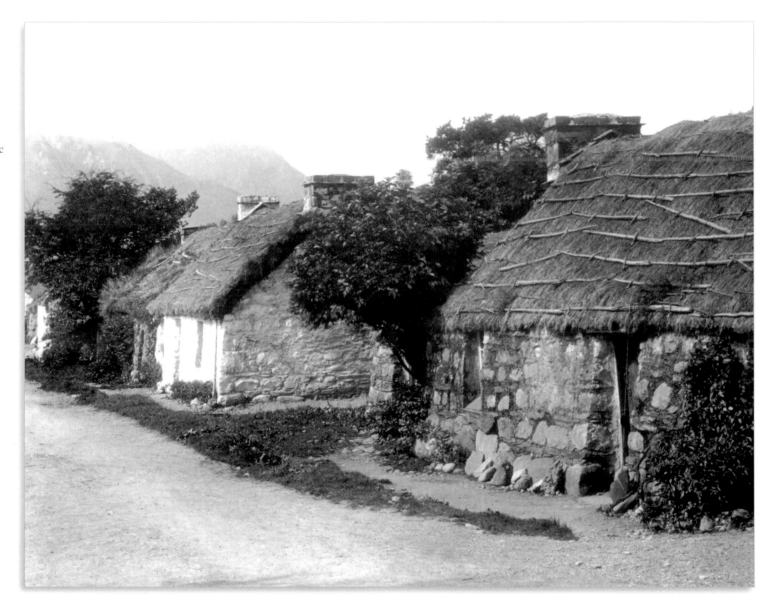

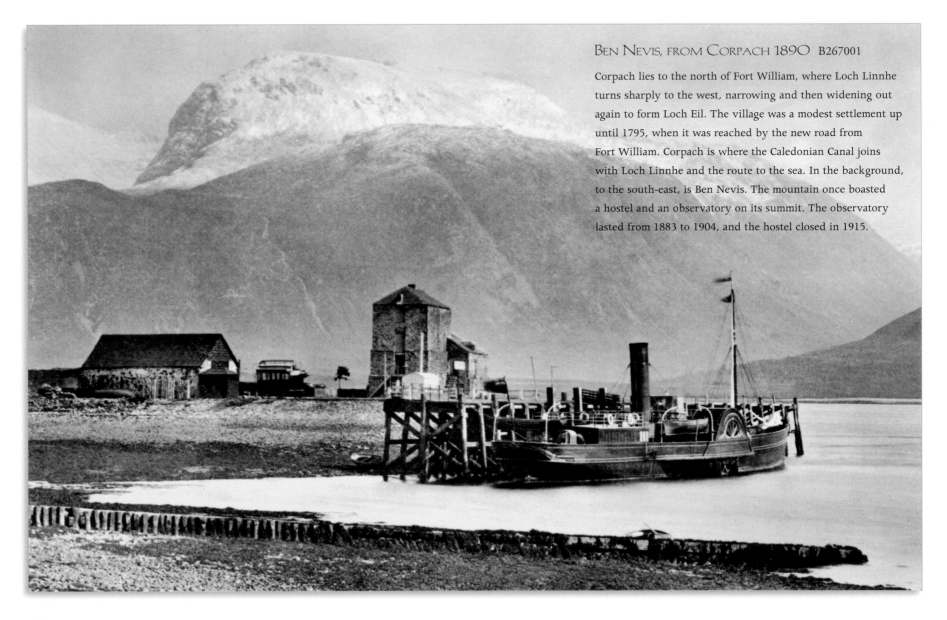

BEN NEVIS, FROM CORPACH 1890 B267001

Corpach lies to the north of Fort William, where Loch Linnhe turns sharply to the west, narrowing and then widening out again to form Loch Eil. The village was a modest settlement up until 1795, when it was reached by the new road from Fort William. Corpach is where the Caledonian Canal joins with Loch Linnhe and the route to the sea. In the background, to the south-east, is Ben Nevis. The mountain once boasted a hostel and an observatory on its summit. The observatory lasted from 1883 to 1904, and the hostel closed in 1915.

ISLE OF SKYE, KYLEAKIN c1890 K53001

At Kyleakin stand the ruins of Castle Moil. It is said that the castle was built by the daughter of one of the Norse kings of the Western Isles. Legend has it that she had a boom placed across the strait, and any ship plying between Skye and the mainland had to pay a toll. The town overlooks the narrow strait of Kyle Akin, which is said to take its name from King Haakon who sailed this way in 1263.

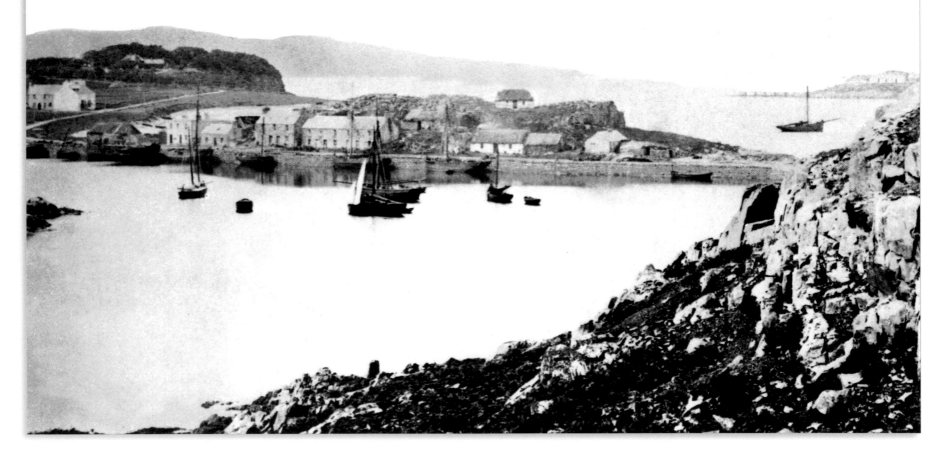

GLEN TORRIDON, BEINN EIGHE 1890 G80001

This wild and rocky landscape in Wester Ross is typical of the Highlands. The looming quartzite peaks of Beinn Eighe are in the background. The glen, which runs 15 miles from the shores of Loch Torridon to Kinlochewe, is popular with walkers, but the terrain can be perilous and the weather can quickly change rapidly for the worse. The UK's first National Nature Reserve was some miles away on the slopes of Sgurr Ban.

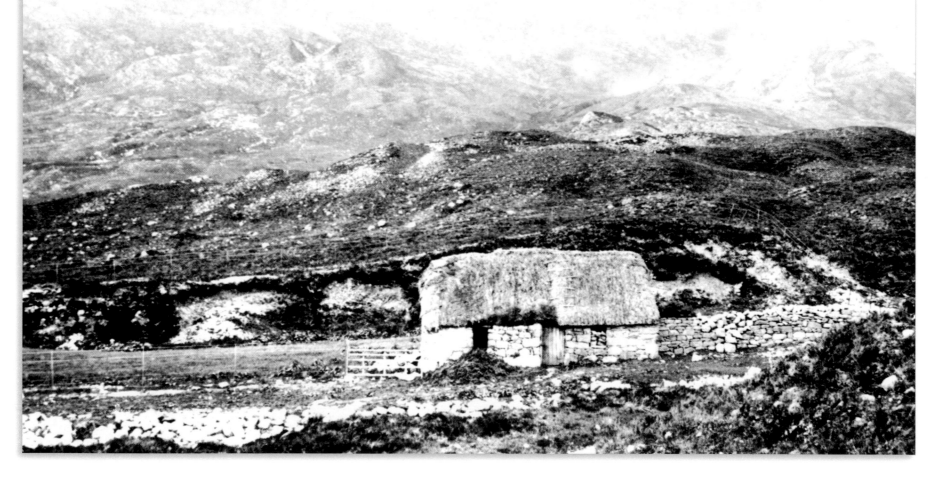

STRATHPEFFER, WASHING DAY c1890
S421003P

The town of Strathpeffer owes its popularity to the discovery of sulphurous springs in the 18th century. These were declared by medical practitioners in the Victorian era to be the most curative in Britain. The village rapidly grew into a popular spa town, with visitors flocking from all over Europe to sample its sulphur and chalybeate springs. It was served by a branch line of the Highland Railway from Fodderty Junction. Are these girls laundresses at one of the hotels?

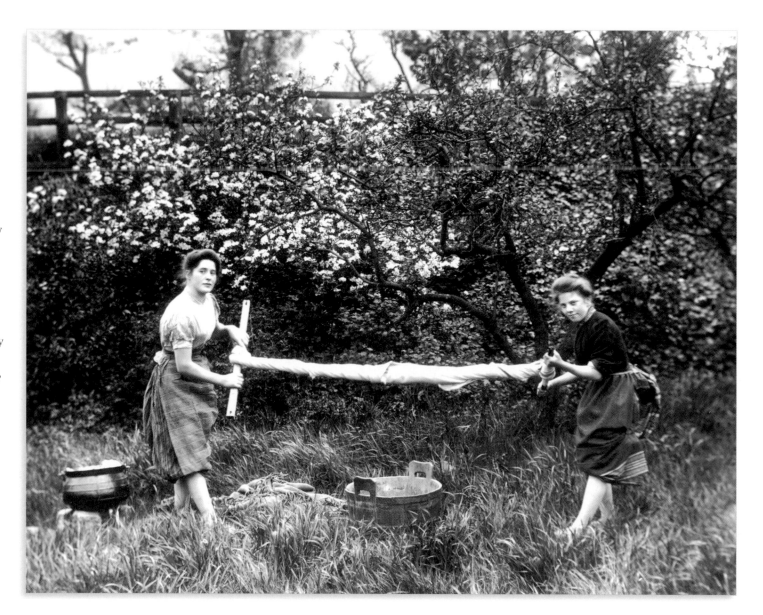

THE HIGHLANDS & ISLANDS

DINGWALL, GENERAL VIEW 1890 D77001

Dingwall stands on the Cromarty Firth. It was the home town of General Hector MacDonald (1853–1903), who enlisted in the 92nd Highlanders at the age of 17. In 1879, MacDonald distinguished himself during the First Afghan War, and General Roberts offered him a Victoria Cross or a commission. He chose the commission, saying that he would win the Victoria Cross later.

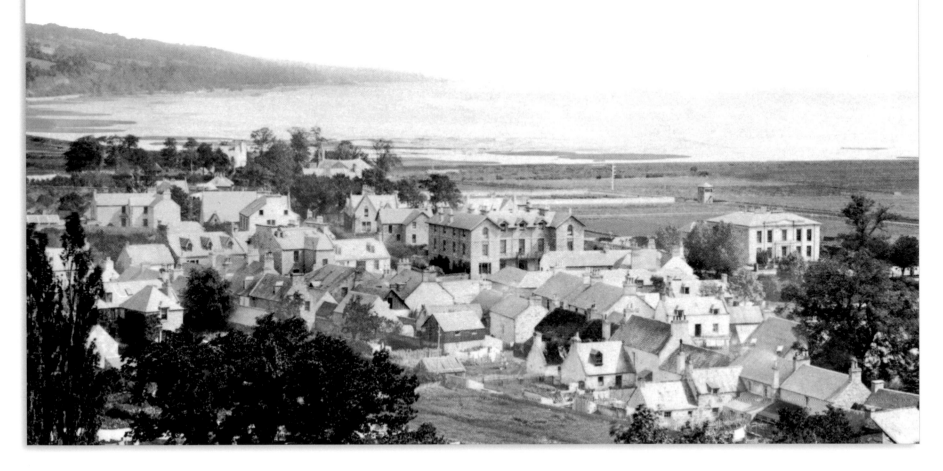

FORTROSE, STREET SCENE 1880 F60002

Fortrose stands on the Black Isle overlooking the inner Moray Firth. Its ruined cathedral dates from the reign of David I. Some of the stone was taken by Cromwell's forces for use in the construction of a fort at Inverness. Fortrose was originally called Chanonry and was made a royal burgh in 1592. In January of that year a hoard of silver coins dating from the time of Robert III were unearthed near the ruins of the cathedral.

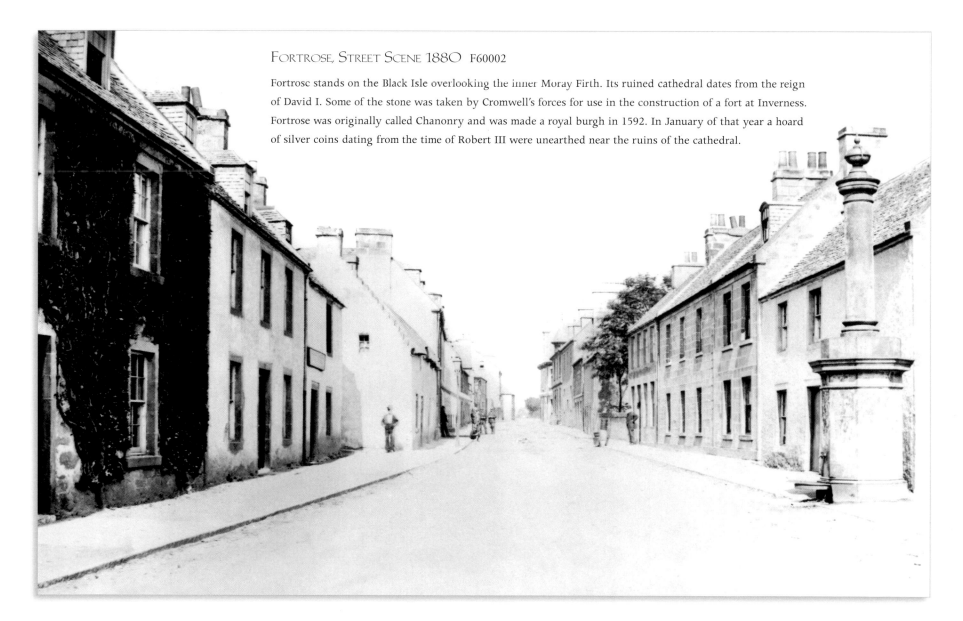

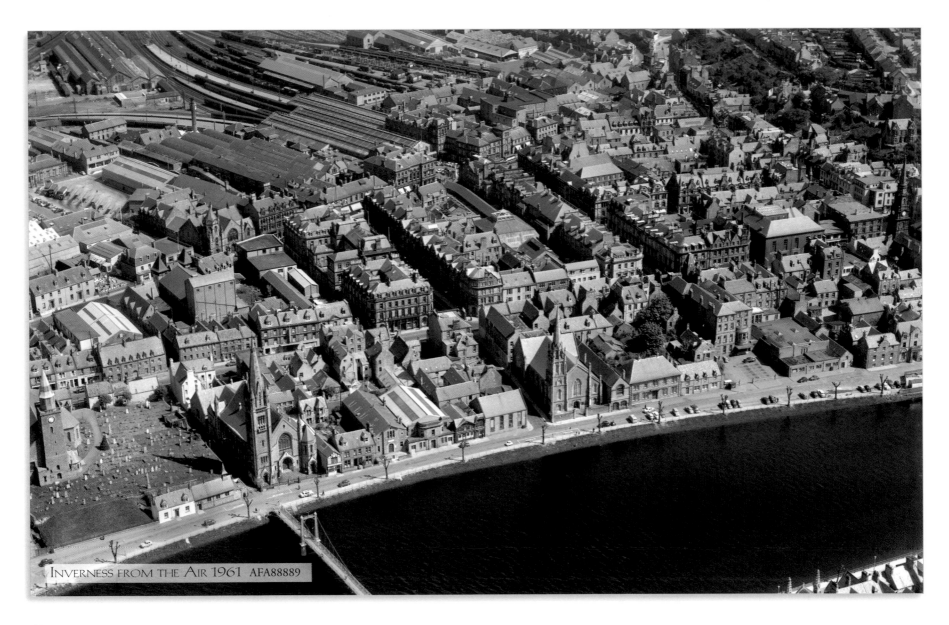

INVERNESS FROM THE AIR 1961 AFA88889

INVERNESS, THE VIEW FROM INVERNESS CASTLE c1890 I255003

The area in and around Inverness has been occupied since ancient times and it was here, in the 6th century, that the capital of the Pictish kingdom stood. It is thought that Macbeth may have lived at Inverness Castle, or used it as a base for operations against the Orcadians. The suspension bridge superseded a stone bridge of seven arches, which was destroyed during severe flooding in 1849. The suspension bridge itself lasted until 1961, when it was demolished.

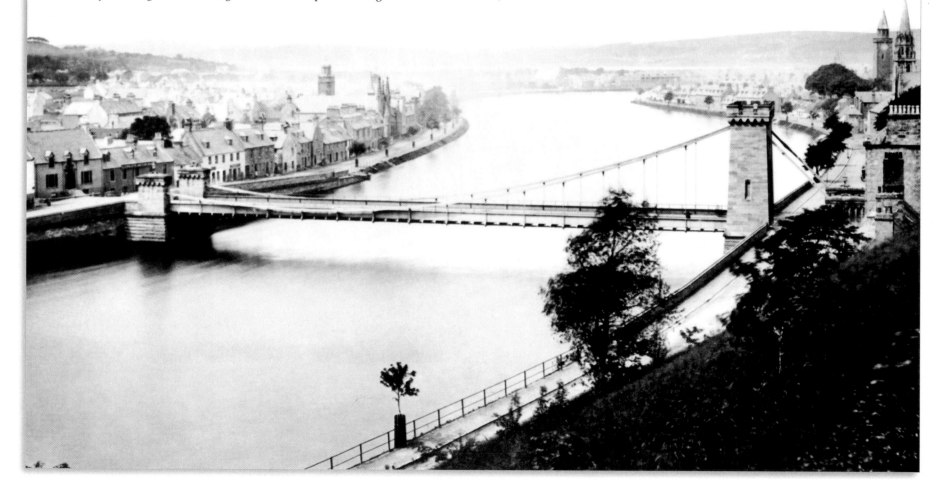

INVERNESS, THE NESS AND CATHEDRAL c1965 I25003

This cathedral church, in its exquisite setting alongside the River Ness, owes its existence to an Englishman, Robert Eden, who became Bishop of Moray and Ross in the 1850s. The building of a new Cathedral was first suggested by the Bishop in 1853. In 1866, the young architect and member of the congregation Alexander Ross, put together the first designs. The foundation stone was laid by the Archbishop of Canterbury, and the building was finally completed in 1869.

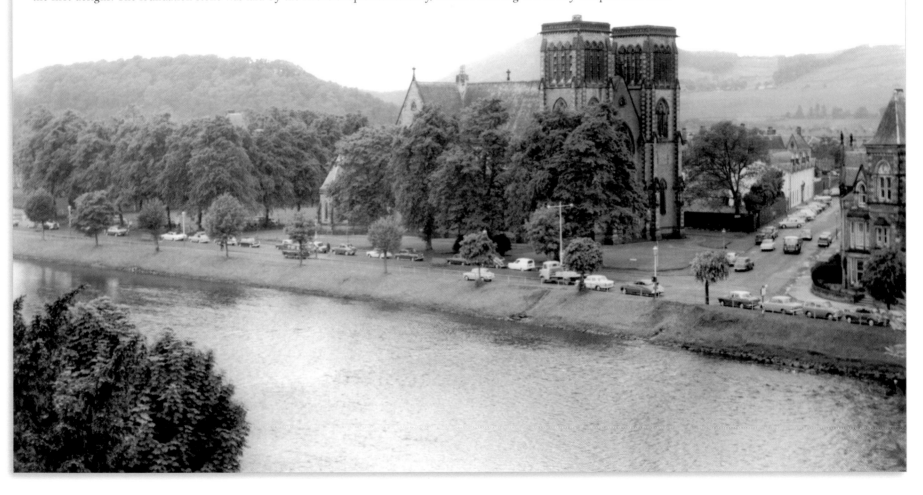

CULLODEN MOOR, THE BATTLEFIELD C1890 I25501

In 1746 Prince Charles Edward Stuart fought at the battle of Culloden Moor. Following the battle, 300 clansmen were herded into Inverness town jail and left without food or water for two days. Those that died were thrown into unmarked trenches. On the right is the memorial cairn built in 1881 by Arthur Forbes of Culloden.

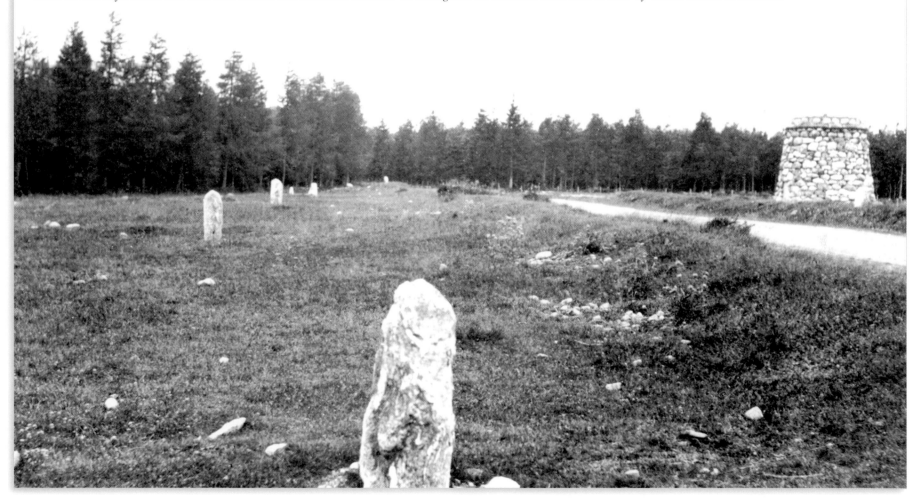

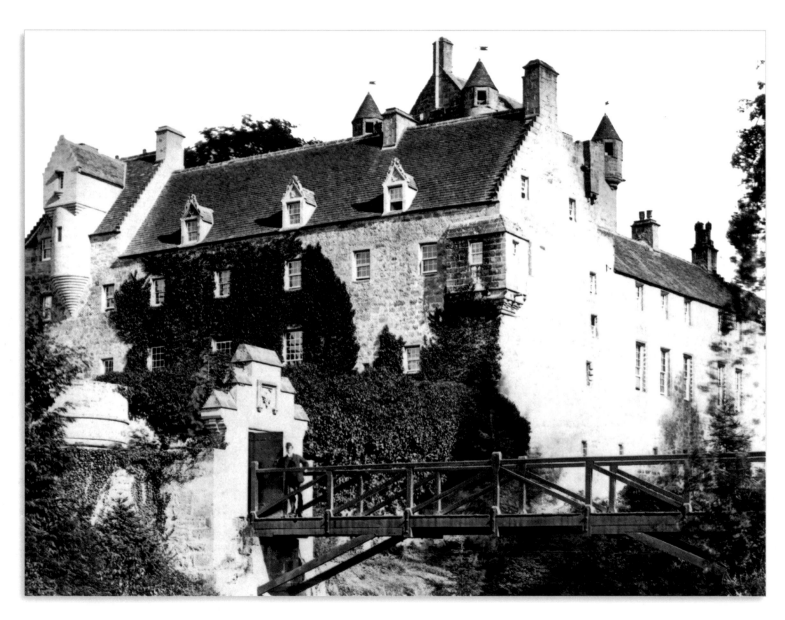

CAWDOR,
THE CASTLE c1890
C212001

A few miles to the south of Nairn stands Cawdor Castle, one of Scotland's finest medieval buildings. It is famous for its association with Macbeth and the murder of Duncan. The keep dates from 1454, and some parts are thought to be even older. The castle was extensively altered during the 16th and 17th centuries and again in the 19th century.

FRASERBURGH, THE HERRING FLEET c1900

F63002P

Fishing was a vital local industry in this remote north-eastern port, and in 1914 there were still more than 200 boats registered here. The Zulu vessel shown in the photograph is considered to be one of the finest fore- and mizzen-rigged luggers ever designed for the North Atlantic waters. Zulus ranged in size from 60ft to 120ft, and carried a huge amount of canvas. The bigger boats had holds capable of carrying 80 tons of herring.

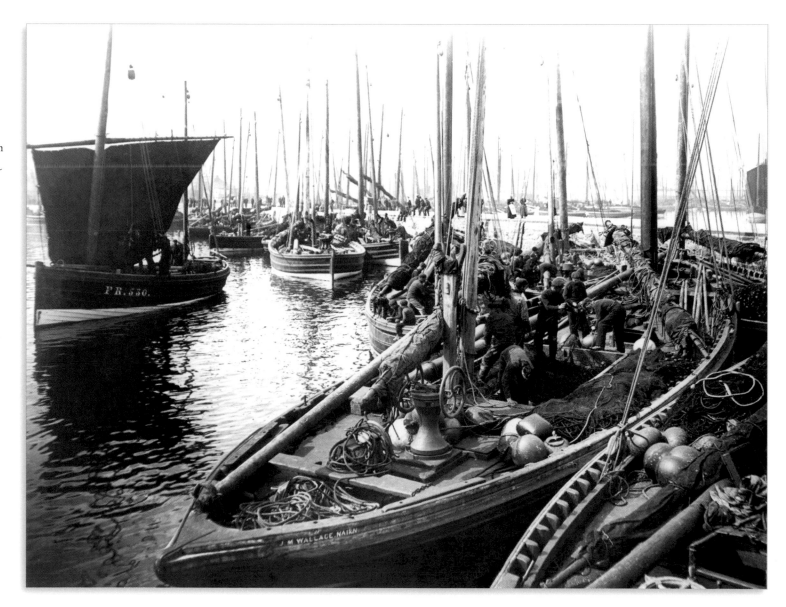

BALMORAL CASTLE c1890 B268001

Queen Victoria and Prince Albert first came to the Balmoral estate in 1842 as guests of Sir Robert Gordon, on the advice of Victoria's Scottish physician Sir James Clark. Both the Queen and the Prince Consort suffered from rheumatism, and it was thought that the climate of upper Deeside might do them some good. Though Victoria was Queen Empress of the greatest empire in history, she had little personal wealth. Money was found to purchase the estate, but plans to rebuild the castle looked in doubt. Then the Queen heard that she had been left £500,000 for her personal use in the will of the eccentric barrister John Camden Neild.

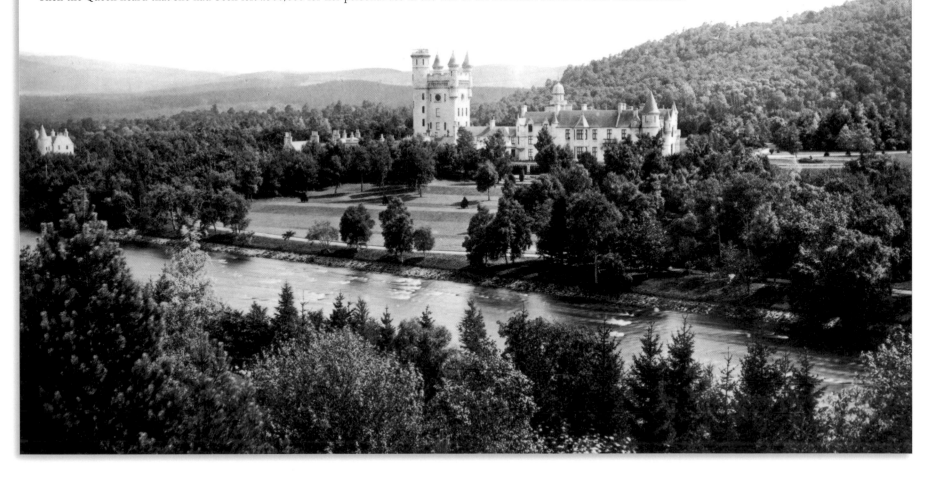

BRAEMAR, THE MILL ON THE CLUNY 1890
B266002

The village of Braemar is situated on the banks of Cluny Burn. It was here, in 1715, that a number of Scottish lords, including the Earl of Mar, met on the pretext of a hunting trip to plan an uprising against the House of Hanover, with the object of returning the Stuarts to the throne of Scotland. Among later visitors to the village was Robert Louis Stevenson—while spending a winter here he wrote 'Treasure Island'.

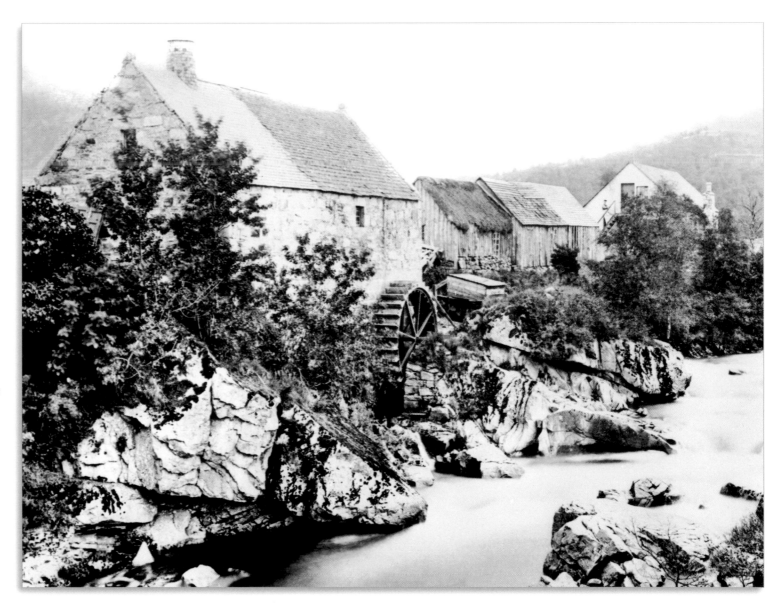

GRAMPIAN

BRAEMAR CASTLE c1960 B266001

This five-storey, L-plan tower-house was built by the Earl of Mar in 1628. It was here in August 1714 that a so-called hunt was assembled by John Erskine, sixth Earl of Mar. It was in fact the start of a rebellion against the house of Hanover and the Union, and the Stuart standard was raised. Though Braemar had been burnt by Graham of Claverhouse in 1689, it had been rebuilt. The curtain wall was added when the castle was used as a garrison for government troops.

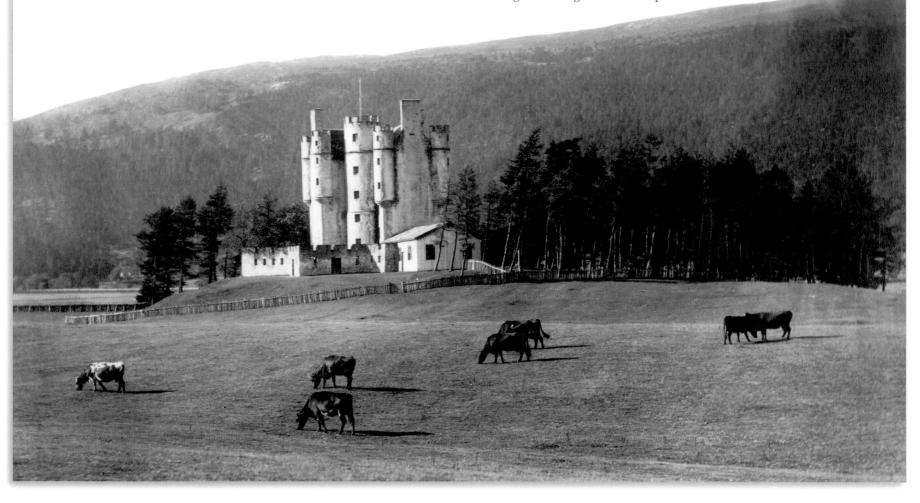

BRAEMAR,
THE CAIRNWELL
PASS 1879
B266003P

The road south from
Braemar climbs through
Glen Clunie and then
over the rugged Cairnwell
Pass, the highest point
on a main road in Britain,
and now the main A93
between Aberdeenshire
and Perthshire. Here there
are scenes of breathtaking
beauty, and herds of wild
red deer roam among
the mountains.

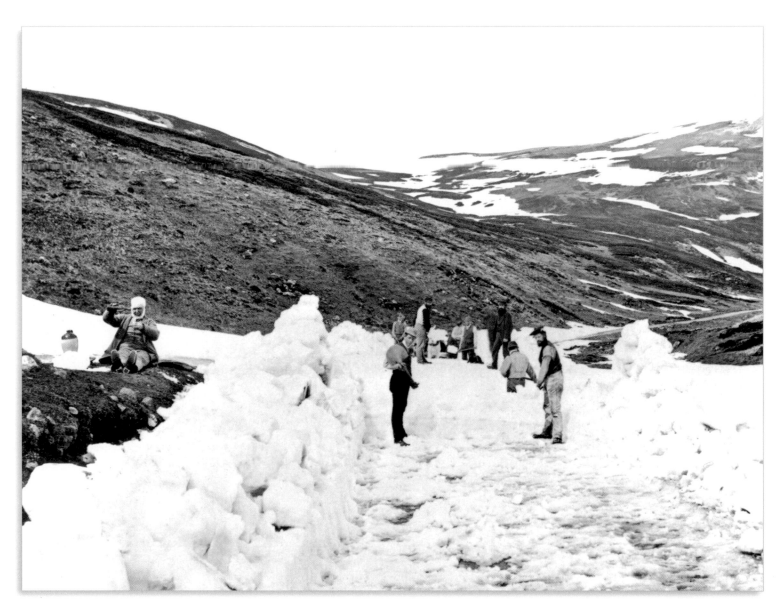

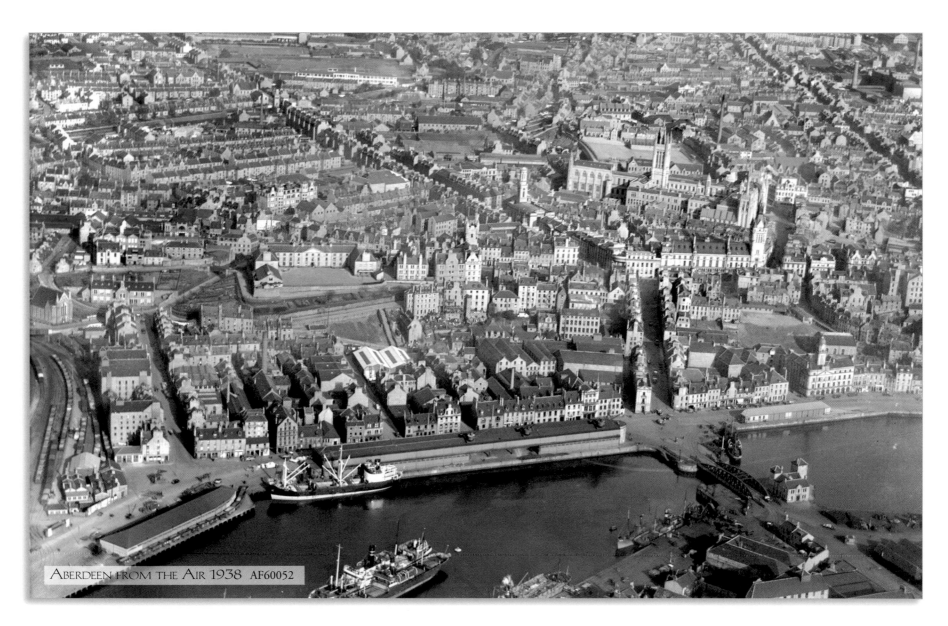

ABERDEEN FROM THE AIR 1938 AF60052

ABERDEEN,
THE AULD BRIG
O' BALGOWNIE
1890
A90304

Aberdeen is now
Scotland's third largest
city. Its charters date back
to the 1100s, although
St Machar is said to have
founded a church here
in AD 580. This single-
arched stone bridge is
situated a few hundred
yards to the north of
St Machar's Cathedral,
and crosses a gorge of
the River Don. It is one
of the most ancient
bridges in Britain, and
was constructed around
1290. The salmon pool
underneath is alluded
to by Byron in his poem
'Don Juan'. In the early
1600s Sir Alexander Hay
left a legacy for repairing
the bridge.

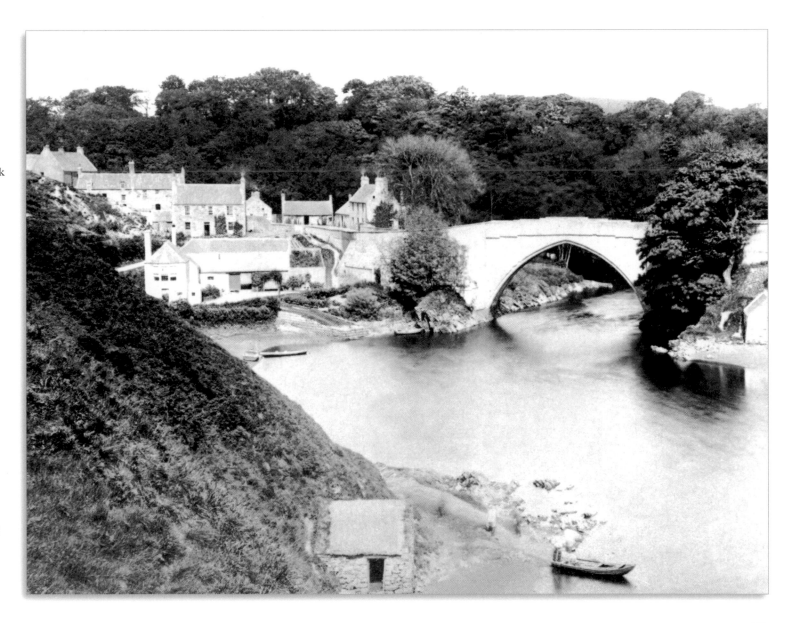

GRAMPIAN

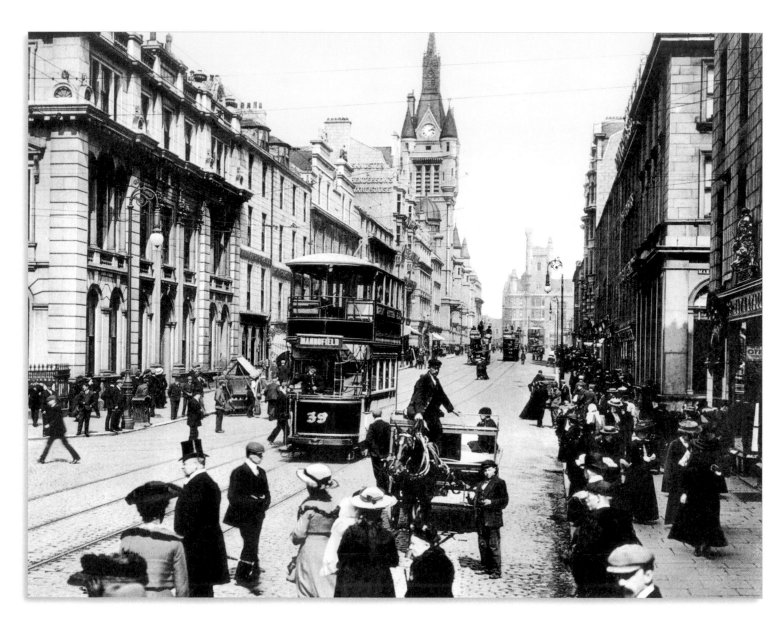

ABERDEEN,
UNION STREET C1899
A90309t

These days Aberdeen is famous for its association with North Sea oil, but shipbuilding, fishing, papermaking and the quarrying of granite have all played their part in the city's development. Here we see electric tramcars competing with a horse and cart in this crowded street. The chief thoroughfare of Aberdeen, Union Street, at this time was three-quarters of a mile long, 70 feet wide and built entirely of granite.

ABERDEEN,
UNION TERRACE AND
GARDENS c1920
A90308

This photograph shows the statue of King Edward VII, the eldest son of Queen Victoria, at the corner of Union Street and Union Terrace. Union Terrace Gardens is a park in the heart of the city of Aberdeen, set to one side of Union Terrace. At the end of the terrace are three impressive buildings— the Central Library, His Majesty's Theatre and St Mark's Church. They are known locally as 'Education, Damnation and Salvation'.

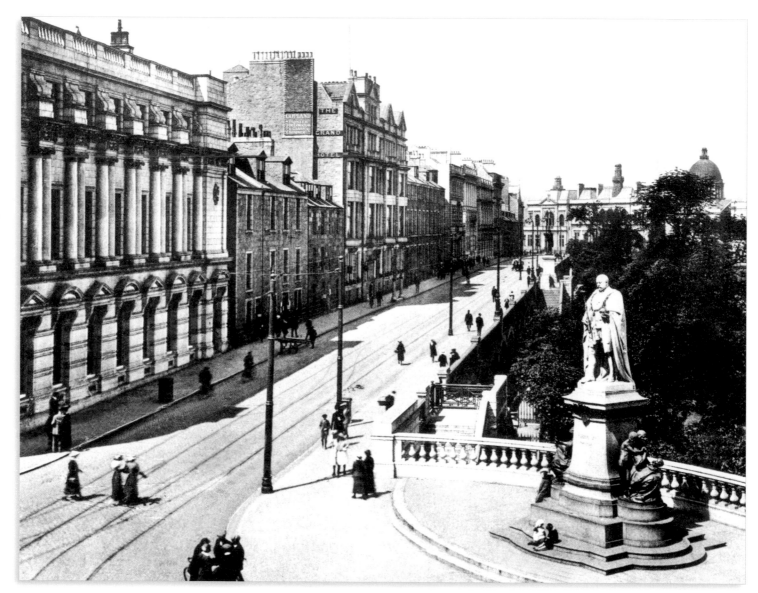

SCOTLAND

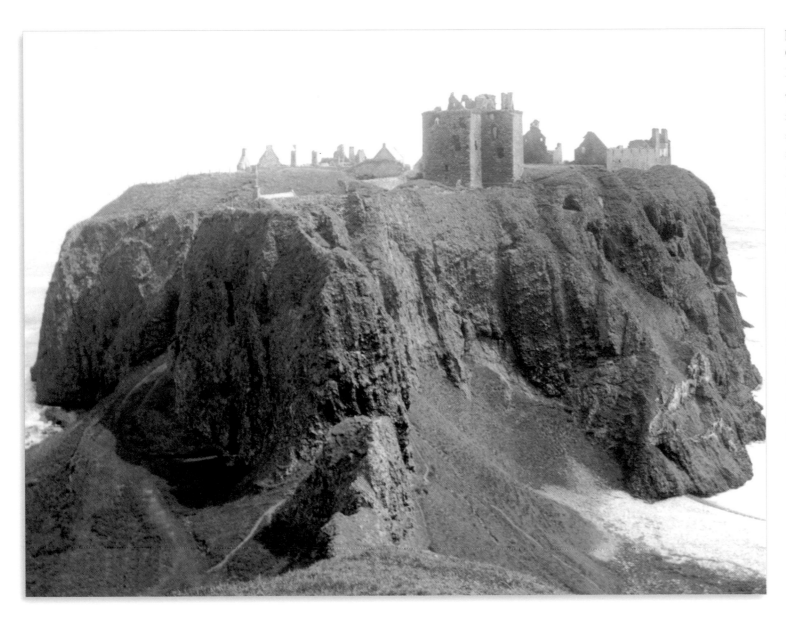

DUNNOTTAR CASTLE c1900
D80401

This impressive and forbidding-looking castle stands to the south of Stonehaven on a rocky headland overlooking the North Sea. It was here, in July 1650, that Charles II was entertained by the Earl Marischal. It was the only fortress in Scotland that flew the Stuart royal flag after Charles's defeat at Worcester in 1651. Dunnottar held out until May 1652, when Sir George Ogilvy of Barras was allowed to surrender with all the honours of war.

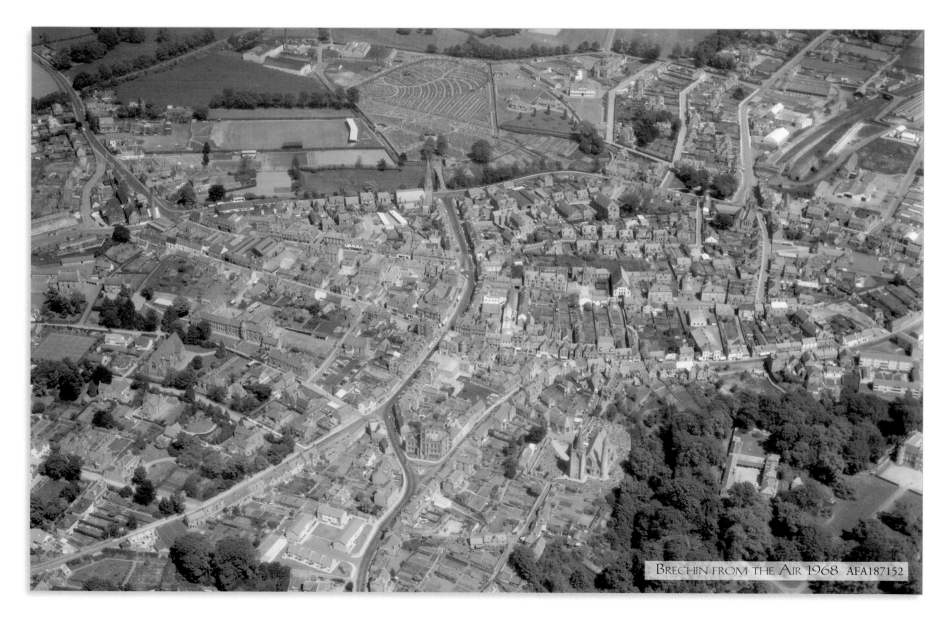

BRECHIN FROM THE AIR 1968 AFA187152

SCOTLAND

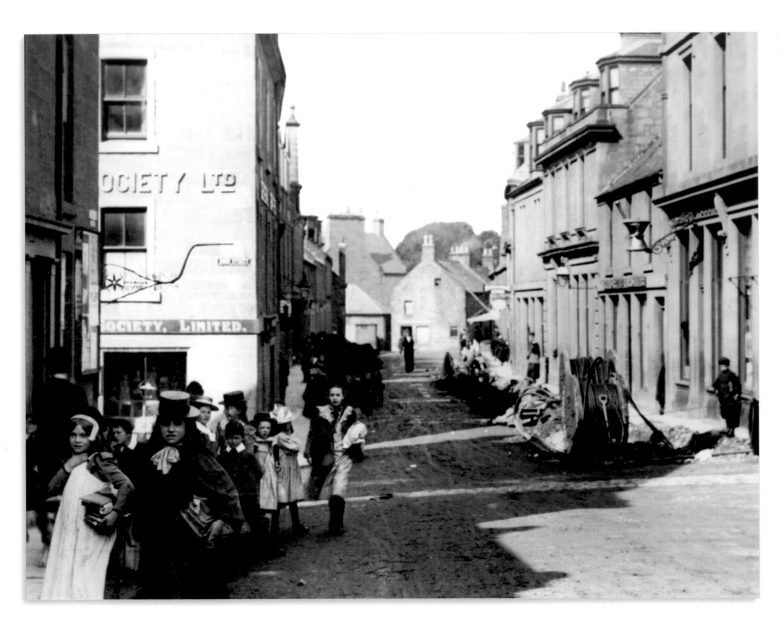

BRECHIN, DAVID STREET 1900
B275002

This small town once played host to one of the significant events in Scotland's history: John Balliol surrendered the realm of Scotland to Edward Longshanks here on 10 July 1296. When Balliol walked into Brechin Castle to meet Bishop Anthony Bek of Durham, the Bishop ripped the red and gold arms of Scotland off Balliol's tunic. Balliol was known afterwards as Toom (empty) Tabard. Brechin's famous landmark is the Round Tower, dating from the 10th or 11th century, and one of only two examples of round towers in Scotland.

SCONE, THE VILLAGE 1899 43917

Scone was where Scotland's kings were crowned. On 1 January 1651, Charles II was crowned king of Scotland with Robert the Bruce's gold circlet. His coronation was bought at a price - Charles agreed to impose the Presbyterian Church in England, and the third civil war was about to begin.

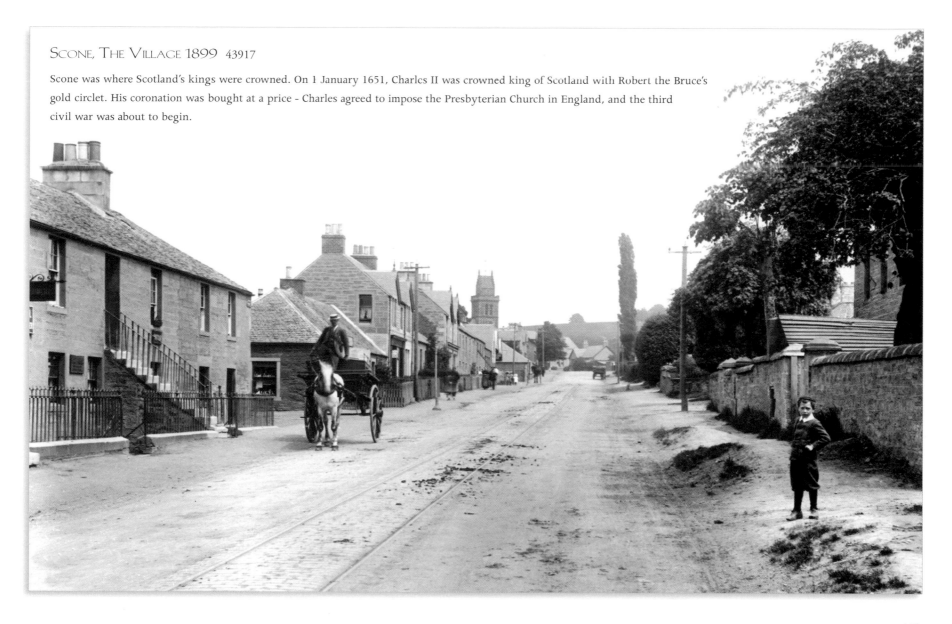

SCOTLAND

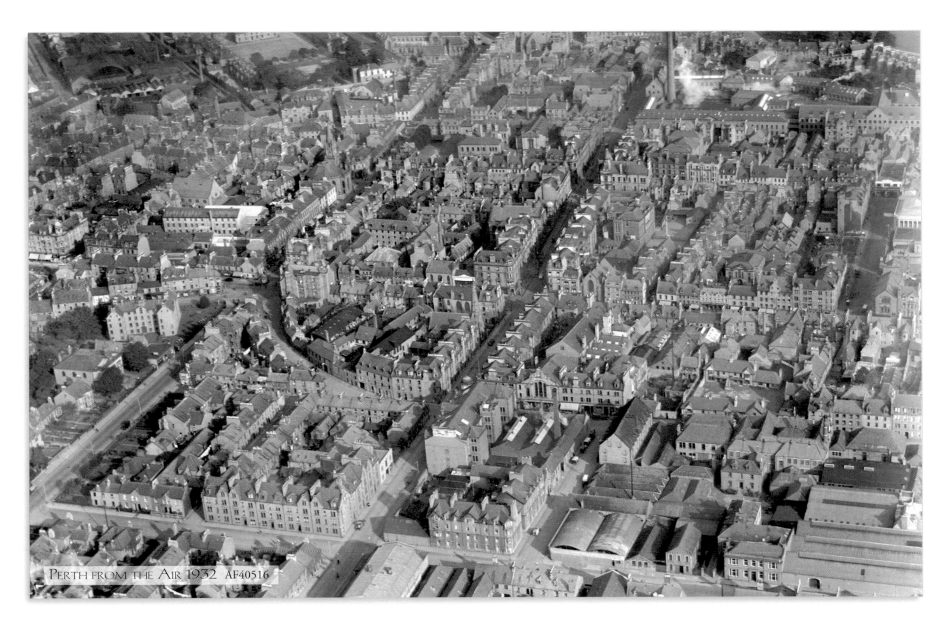

PERTH FROM THE AIR 1932 AF40516

PERTH, MONCRIEFFE ISLAND AND THE TAY 1901 47430

An ancient royal burgh, Perth was once capital of Scotland. It was at Perth, in 1559, that John Knox gave his famous sermon from the pulpit of St John's Church, regarded by many as the start of the Reformation in Scotland. Cutting across the middle of the picture is the bridge carrying the Caledonian Railway, while on the far right is the Victoria Road bridge. Between the two are the county buildings, which occupy the site of the house in which the Gowrie conspiracy against James VI was hatched in 1600.

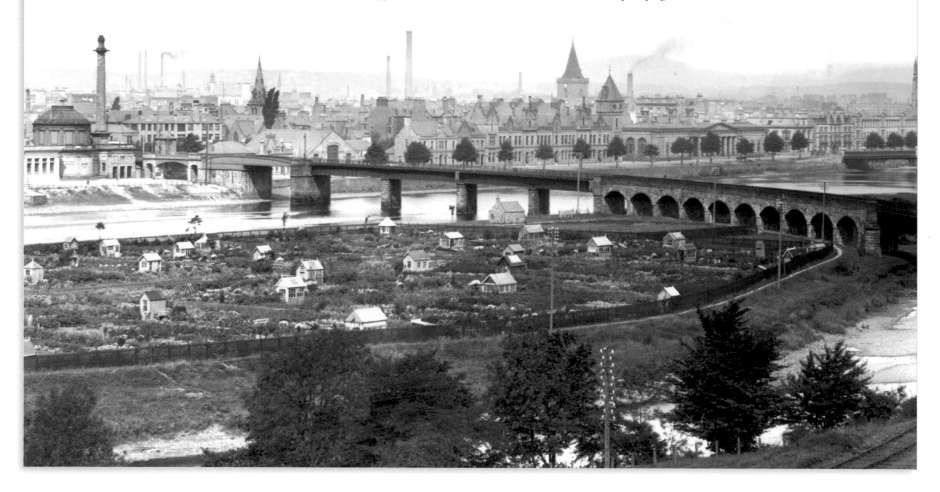

PERTH, THE BRIDGE 1899 43897

Built of rose-red sandstone, Perth Bridge was completed in 1771. The city then had a population of nearly 8,000. It was still an important port, with several hundred vessels coming up river every year to discharge and take on cargo.

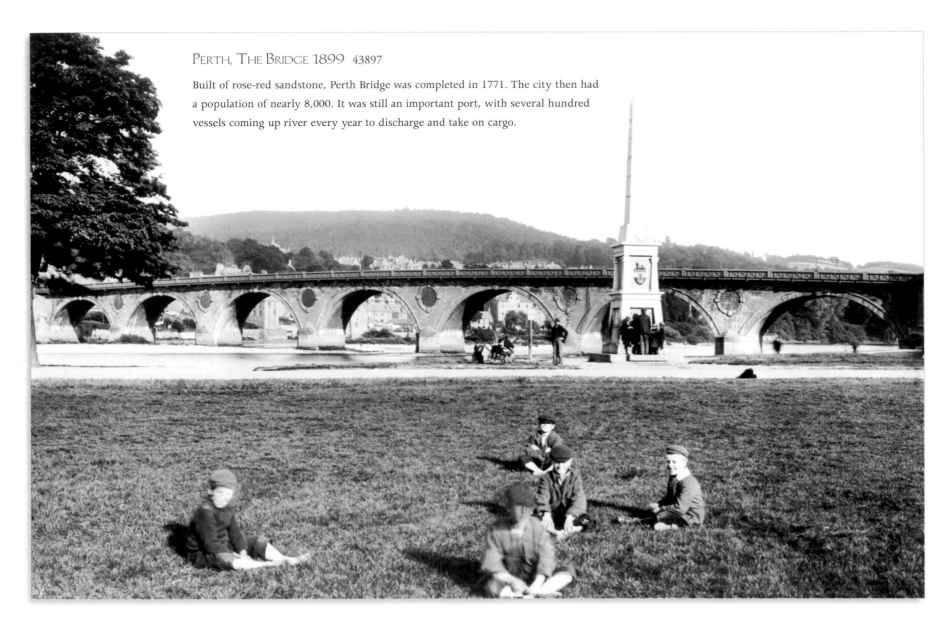

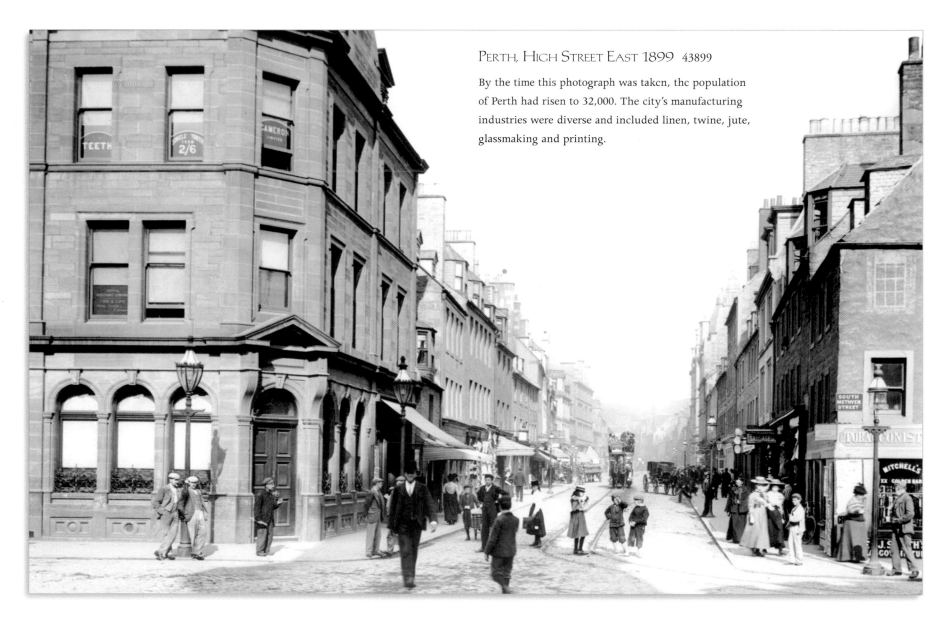

PERTH, HIGH STREET EAST 1899 43899

By the time this photograph was taken, the population of Perth had risen to 32,000. The city's manufacturing industries were diverse and included linen, twine, jute, glassmaking and printing.

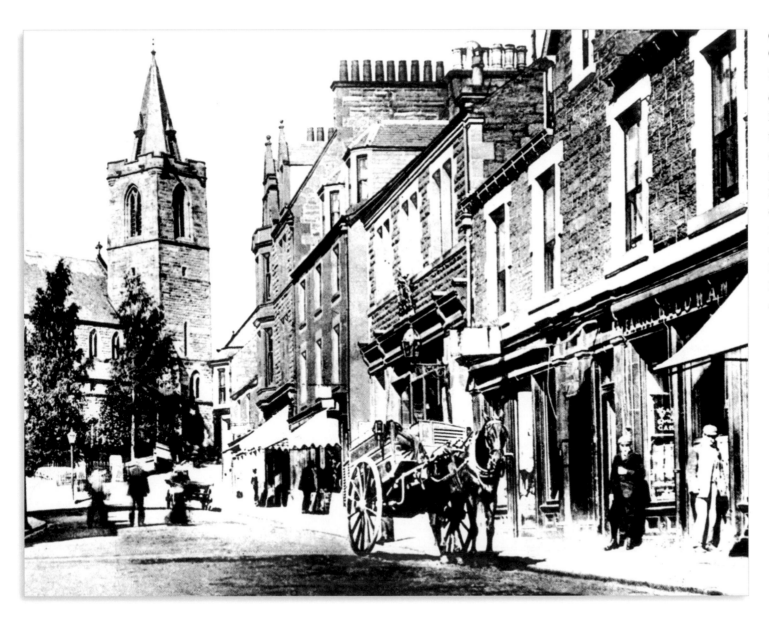

CRIEFF,
COMRIE STREET 1904
52682

Crieff was originally called
Drummond. In January 1716,
the settlement was totally
destroyed when the Jacobites
put the town to the torch.
It was rebuilt thanks to the
efforts of James Drummond,
3rd Duke of Perth. On his
retreat north in 1745,
Prince Charles Edward Stuart
held a council of war in Crieff
at the Drummond Arms.

CRIEFF,
DRUMMOND
CASTLE 1899 44359

Situated three miles south-west of Crieff, Drummond Castle was originally built by John, the first Lord Drummond in 1491. It has endured its share of troubles: it was besieged and bombarded by Cromwell, destroyed in 1689 and subsequently rebuilt, garrisoned by Hanoverian troops in 1715, and finally partially dismantled in 1745 by the Jacobite Duchess of Perth to deny it to the English and their allies.

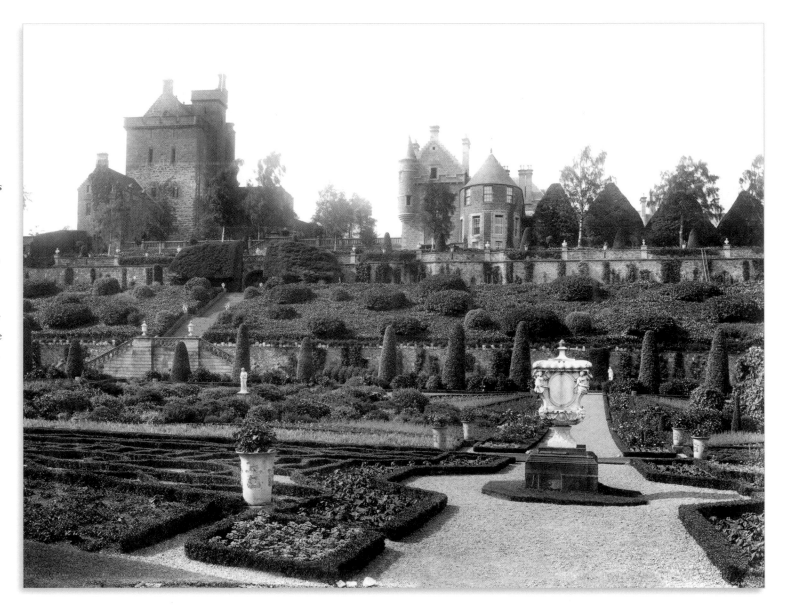

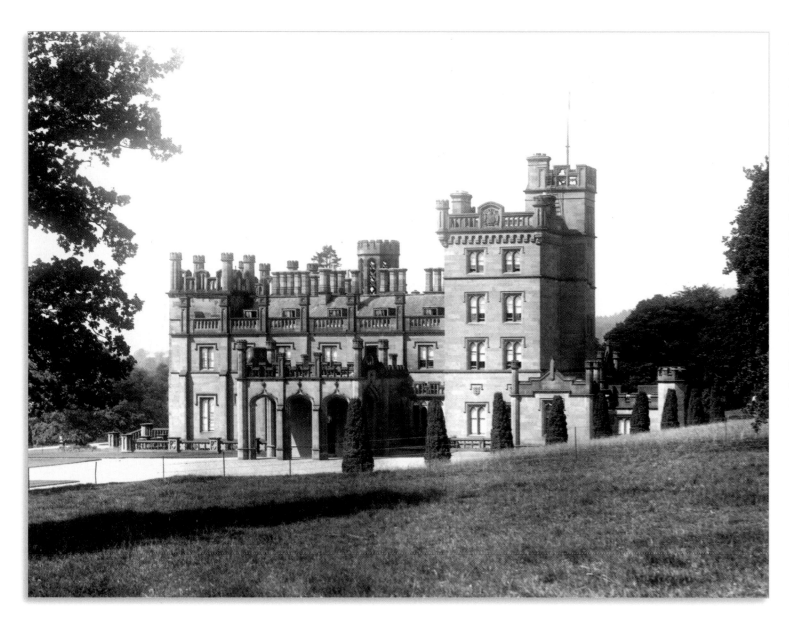

ABERCAIRNY HOUSE
1899 44385

Built between 1804 and 1844 by Richard Crichton and the Dickson brothers for Charles and James Moray, Abercairny is an example of a departure from the traditional approach to the design of country houses. Though it features a tower, the internal arrangement was not planned around a grand staircase or central hall, but around corridors. Similar houses include Southill (1796–1803) and a proposed design for Mamhead (1822).

COMRIE, VIEW FROM THE EAST 1899 44405P

Situated between Crieff and St Fillans on the Highland fault line, Comrie is famous for the number of earth tremors experienced by its inhabitants. The first recorded tremor was in 1789, and the most sustained was a series of 20 within 24 hours in 1839.

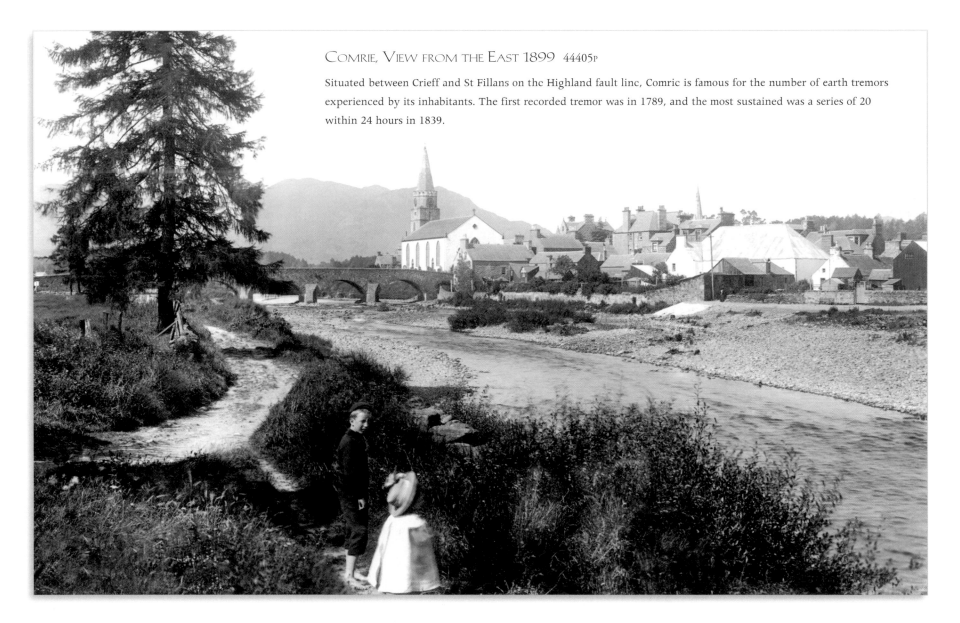

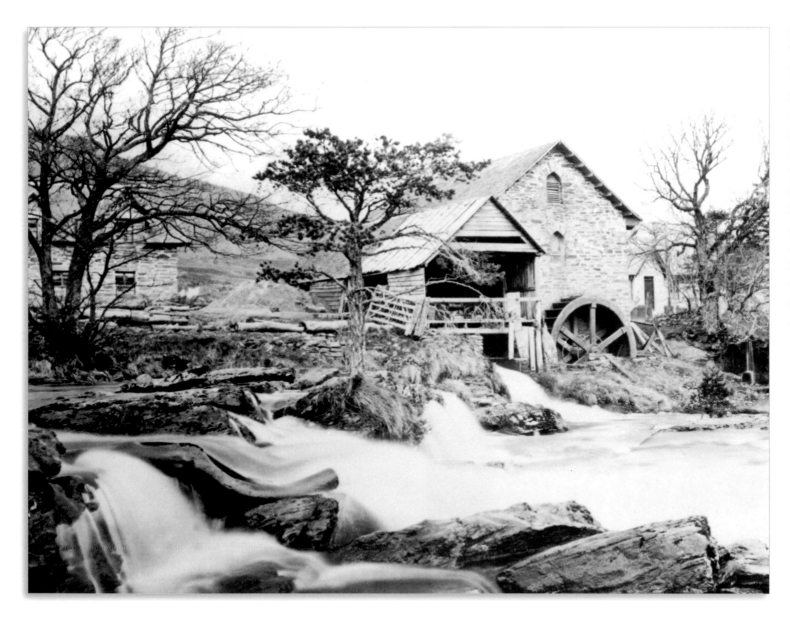

Killin, The Mill 1890
K51004

Killin mill stands on the River Dochart. Not far away is the ruined Breadalbane stronghold of Finlarig Castle. One of its more interesting features is what is thought to be an ancient beheading pit. At Killin are the dramatic Falls of Dochart, a series of rapids carrying the river under the bridge and through the village.

LOCH KATRINE, TROSSACHS PIER c1890 L93002

An excursion steamer waits at the pier. The picturesque loch, which is ringed with hills, features in Sir Walter Scott's poem 'The Lady of the Lake'. The famous steamer SS 'Sir Walter Scott' was built on the River Clyde, then transported by barge up Loch Lomond, and dragged by horses up the steep incline from Inversnaid along to the west end of the loch. Here she was re-assembled and launched. She is the last screw steamer to be operating a regular service in Scotland.

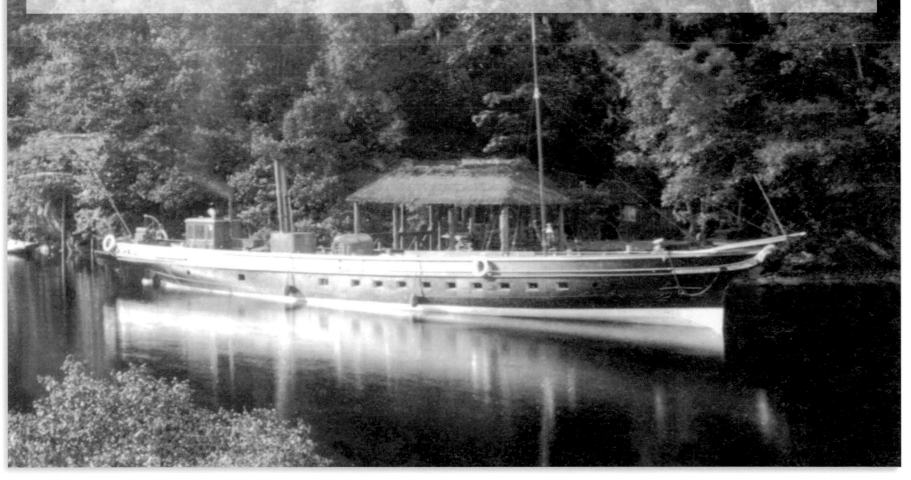

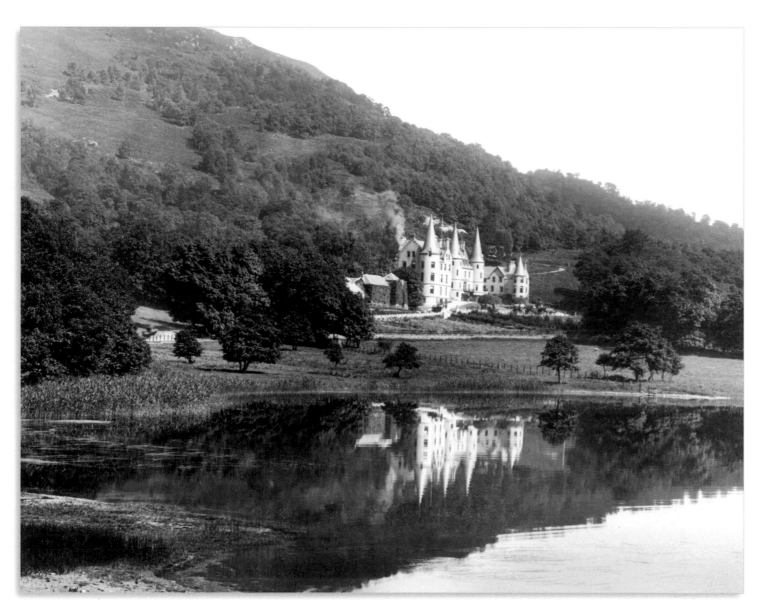

LOCH ACHRAY C1899
44603

This small loch is sandwiched between Loch Katrine and Loch Vennachar, seven miles west of Callendar. This picture shows the Trossachs Hotel situated on the northern shore, and the wooded slopes of Sron Armailte. Dorothy Wordsworth described the visit she made with her poet brother to the loch: 'We came up to that little lake, and saw it before us in its true shape in the cheerful sunshine. The Trossachs, overtopped by Ben Ledi and other high mountains, enclose the lake at the head: and those houses which we had seen before, with their cornfields sloping towards the water, stood very prettily under low woods.'

DUNBLANE,
THE BRIDGE AND THE
CATHEDRAL 1899
44651

The body of the cathedral
dates from the 13th
century, but the tower is
Norman. During the
16th century, the roof of
the nave collapsed and was
not finally restored until
1893.

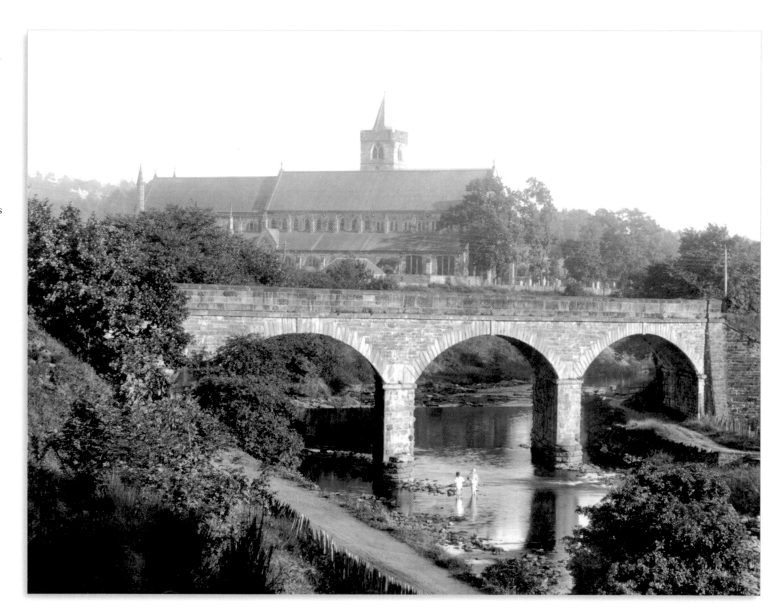

DOUNE CASTLE FROM THE BRIDGE 1899 44645

Situated to the south-east of the town on the left bank of the river Teith at its junction with the Ardoch, Doune Castle derives its name from the Gaelic word 'dun', meaning a fortified place. It differs from the earlier great castles such as Kildrummy and Bothwell, in that the domestic apartments are incorporated into the gatehouse. In older castles the practice was to position them to the rear of the courtyard.

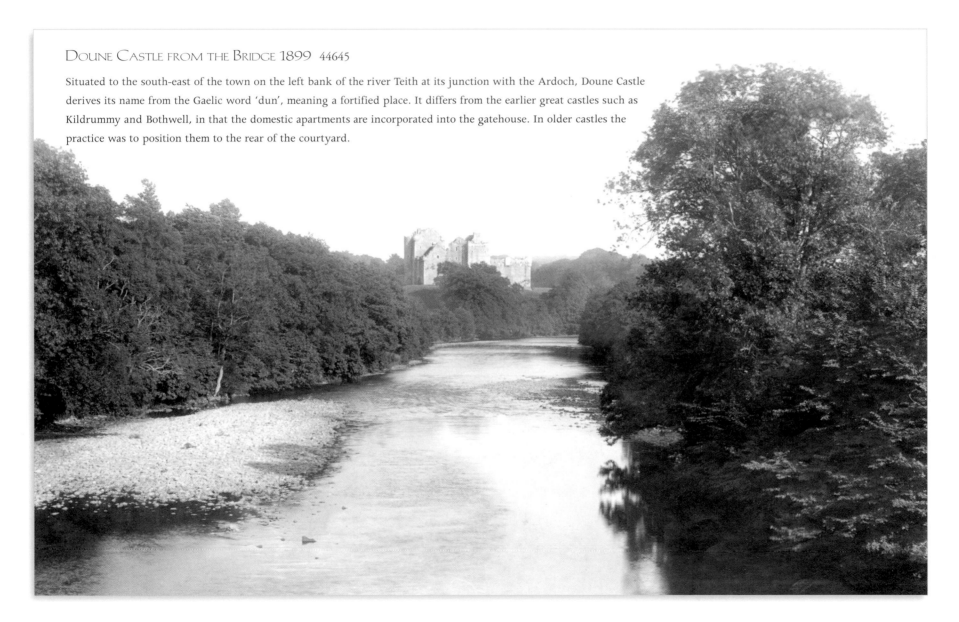

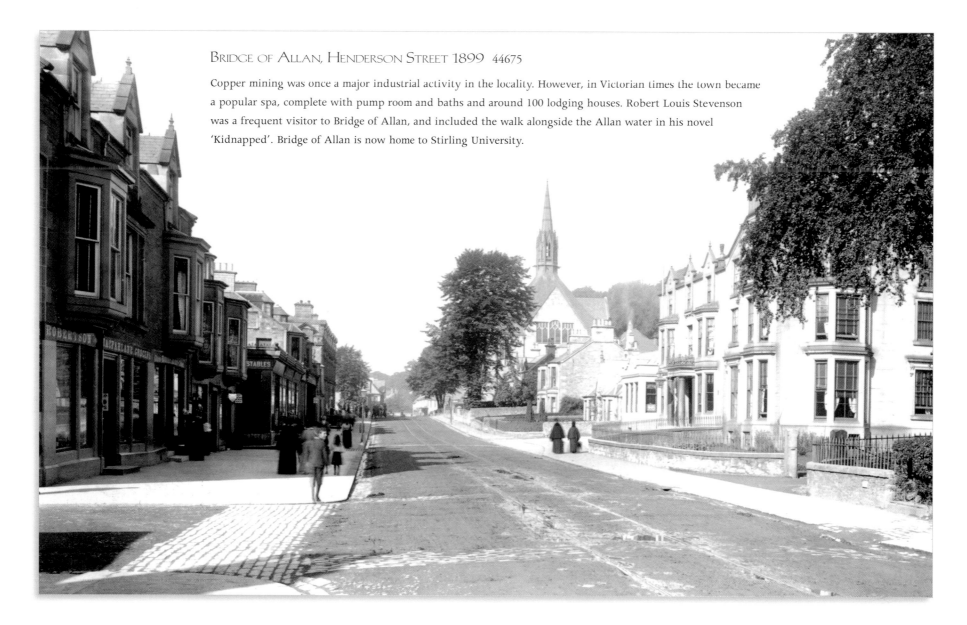

BRIDGE OF ALLAN, HENDERSON STREET 1899 44675

Copper mining was once a major industrial activity in the locality. However, in Victorian times the town became a popular spa, complete with pump room and baths and around 100 lodging houses. Robert Louis Stevenson was a frequent visitor to Bridge of Allan, and included the walk alongside the Allan water in his novel 'Kidnapped'. Bridge of Allan is now home to Stirling University.

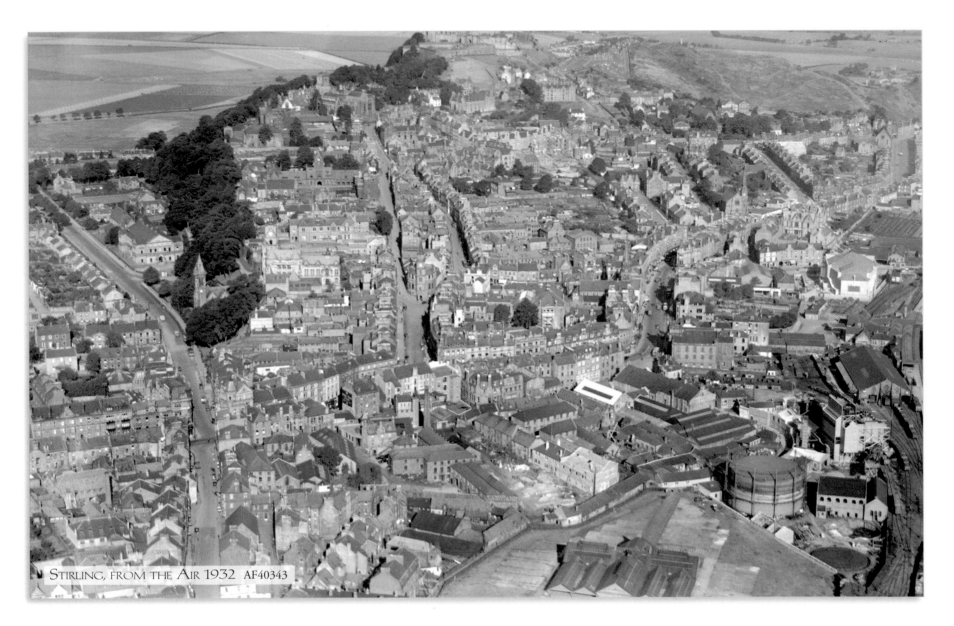

STIRLING, FROM THE AIR 1932 AF40343

STIRLING, BROAD STREET 1899 44705

It was at Stirling that both James II and James V were born and where Mary, Queen of Scots and James VI both lived for a number of years. Following defeat at the Battle of Dunbar, Major General David Leslie and several thousand survivors of his army took shelter in Stirling. The town eventually fell to General Monk. This photograph was taken looking towards Mar's Wark: dating from 1570, this uncompleted renaissance building was intended for use by the Earl of Mar who was Regent.

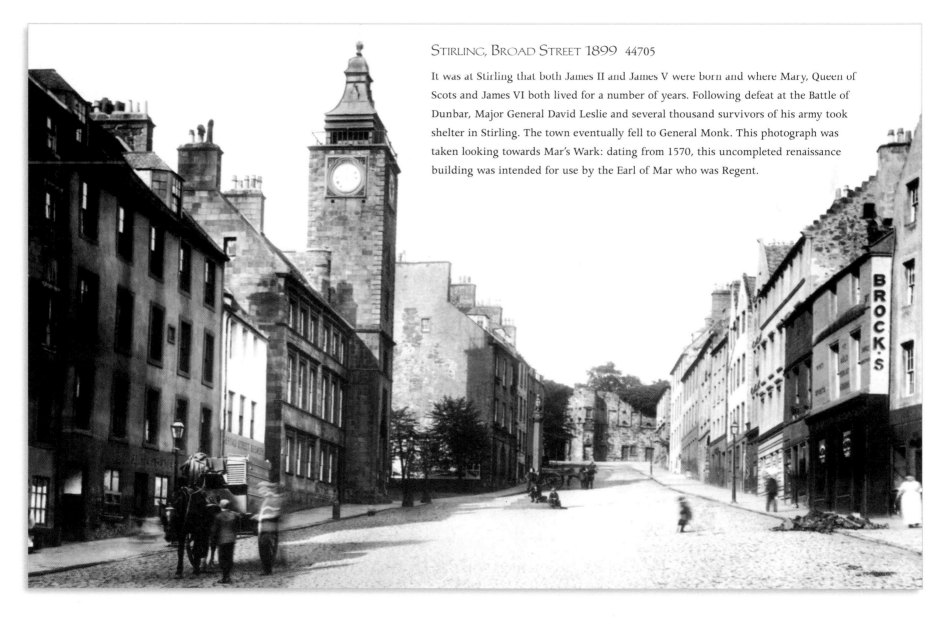

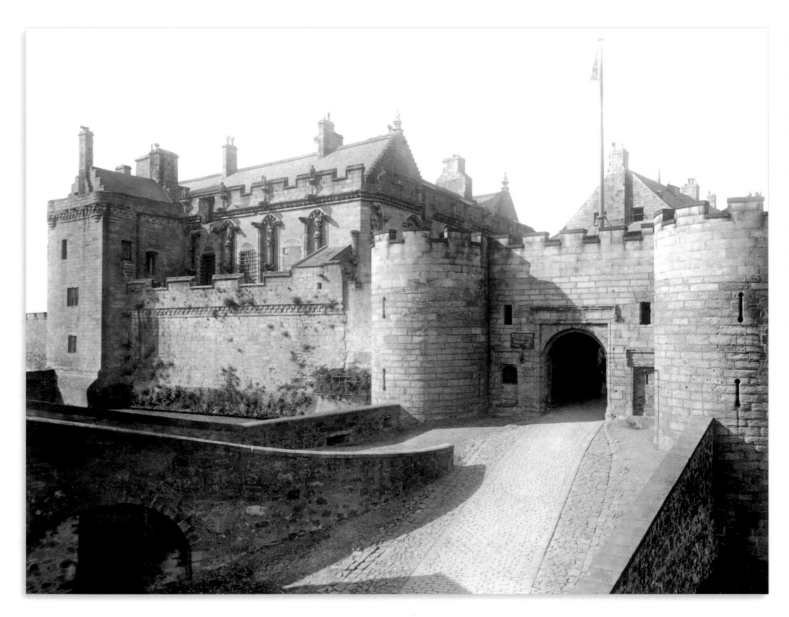

STIRLING, THE CASTLE 1899
44696

One of Scotland's greatest royal fortresses, Stirling Castle was taken by William Wallace in 1297 but was surrendered to Edward I in August 1305 following a siege. The survivors of the garrison, commanded by Sir William Oliphant, were brought before Longshanks and made to kneel in supplication.

STIRLING, THE OLD BRIDGE 1899 44701

Stirling is the last place where there is a bridge over the Forth before the river widens into an estuary. The town and its castle have therefore been fought over on numerous occasions. Dating from about 1400, the bridge was for years one of only a handful of crossing points over the Forth. In 1745, one of the arches was blown up to prevent Prince Charles Edward's forces from entering the town.

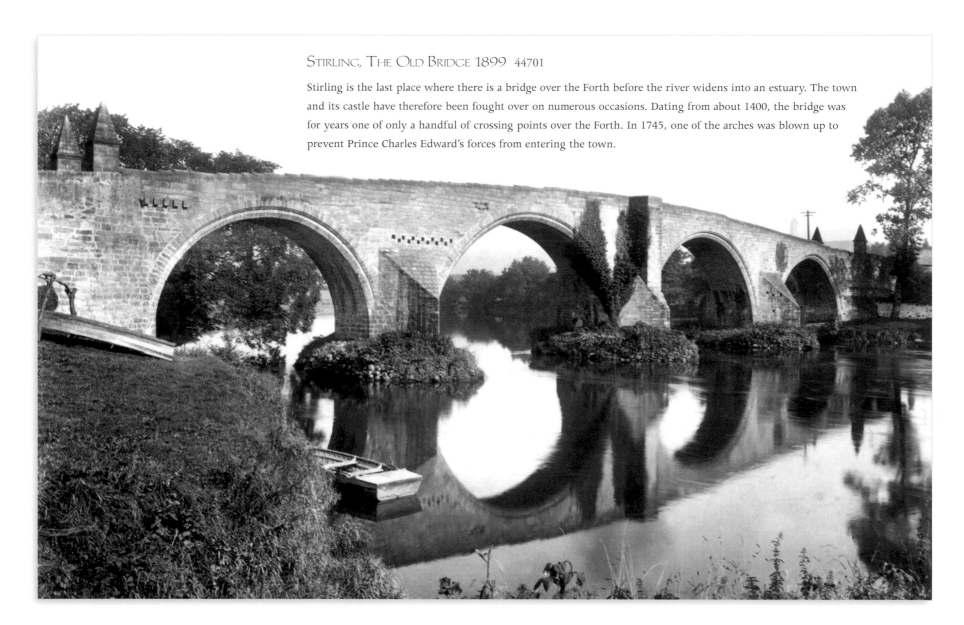

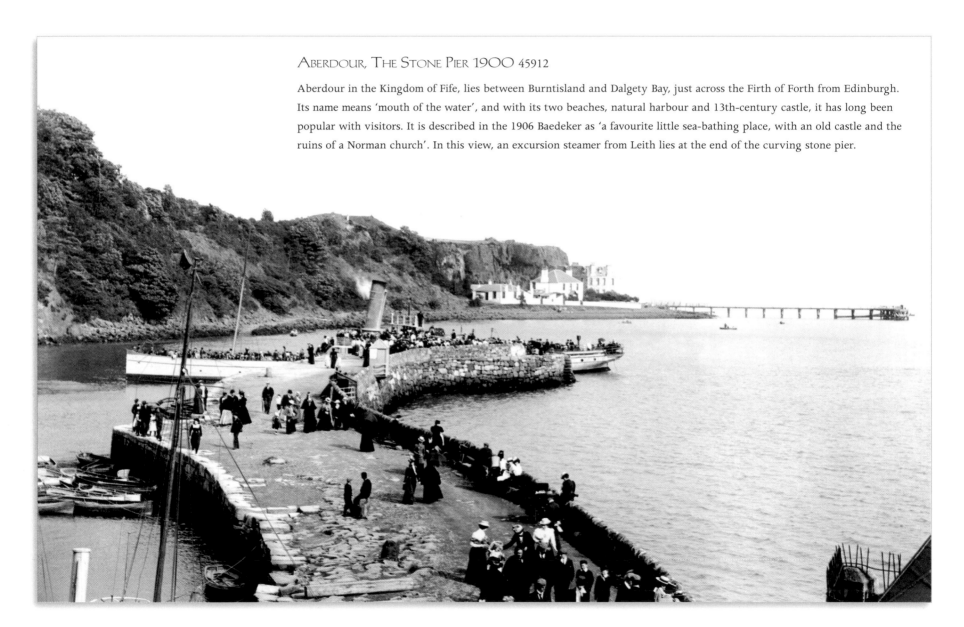

ABERDOUR, THE STONE PIER 1900 45912

Aberdour in the Kingdom of Fife, lies between Burntisland and Dalgety Bay, just across the Firth of Forth from Edinburgh. Its name means 'mouth of the water', and with its two beaches, natural harbour and 13th-century castle, it has long been popular with visitors. It is described in the 1906 Baedeker as 'a favourite little sea-bathing place, with an old castle and the ruins of a Norman church'. In this view, an excursion steamer from Leith lies at the end of the curving stone pier.

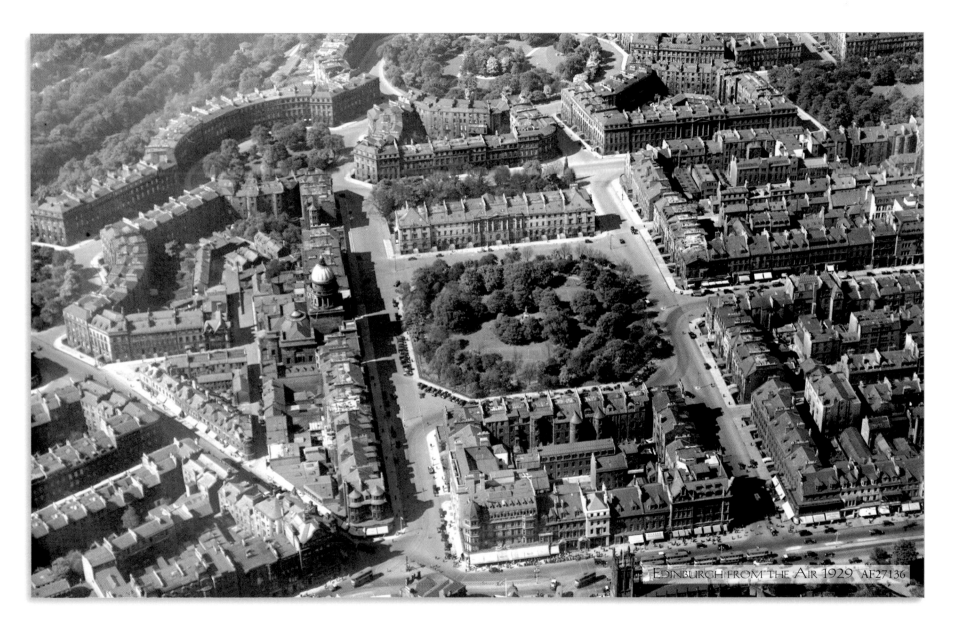

Edinburgh from the Air 1929 AF27136

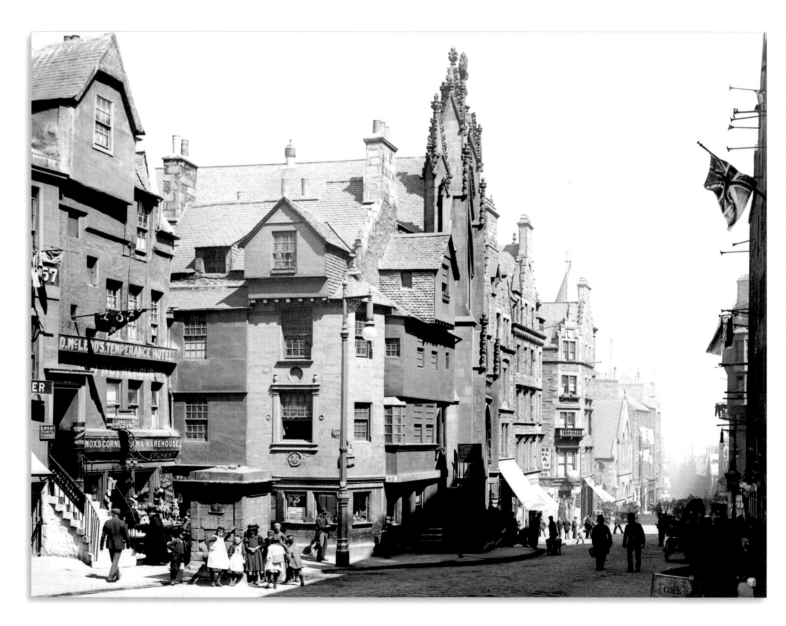

EDINBURGH,
JOHN KNOX'S
HOUSE 1897
39125

This view shows the lower reach of the High Street looking towards Canongate. The building immediately behind the lamp standard is known as John Knox's house. Dating from the 16th century, the house is said to have been built by Mary, Queen of Scots' goldsmith. Just how long Knox lived here is open to debate.

EDINBURGH,
HOLYROOD PALACE AND
ARTHUR'S SEAT 1897
39168

The building of Holyroodhouse was started in about 1500 by James IV; the work continued under James V, who added a new tower and quadrangle. In May 1544, the palace was badly damaged when it was set on fire by the Earl of Hertford's troops. Extensive alterations to the palace were undertaken between 1670 and 1679 by Sir William Bruce, the king's surveyor in Scotland. The strong French influence in Sir William's designs reflected Charles II's passion for all things Gallic.

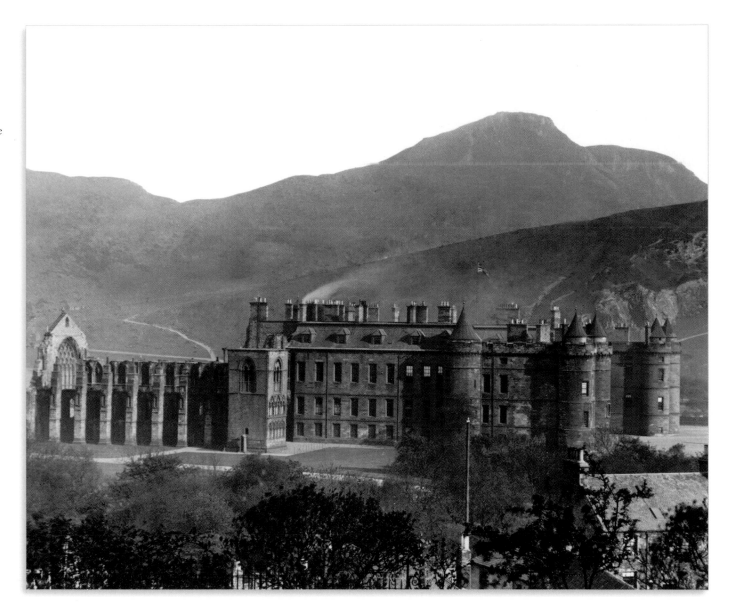

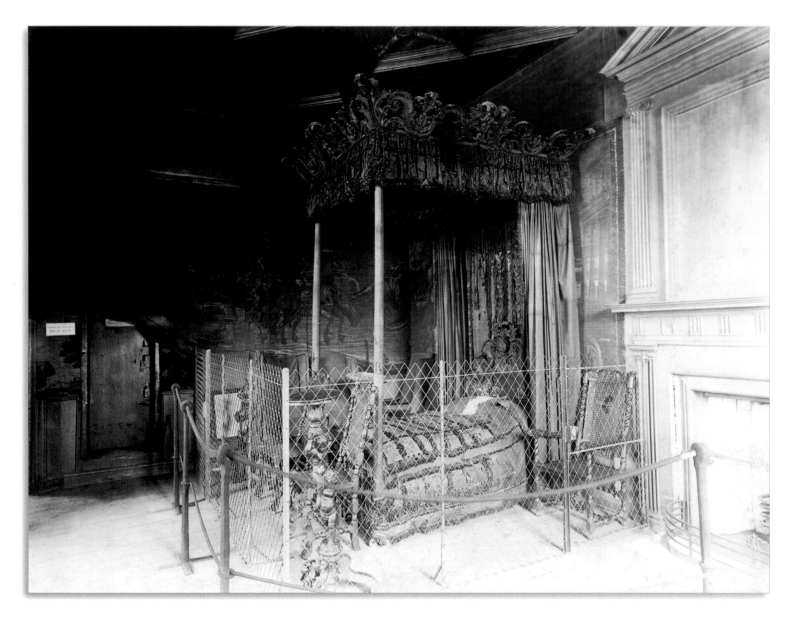

EDINBURGH,
HOLYROOD PALACE,
KING CHARLES'S
BEDROOM 1897
39172

A fence and rope guard the old feathered four-poster bed, with the elaborate canopy and drapes, though now dusty and faded, giving the bed a majestic and regal air.

EDINBURGH,
THE CASTLE 1897
39121A

The Edinburgh Castle we
see today is, with a few
additions, that built by the
Earl of Morton following
the siege of 1572. Here
we see a battalion of the
Black Watch parading
on the castle esplanade.
Raised by General Wade
in 1725, the Black Watch
was formally constituted
as a regiment of the line in
1739, and its strength was
increased from four to
ten companies.

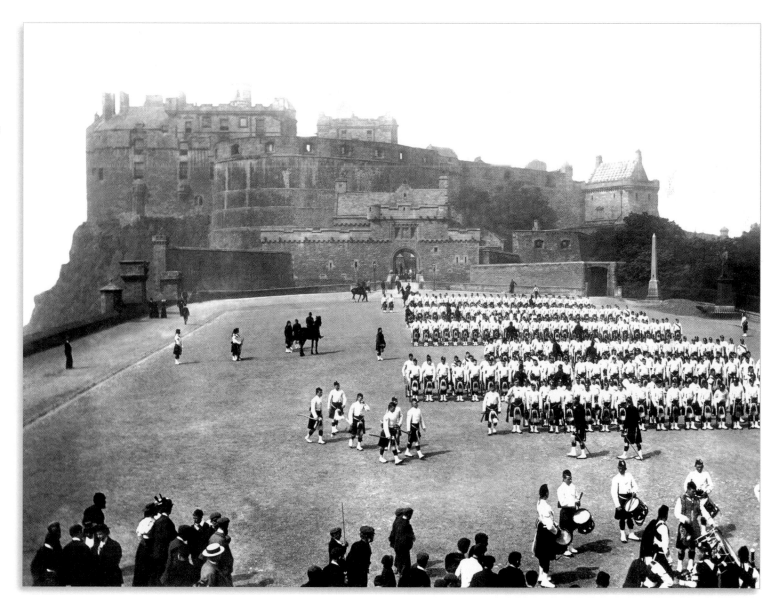

EDINBURGH

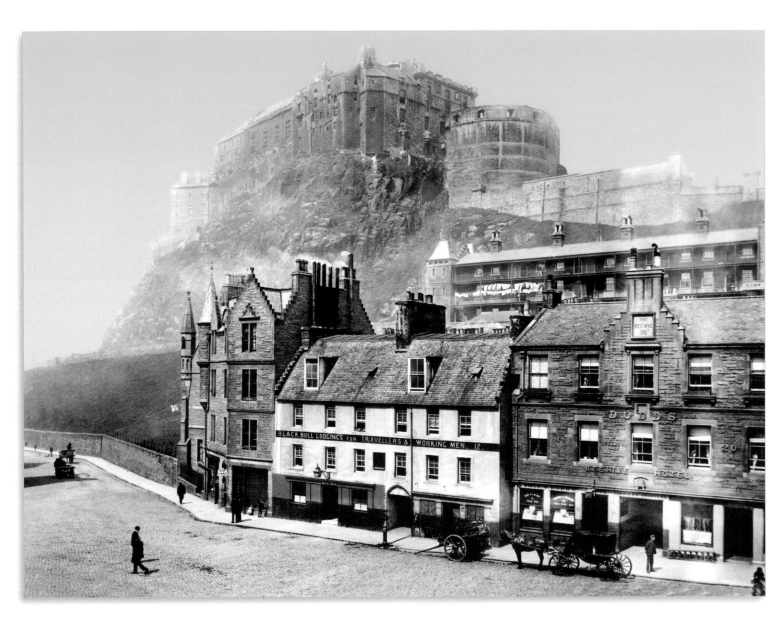

EDINBURGH, CASTLE FROM GRASSMARKET 1897
39121t

This was the site of many an execution and the location of the Porteous Riots in 1736. John Porteous was appointed captain of one of the companies employed to keep the peace. At a riot following the execution of a man named Robertson, Porteous ordered his men to fire on the crowd. He was later taken into custody, tried and condemned to death, but a stay of execution was granted. On 7 September, a mob broke into the jail and lynched him in the Grassmarket.

EDINBURGH, PRINCES STREET 1897 39108

At the turn of the 20th century Princes Street boasted a number of hotels. The most expensive to stay at was the North British at Waverley Station. Next on the list were the Caledonian, the Station and the Royal, followed by the somewhat cheaper Royal British, the Douglas and the Bedford. There was also the Old Waverley, which was a temperance establishment.

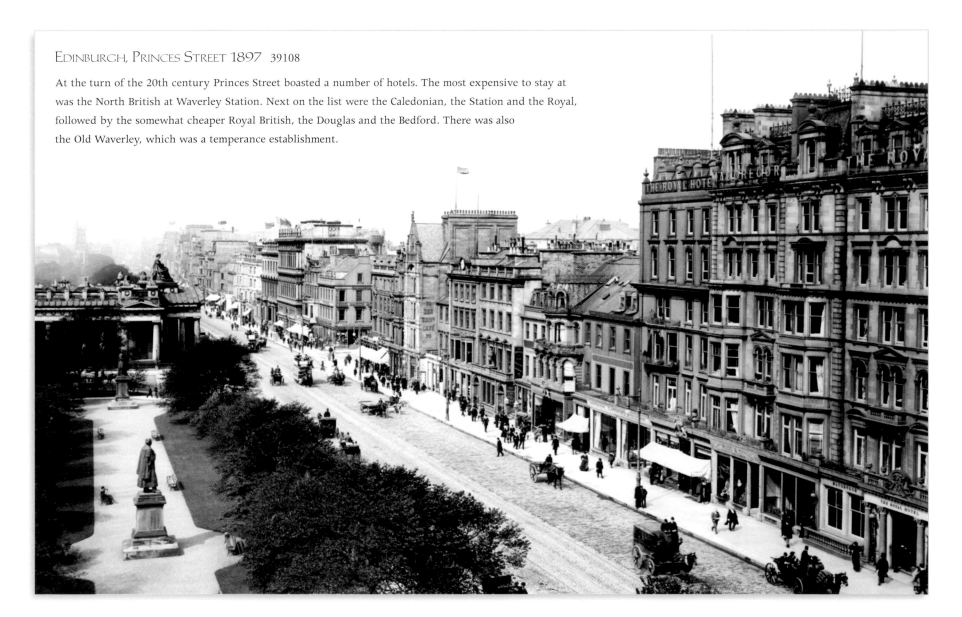

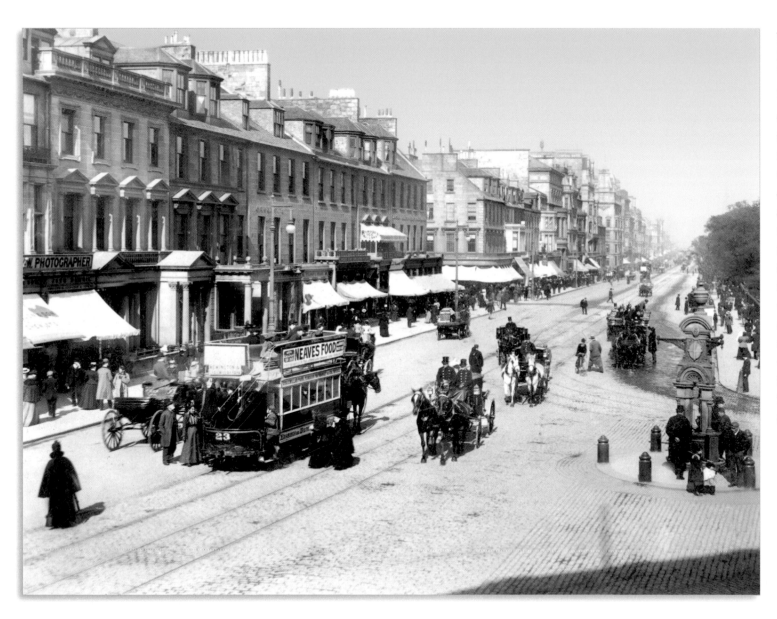

Considered to be one of the finest boulevards in Europe, Princes Street was the place to shop and eat. Restaurants included a branch of Ferguson & Forrester, the Royal British, and Littlejohn's. Confectioners included Mackies, and also Ritchies, where shortbread was a speciality. This photograph was taken looking west along the main thoroughfare of the New Town, with Princes Street Gardens on the left.

EDINBURGH,
ST GILES'S CATHEDRAL
1897 39127

The oldest parish church in
Edinburgh, St Giles's was
erected in the early
12th century on the site of
an older building. In 1385,
much of the church was badly
damaged by fire, and the
rebuilding was not completed
until 1460. In 1634, Charles I
attempted to re-establish the
Scottish Episcopal Church,
and St Giles's was for a short
period elevated to the status
of a cathedral. It became a
cathedral again under
Charles II, only to revert to
being a parish church
in 1688.

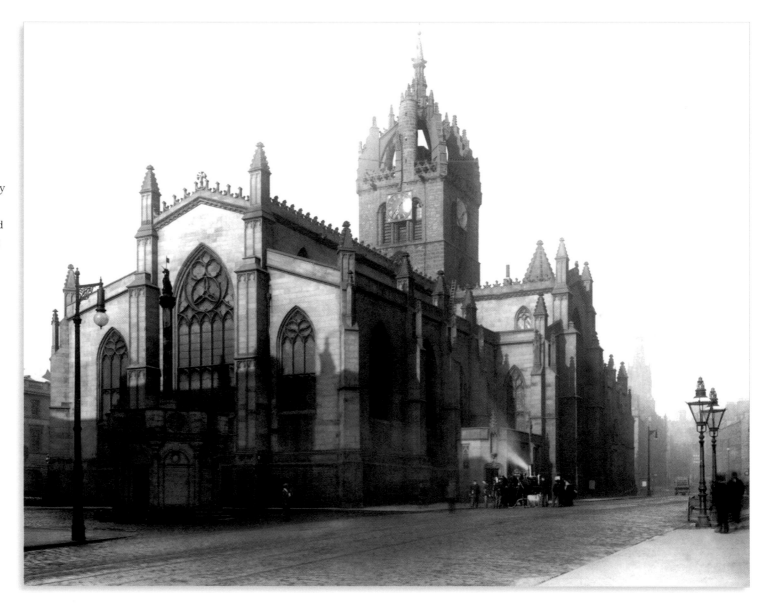

ROSLIN CHAPEL 1897 39164

Roslin is famous for its castle and chapel. The oldest part of the castle, which was founded by Sir William Sinclair, dates from the early 14th century. The consecration of the chapel was delayed because a murder had been committed on the premises by the chief stonemason. The chapel, which is famed for its elaborate carvings, was founded in 1446 as a collegiate church, but only the lady chapel and choir were completed. The church was badly damaged by rioters in 1688 and was restored in the 19th century.

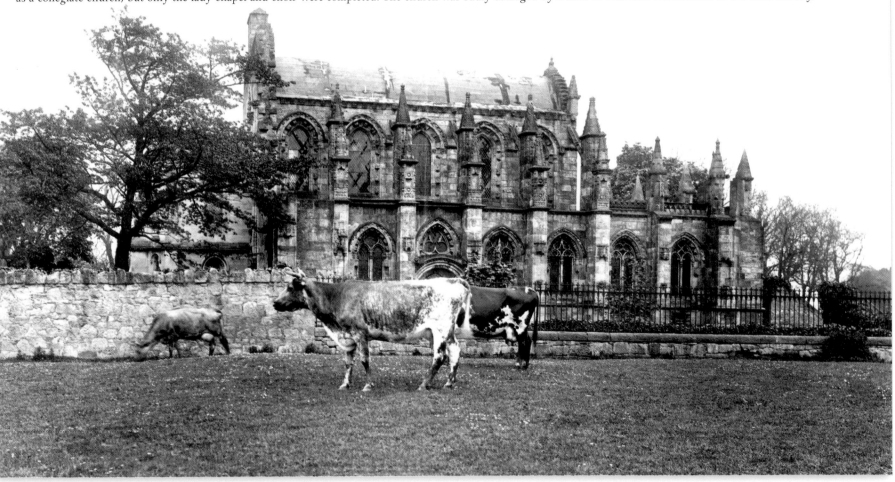

EDINBURGH, THE CANONGATE TOLBOOTH 1897
39124A

The Canongate was where the canons of Holyrood Abbey entered the Old Town. The tolbooth, with its projecting clock, is one of the most famous landmarks on the Royal Mile and dates from 1591. Note the poles used for drying washing. When this picture was taken, the tolbooth was already more than 300 years old, having been built at the end of the 16th century. It has had a varied career, having been used as a courthouse and a prison.

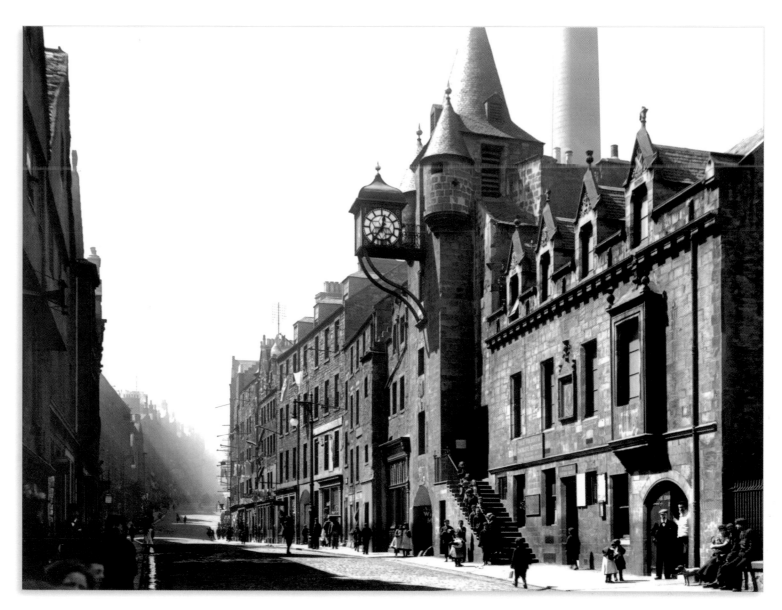

HAWTHORNDEN, BEN JONSON'S TREE 1897 39162

It is said that Drummond was sitting under the great sycamore tree in front of the house when
Jonson trudged up the path. Drummond met him with 'Welcome, welcome, royal Ben!' Jonson
replied: 'Thank ye, thank ye, Hawthornden!' Drummond's library was one of the finest of
its day, containing about 1,400 books in English, French, Latin, Greek, Spanish, Italian
and Hebrew.

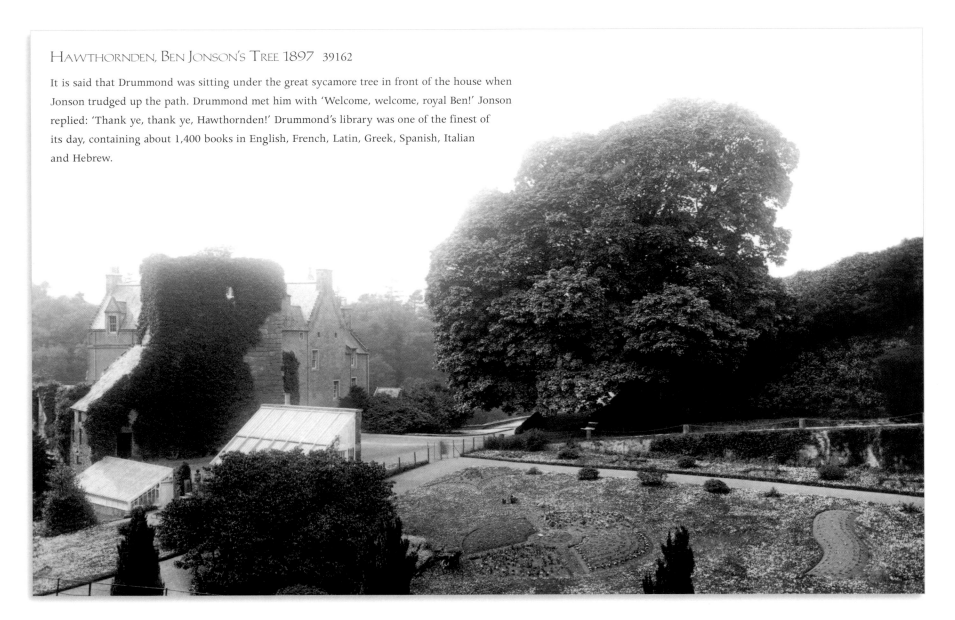

Hawthornden 1897
39159

Located nine miles south of Edinburgh, Hawthornden stands high above the river North Esk amid a densely wooded estate. The home of the poet William Drummond (1585-1649), the house was extensively rebuilt by him in 1638. The English poet laureate Ben Jonson stayed here from December 1618 until the middle of January 1619 as a guest of Drummond.

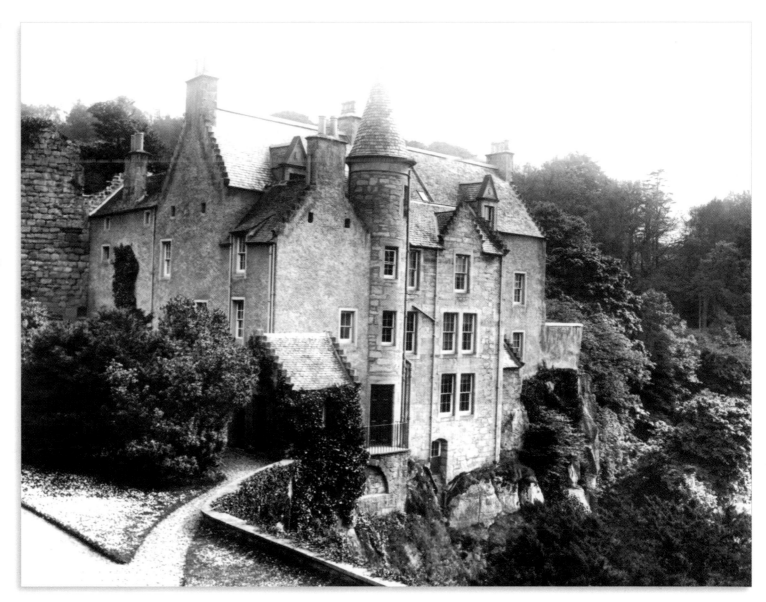

LOTHIAN & THE BORDERS

LINLITHGOW PALACE 1897 39154

The Palace is situated upon the south shore of Linlithgow Loch. King David I built the first manor house at Linlithgow, and the church of St Michael next to it. In 1301, Edward Longshanks set about rebuilding and heavily fortifying the palace, and it was held by the English until the autumn of 1313. It was here that Mary, Queen of Scots was born in 1542. The palace is thought to have been burnt down accidently in 1746 by General Hawley's troops.

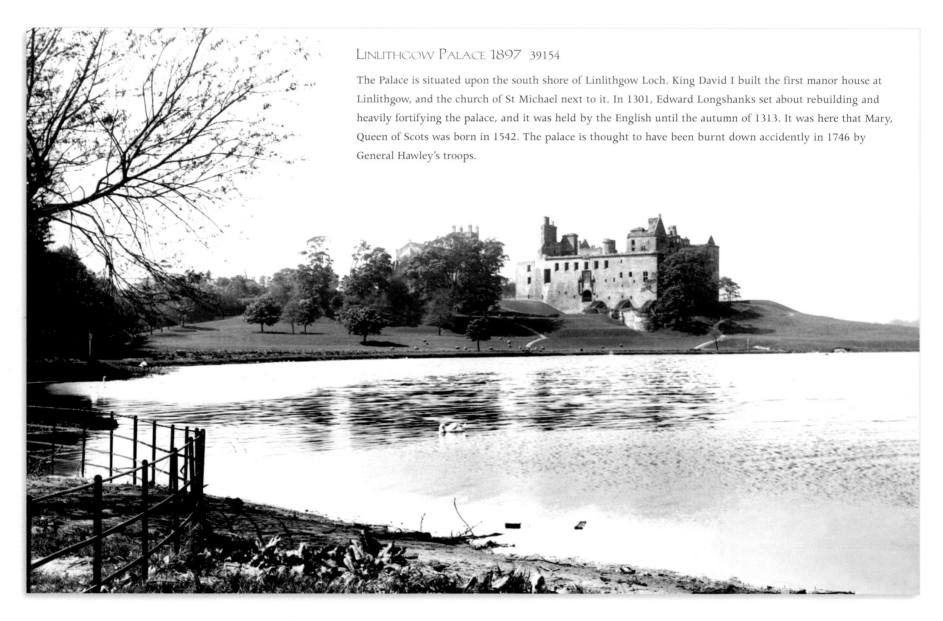

LINLITHGOW,
THE CROSSWELL 1897
39157t

This well, with its thirteen
water jets, is a reconstruction
of an earlier one destroyed
by Oliver Cromwell's troops.
All is peace and quiet in
this scene, but things were
livelier on 23 January 1570.
Lord James Stewart, Earl of
Moray and Regent, was shot
by James Hamilton as he
rode through the town. The
assassin fired his musket from
an upper window in a house
belonging to the archbishop
of St Andrews, who also
appears to have supplied
the getaway horse. The
Archbishop was executed at
Stirling in 1571 without the
formality of a trial.

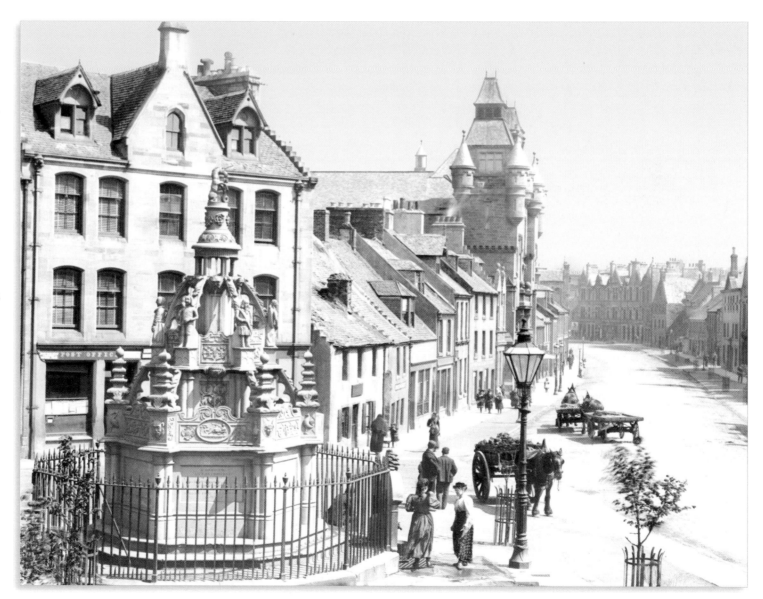

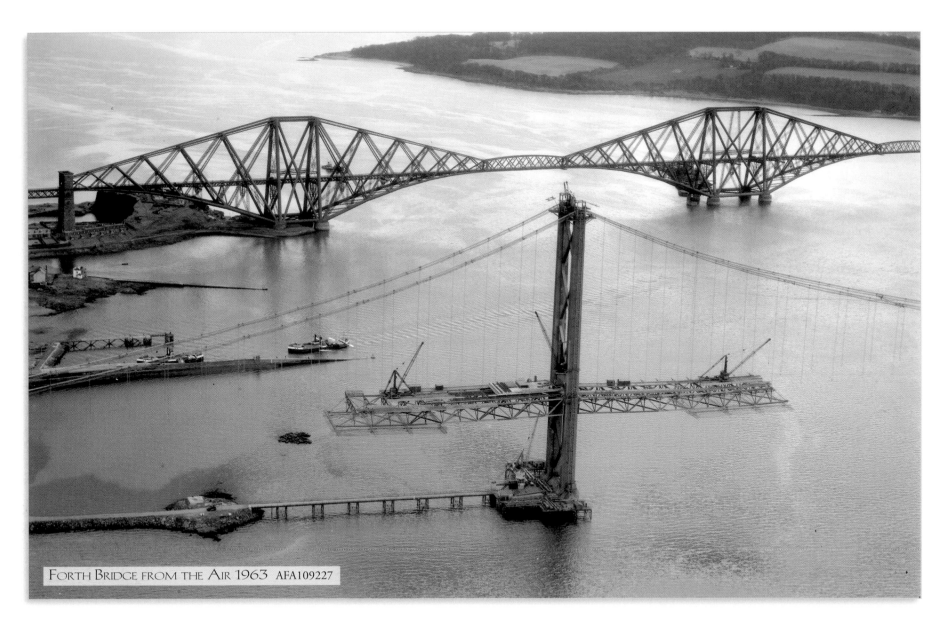

FORTH BRIDGE FROM THE AIR 1963 AFA109227

THE FORTH BRIDGE 1897
39145

Designed by Sir John Fowler
and Sir Benjamin Baker, the
Forth Bridge cost £3,000,000
to build. Of the workforce of
4,500 men, 57 were killed in
work-related accidents. Built
between 1883 and 1890, the
bridge was constructed to carry
the North British Railway's
main line between Edinburgh
and Aberdeen. It has an overall
length of 2,700 yards including
approach viaducts. The tracks
run across the bridge 150 feet
above sea level.

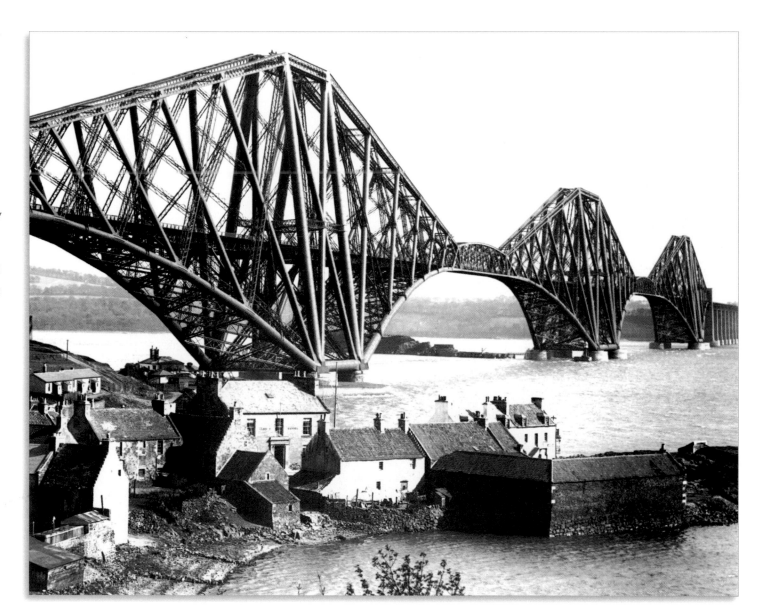

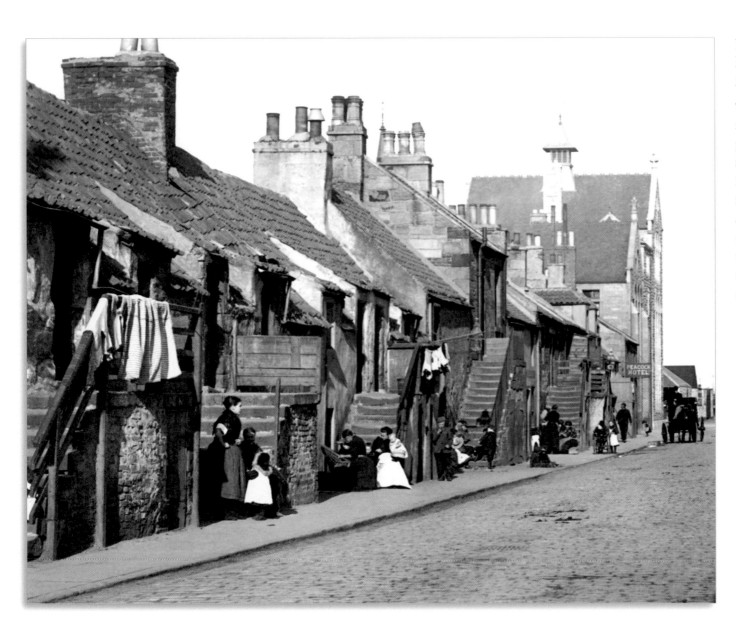

NEWHAVEN,
FISHERMEN'S COTTAGES 1897
39137

The fishermen's wives were
noted for their dresses, which
probably reflected their Dutch and
Scandinavian origins. They were also
known for their cries when selling
fish: 'Caller Herrin' (fresh herrings)
and 'Caller Ou' (fresh oysters). Here
we see their terraced cottages, with
the characteristic outside stair to
the first-floor door. Below were
storerooms for nets and sails.

NEWHAVEN, THE HARBOUR 1897 39139

A little more than one mile to the west of Leith is the small fishing village of Newhaven. It was here that James IV founded a royal dockyard where he could build his navy. The first ship that was launched was the 'Great Michael', a huge warship capable of carrying 420 gunners and 1,000 soldiers. The original population of Newhaven was probably of Dutch and Scandinavian origin. For generations the people rarely moved out of their own community, keeping their traditions and customs alive.

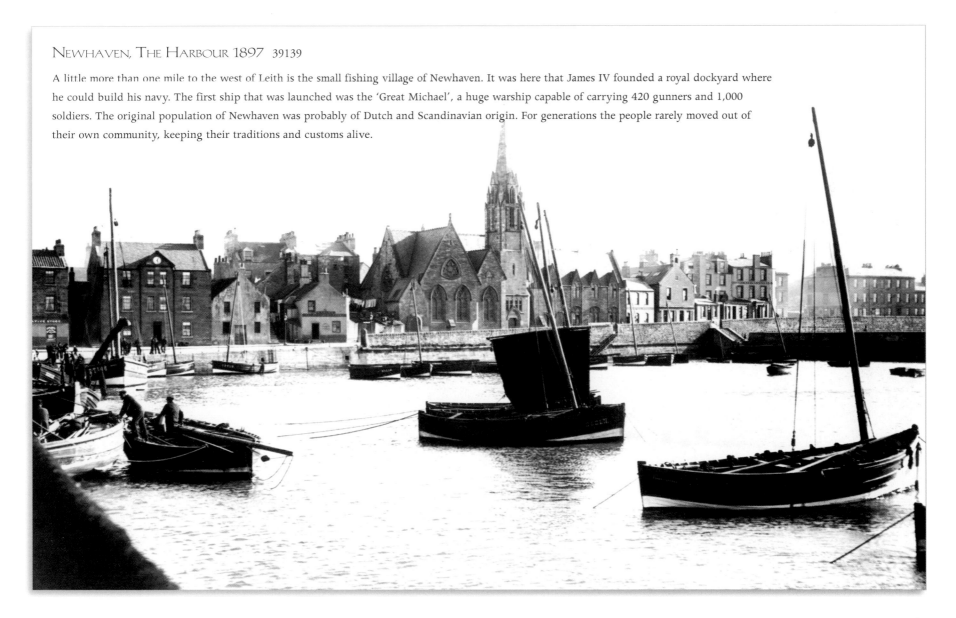

EYEMOUTH, THE HARBOUR c1960 E119004

The picturesque coastal town of Eyemouth is situated five miles north of the border where the Eye Water flows into the North Sea. Eyemouth's fine natural harbour has been the base for fishermen since medieval times. It was once the haunt of smugglers, who imported illicit spirits from the Continent. With its sheltered sandy beaches, it has become popular with holiday makers.

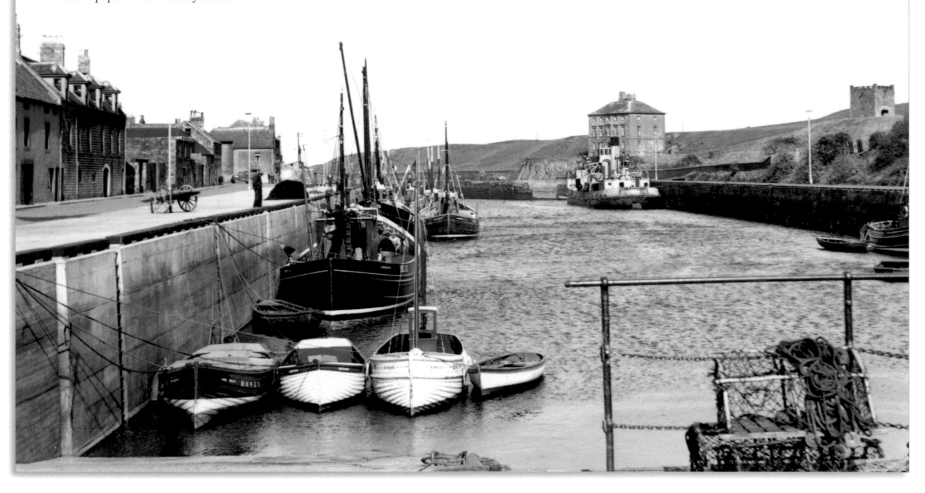

TANTALLON CASTLE 1897 39187

Tantallon Castle perches on top of cliffs overlooking the Firth of Forth. It was once the seat of the powerful Douglas family, wardens of the Border Marches and lords of Galloway. With its great battlemented walls it provided a formidable defence, and was protected from invaders by a 12ft-thick curtain wall, ditches and lofty sea cliffs. The family had their own comfortable quarters in the circular Douglas Tower at the north-west end. However, during Cromwell's invasion in 1651 the castle suffered considerable damage and it was never to regain its status.

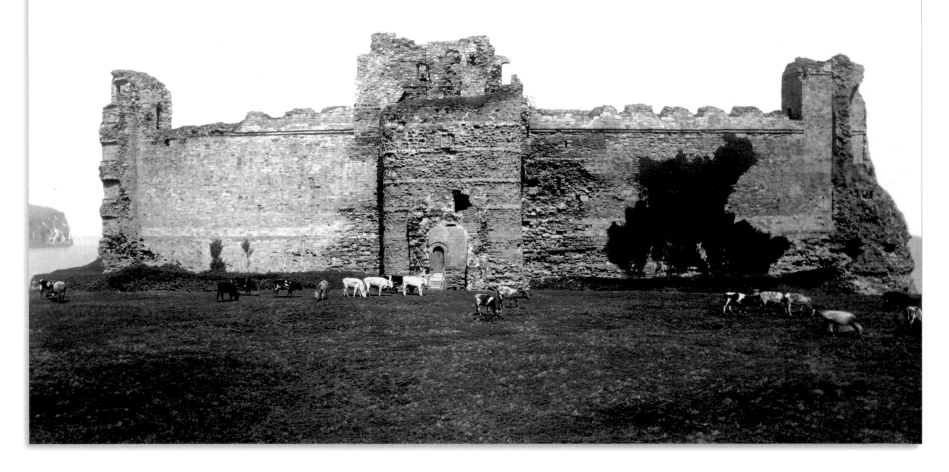

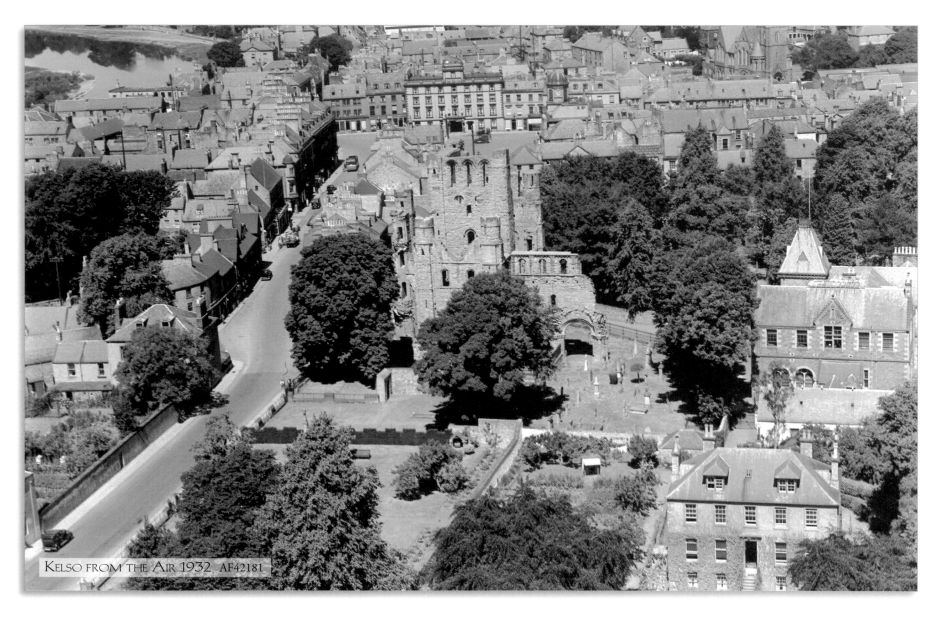

KELSO FROM THE AIR 1932 AF42181

KELSO, THE VIEW FROM MAXWELLHEUGH c1955 K55007

This magnificent stone bridge was built in the early 1800s to replace another that was washed away in the floods of 1797. It was designed by the celebrated engineer John Rennie, and is a smaller-scale version of the Waterloo Bridge in London that he designed later. The scene here of the Kelso and the flowing River Tweed may look peaceful enough, but in the 1850s the townspeople rioted violently, protesting against the level of tolls.

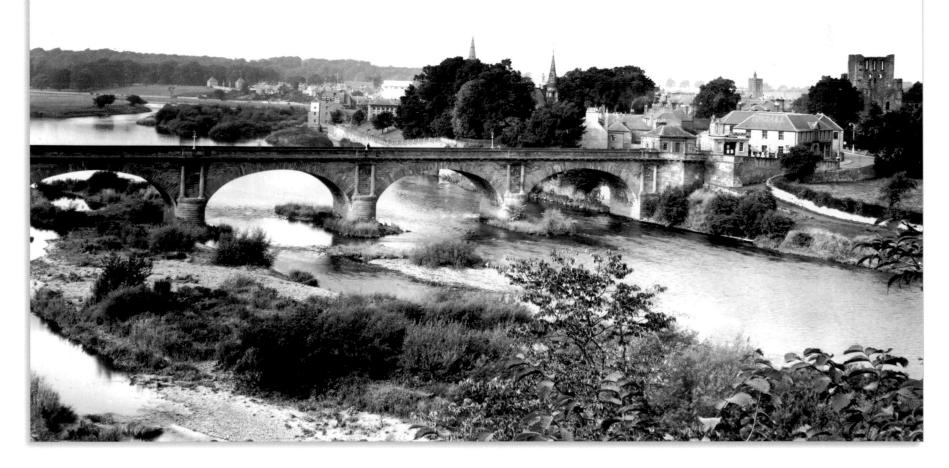

ST BOSWELLS, THE BUCCLEUCH HOUNDS c1955 S417010

The village of St Boswells borders the main road from Jedburgh to Edinburgh. The 5th Duke of Buccleuch was just a boy when inherited his title in 1819. He lived at Dalkeith, but also had a lodge at Eildon near Melrose. The kennels for his hunt were built in 1836 on land close by the village green. He improved and enlarged them in 1843. In the hunting season as many as 350 huntsmen, horses and grooms would assemble at the kennels. Each huntsman brought two horses, riding one in the morning and the other in the afternoon. When hunting was banned in the 1990s the hounds were moved to Greenwells, near Eildon Hall.

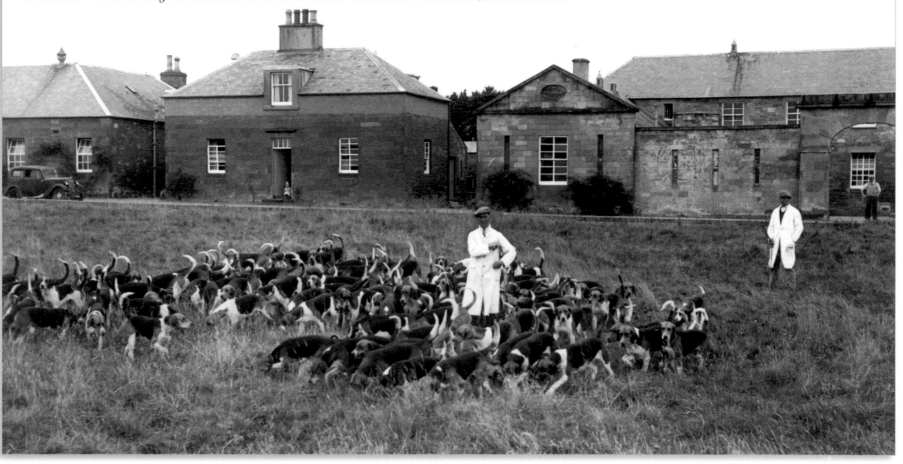

ABBOTSFORD HOUSE 1897 39198

In 1811 Sir Walter Scott purchased the Cartley Hole estate on the banks of the Tweed and changed its name to Abbotsford. The house was designed in the baronial style by Scott himself, and built between 1817 and 1824, complete with steam central heating. It includes an armoury where Scott's collection of weapons are displayed.

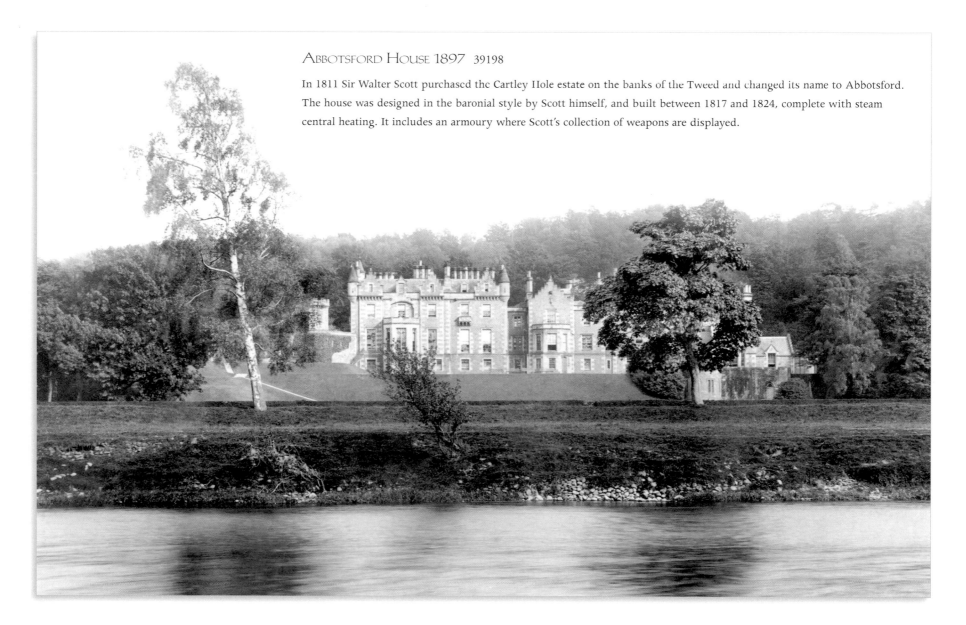

INDEX

Frith Products & Services

Francis Frith would doubtless be pleased to know that the pioneering publishing venture he started in 1860 still continues today. Over a hundred and forty years later, The Francis Frith Collection continues in the same innovative tradition and is now one of the foremost publishers of vintage photographs in the world. Some of the current activities include:

Interior Decoration

Today Frith's photographs can be seen framed and as giant wall murals in thousands of pubs, restaurants, hotels, banks, retail stores and other public buildings throughout the country. In every case they enhance the unique local atmosphere of the places they depict and provide reminders of gentler days in an increasingly busy and frenetic world.

Product Promotions

Frith products are used by many major companies to promote the sales of their own products or to reinforce their own history and heritage. Frith promotions have been used by Hovis bread, Courage beers, Scots Porage Oats, Colman's mustard, Cadbury's foods, Mellow Birds coffee, Dunhill pipe tobacco, Guinness, and Bulmer's Cider.

Genealogy and Family History

As the interest in family history and roots grows world-wide, more and more people are turning to Frith's photographs of Great Britain for images of the towns, villages and streets where their ancestors lived; and, of course, photographs of the churches and chapels where their ancestors were christened, married and buried are an essential part of every genealogy tree and family album.

Frith Products

All Frith photographs are available Framed or just as Mounted Prints and Posters (size 23 x 16 inches). These may be ordered from the address below. From time to time other products - Address Books, Calendars, Table Mats, etc - are available.

The Internet

Already ninety thousand Frith photographs can be viewed and purchased on the internet through the Frith websites and a myriad of partner sites.

For more detailed information on Frith companies and products, look at these sites:

www.francisfrith.co.uk
www.francisfrith.com
(for North American visitors)

See the complete list of Frith Books at:

www.francisfrith.co.uk

This web site is regularly updated with the latest list of publications from The Francis Frith Collection. If you wish to buy books relating to another part of the country that your local bookshop does not stock, you may purchase on-line.

For further information, trade, or author enquiries please contact us at the address below:
The Francis Frith Collection, Frith's Barn, Teffont, Salisbury, Wiltshire, England SP3 5QP.
Tel: +44 (0)1722 716 376 Fax: +44 (0)1722 716 881 Email: sales@francisfrith.co.uk

See Frith books on the internet at www.francisfrith.co.uk

FREE PRINT OF YOUR CHOICE

Mounted Print
Overall size 14 x 11 inches (355 x 280mm)

CHOOSE A PHOTOGRAPH FROM THIS BOOK

IMPORTANT!

These special prices are only available if you use this form to order .

You must use the ORIGINAL VOUCHER on this page (no copies permitted).

We can only despatch to one address.

This offer cannot be combined with any other offer.

Send completed Voucher form to:
**The Francis Frith Collection,
Frith's Barn, Teffont, Salisbury,
Wiltshire SP3 5QP**

Choose any Frith photograph in this book.
Simply complete the Voucher opposite and return it with your remittance for £2.25 (to cover postage and handling) and we will print the photograph of your choice in SEPIA (size 11 x 8 inches) and supply it in a cream mount with a burgundy rule line (overall size 14 x 11 inches).

Please note: photographs with a reference number starting with a "Z" are not Frith photographs and cannot be supplied under this offer.
Offer valid for delivery to UK addresses only.

PLUS: Order additional Mounted Prints at HALF PRICE - £7.49 each (normally £14.99)
If you would like to order more Frith prints from this book, possibly as gifts for friends and family, you can buy them at half price (with no additional postage and handling costs).

PLUS: Have your Mounted Prints framed
For an extra £14.95 per print you can have your mounted print(s) framed in an elegant polished wood and gilt moulding, overall size 16 x 13 inches (no additional postage and handling required).

Voucher *for FREE and Reduced Price Frith Prints*

Please do not photocopy this voucher. Only the original is valid, so please fill it in, cut it out and return it to us with your order.

Picture ref no	Page no	Qty	Mounted @ £7.49	Framed + £14.95	Total Cost £
		1	Free of charge*	£	£
			£7.49	£	£
			£7.49	£	£
			£7.49	£	£
			£7.49	£	£
			£7.49	£	£

Please allow 28 days for delivery. Offer available to one UK address only

* Post & handling	£2.25	
Total Order Cost	£	

Title of this book .

I enclose a cheque/postal order for £
made payable to 'The Francis Frith Collection'

OR please debit my Mastercard / Visa / Maestro / Amex card, details below

Card Number

Issue No (Maestro only) Valid from (Maestro)

Expires Signature

Name Mr/Mrs/Ms .
Address .
. .
. .
. Postcode
Daytime Tel No .
Email .

ISBN 1-84589-185-6 Valid to 31/12/08

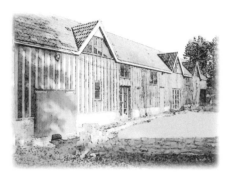

Can you help us with information about any of the Frith photographs in this book?

We are gradually compiling an historical record for each of the photographs in the Frith archive. It is always fascinating to find out the names of the people shown in the pictures, as well as insights into the shops, buildings and other features depicted.

If you recognize anyone in the photographs in this book, or if you have information not already included in the author's caption, do let us know. We would love to hear from you, and will try to publish it in future books or articles.

Our production team

Frith books are produced by a small dedicated team at offices in the converted Grade II listed 18th-century barn at Teffont near Salisbury, illustrated above. Most have worked with the Frith Collection for many years. All have in common one quality: they have a passion for the Frith Collection.
The team is constantly expanding, but currently includes:

Paul Baron, Jason Buck, John Buck, Ruth Butler, Heather Crisp, David Davies, Louis du Mont, Isobel Hall, Lucy Hart, Julian Hight, Peter Horne, James Kinnear, Karen Kinnear, Tina Leary, Stuart Login, Sue Molloy, Sarah Roberts, Kate Rotondetto, Dean Scource, Eliza Sackett, Terence Sackett, Sandra Sampson, Adrian Sanders, Sandra Sanger, Julia Skinner, Miles Smith, Lewis Taylor, Shelley Tolcher, Lorraine Tuck, Miranda Tunnicliffe, David Turner and Ricky Williams.